WHISTLER AND HIS CIRCLE IN VENICE

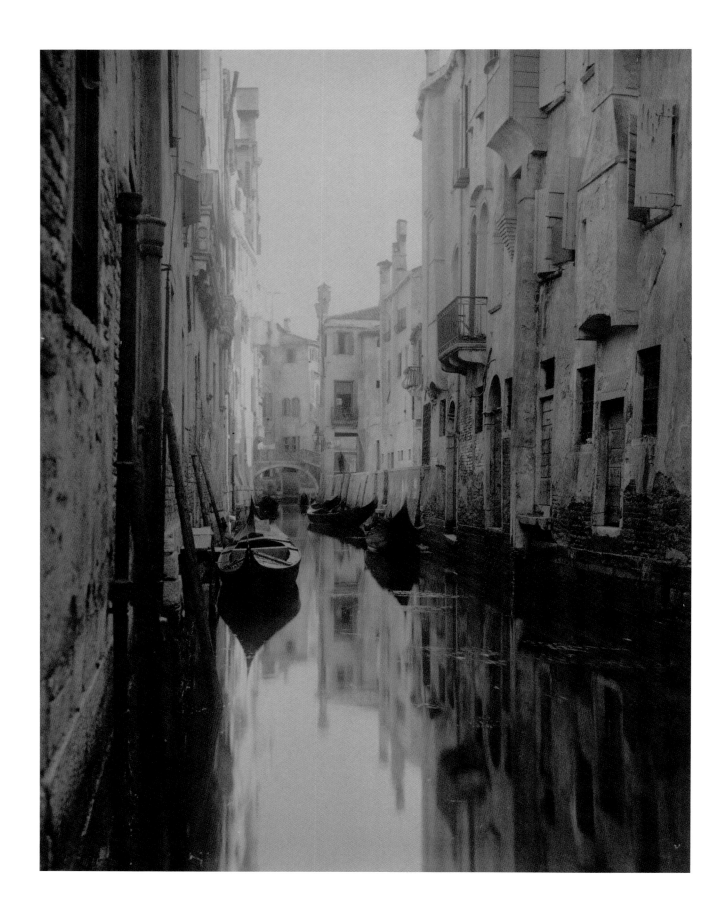

Whistler
AND HIS CIRCLE IN
VENICE

Eric Denker

MERRELL

in association with

The Corcoran Gallery of Art

AND THE FREER GALLERY OF ART, SMITHSONIAN INSTITUTION

This book is dedicated to Judith and Robert Martin
with gratitude for their encouragement, friendship, and love

First published 2003 by
Merrell Publishers Limited
42 Southwark Street
London SE1 1UN

in association with

The Corcoran Gallery of Art
500 Seventeenth Street, NW
Washington, D.C. 20006

Published on the occasion of the exhibition
Whistler and His Circle in Venice
organized by The Corcoran Gallery of Art,
Washington, D.C.

Exhibition itinerary:

The Corcoran Gallery of Art, Washington, D.C.
February 8 – May 5, 2003

The Grolier Club
September 17 – November 22, 2003

A catalogue record for this book is available from
the Library of Congress

British Library Cataloguing-in-Publication Data:
Denker, Eric
Whistler and his circle in Venice
1.Whistler, James McNeill, 1834–1903 –
Criticism and interpretation 2.Whistler, James
McNeill, 1834–1903 – Homes and haunts – Italy
– Venice 3.Whistler, James McNeill, 1834–1903 –
Friends and associates 4.Venice (Italy) – In art
I.Title II.Corcoran Gallery of Art
759.1'3

ISBN 1 85894 200 4 (hardcover edition)
ISBN 1 85894 201 2 (softcover edition)

Produced by Merrell Publishers
Designed by Matt Hervey
Edited by Christine Davis and Joyce Willcocks
Index by Helen Smith
Printed and bound in Singapore

Jacket/cover, front: James McNeill Whistler,
The Church of San Giorgio Maggiore, 1800, detail
(pl. 27)
Jacket/cover, back, and pages 112–13: Thomas
Moran, *View of Venice*, 1888, detail (pl. 86)
Frontispiece: Alfred Stieglitz, *A Venetian Canal*,
1894, detail (pl. 143)
Pages 56–57: James McNeill Whistler,
Nocturne—San Giorgio, 1880, detail (pl. 13)

NOTES ON THE TEXT
The titles of works cited in the text follow the
spelling, capitalization, and punctuation of the
artist.

Numbers preceded by 'M' relate to Whistler's
pastels and refer to the catalogue numbers in
Margaret F. MacDonald, *James McNeill Whistler,
Drawings, Pastels, and Watercolours, a Catalogue
Raisonée*, New Haven CT and London (Yale
University Press) 1995. Numbers preceded by
'K.' relate to Whistler etchings and refer to the
catalogue numbers in Edward Kennedy, *The
Etched Work of Whistler: A Catalogue Raisonné*,
New York (The Grolier Society) 1910. State
numbers are indicated for Whistler etchings
only if prior to the final state.

Contents

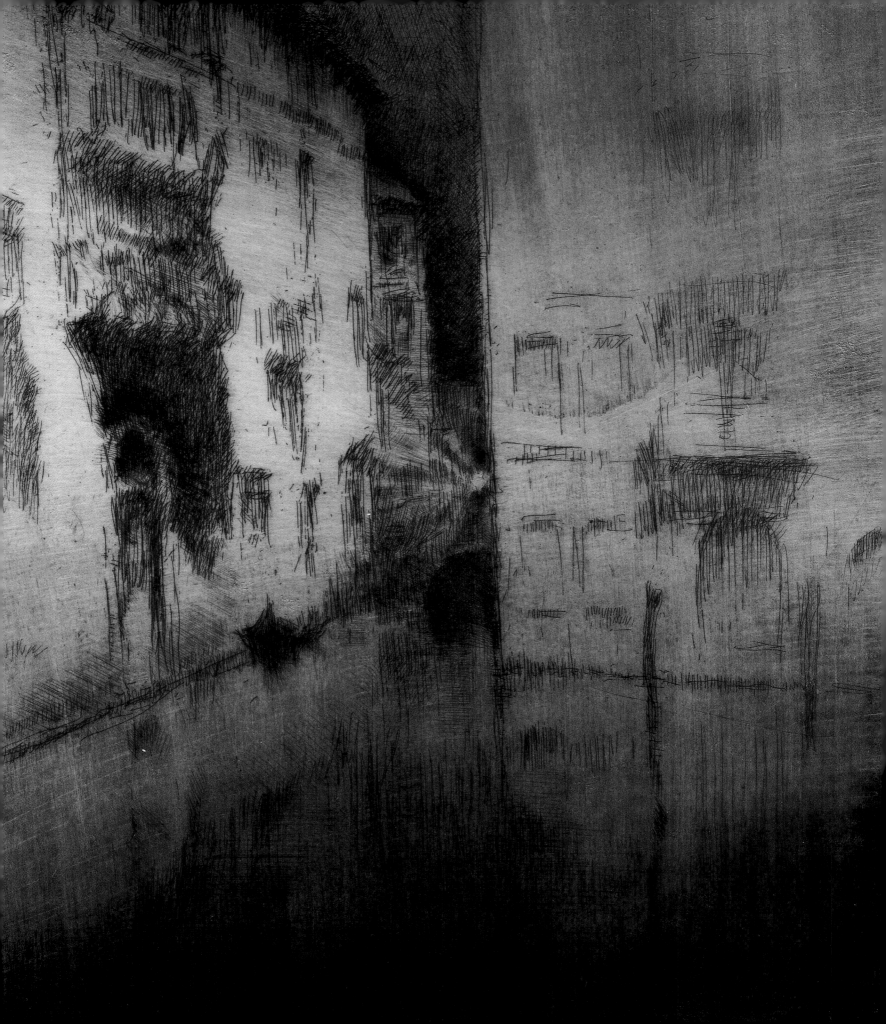

Preface

In September of 1879 the American expatriate artist James McNeill Whistler arrived in Venice with a modest commission from the Fine Art Society of London to produce a set of twelve etchings over a period of three months. In the end, Whistler would remain in Venice not just for a season but for fourteen months, returning to London only in November of 1880. During his time in the city he executed not twelve but more than fifty prints, in addition to a handful of paintings and approximately one hundred pastels.

On Whistler's return to England, the Venetian etchings and pastels re-established his flagging artistic reputation, and marked a turning point in his career. His innovative approach to the city and his technical explorations of media combined to produce a powerful new vision of Venice for contemporary artists and viewers. The nature of Whistler's achievement, and the influence of his vision on subsequent generations of artists, is the subject of this publication, which commemorates the one hundredth anniversary of the artist's death.

Already by 1908, Whistler's biographers Joseph and Elizabeth Pennell could write: "Whistler's work during his fourteen months in Venice is better known than any he ever did."[1] Following Whistler's death, in 1903, a major selection of the Venetian works was included in the memorial shows in London, Boston,

and New York. During the next decade, Whistler's friends and colleagues published numerous memoirs of their time with the artist in Venice, books and articles that provided valuable information on his life and work during this period. While many authors related tales of his flamboyant character and irascible temperament, several also included serious artistic consideration of this crucial period in his development.[2] At the same time, a series of books and catalogues established the parameters of Whistler's œuvre, particularly his accomplishments as a printmaker.[3] Whistler's reputation declined with the death of many of his contemporaries and champions, and with the changing aesthetic tides of the early twentieth century. While Whistler's reputation as a significant painter went into eclipse, his etchings continued to be acknowledged by collectors and curators as among the most important achievements in the history of printmaking.

It was not until the 1960s that serious scholarly interest in Whistler re-emerged with a younger generation of academics who, with sufficient aesthetic distance, critically re-evaluated Whistler's development and achievement within the context of his own period.[4] Beginning in 1970, Robert Getscher devoted special attention to the Venetian etchings and later extended his inquiries to include both an exploration of Whistler's pastels and an analysis of his influence on contemporary printmaking.[5] During the last quarter

James McNeill Whistler, *Nocturne: Palaces*, 1879–80, detail (pl. 50)

of the century, the catalogue raisonné of Whistler's paintings gave scholars and students a significant tool with which to analyse Whistler's life and art.[6] In 1984, a spate of scholarly activity related to the commemoration of the one-hundred-and-fiftieth anniversary of Whistler's birth resulted in a flurry of catalogues, books, articles, and exhibitions. Katherine Lochnan's seminal book on Whistler's etchings, in conjunction with an exhibition at The Metropolitan Museum of Art in New York, examined the evolution of Whistler as a printmaker, and included a particularly incisive reconsideration of the Venetian work.[7] By the 1980s, an argument could be made that Whistler's etchings and lithographs were, after those of Rembrandt, the most thoroughly studied prints in the history of art.

During the last twenty years, art historians have reconsidered Whistler's development as an artist, placing him successively in the contexts of Victorian British art, French Realism and Impressionism, and nineteenth-century American artists working abroad.[8] Margaret F. MacDonald's monumental 1995 catalogue raisonné of Whistler's works on paper contributed another invaluable tool to scholarship, cataloguing and illustrating for the first time all of the extant work, including the Venetian pastels and drawings.[9] The catalogue raisonné of the lithographs from The Art Institute of Chicago similarly contributes to our fuller appreciation of another part of Whistler's creative experience.[10] In the last decade the Centre for Whistler Studies in Glasgow University Library has continually enhanced our access to the letters and writings of Whistler, through scholarly publications and through the Internet, allowing a direct entrée into the personal expression of the artist.[11] With the many contributions to the Whistler literature of the last twenty years, scholars have a broader and deeper understanding of the evolution of Whistler's work, of his significant contributions to nineteenth-century

aesthetic theory, and of his crucial influence on the development of a formalist vocabulary for modern art. The vast Whistler scholarship, and particularly the increased documentation available, encourages a more thorough consideration of individual episodes of Whistler's career, including the already well-known Venetian period.

Recently, Whistler's Venice has been the object of several extensive scholarly studies carefully scrutinizing the artist's activities and production during this seminal fourteen-month period of his career.[12] Grieve and MacDonald have added significantly to our understanding of Whistler's achievements through exhaustive research, topographical detective work, and insightful analysis. Whistler's Venetian sojourn, already one of the best-examined aspects of his life, has been given further definition and detail. This catalogue and the accompanying exhibition are indebted to Margaret F. MacDonald for her historical research and insightful analysis of the corpus of Venetian works, and to Alastair Grieve for his documentation and identification of sites, as well as his estimable knowledge of the artistic context of the period in Venice. The following essays focus on the nature of Whistler's achievement in the Venetian etchings and pastels, the nature of his innovative approach and technical advances, and the influence of his vision of Venice on his contemporaries and on subsequent generations of artists.

Eric Denker, August 2002

NOTES

1. Elizabeth Robins and Joseph Pennell, *The Life of James McNeill Whistler*, 1st edn, London (William Heinemann) 1908, I, p.261.

2. See Otto Bacher, *With Whistler in Venice*, New York (The Century Company) 1908; Mortimer Menpes, *Whistler as I Knew Him*, New York (Macmillan Company) 1904; Thomas Robert Way, *Memories of James McNeill Whistler, the Artist*, New York and London (John Lane) 1912.

3. See Howard Mansfield, *A Descriptive Catalogue of the Etchings and Drypoints of James Abbott McNeill Whistler*, Chicago (The Caxton Club) 1909, and Edward G. Kennedy, *The Etched Work of Whistler*, New York (The Grolier Club) 1910.

4. See Denys Sutton, *Nocturne: The Art of James McNeill Whistler*, London (Country Life) 1963, and *James McNeill Whistler*, exhib. cat. by Frederick Arnold Sweet, The Art Institute of Chicago, 1968.

5. Robert H. Getscher, *Whistler and Venice*, PhD diss., Cleveland, Case Western Reserve University, 1970; *The Stamp of Whistler*, exhib. cat. by Robert H. Getscher, Oberlin OH, Allen Memorial Art Museum, 1977; Robert H. Getscher, *James Abbott McNeill: Pastels*, London (John Murray) 1991.

6. Andrew McLaren Young, Margaret F. MacDonald, Robin Spencer, and Hamish Miles, *The Paintings of James McNeill Whistler*, 2 vols., New Haven CT and London (Yale University Press) 1980.

7. Katherine A. Lochnan, *The Etchings of James McNeill Whistler*, New Haven CT and London (Yale University Press) 1984.

8. See *James McNeill Whistler*, exhib. cat. by Richard Dorment, Margaret F. MacDonald, *et al.*, London, Tate Gallery, 1994; *Venice: The American View, 1860–1920*, exhib. cat. by Margaretta M. Lovell, The Fine Arts Museums of San Francisco, 1994–95; Margaretta M. Lovell, *A Visitable Past: Views of Venice by American Artists, 1860–1915*, Chicago and London (The University of Chicago Press) 1989; *The Lure of Italy: American Artists and the Italian Experience, 1760–1914*, exhib. cat. by Theodore Stebbins, Jr., Boston, Museum of Fine Arts in association with Harry N. Abrams, Inc., New York, 1992.

9. Margaret F. MacDonald, *James McNeill Whistler, Drawings, Pastels, and Watercolours, a Catalogue Raisonné*, New Haven CT and London (Yale University Press) 1995.

10. Martha Tedeschi *et al.*, *The Lithographs of James McNeill Whistler: A Catalogue Raisonné*, 2 vols., Chicago (The Art Institute of Chicago) 1998.

11. Nigel Thorp, *The Letters of James McNeill Whistler*, Glasgow (Centre for Whistler Studies) forthcoming.

12. See Margaret F. MacDonald, *Palaces in the Night: Whistler in Venice*, Aldershot, Hampshire (Lund Humphries) 2001; Alastair Grieve, *Whistler's Venice*, New Haven CT and London (Yale University Press) 2000; *James McNeill Whistler: The Venetian Etchings*, exhib. cat. by Margaret F. MacDonald *et al.*, Venice, Querini-Stampalia Foundation, 2001.

Mortimer Menpes, *Palazzi on a Canal*, undated (pl. 108)

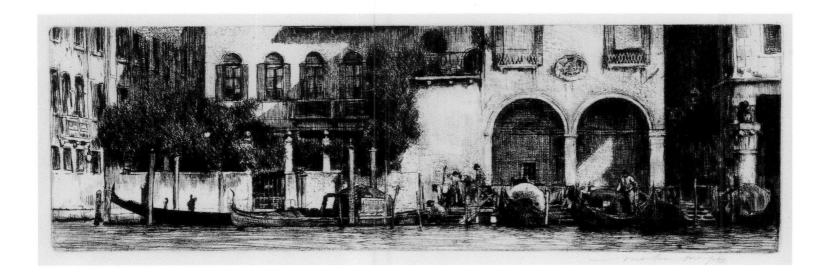

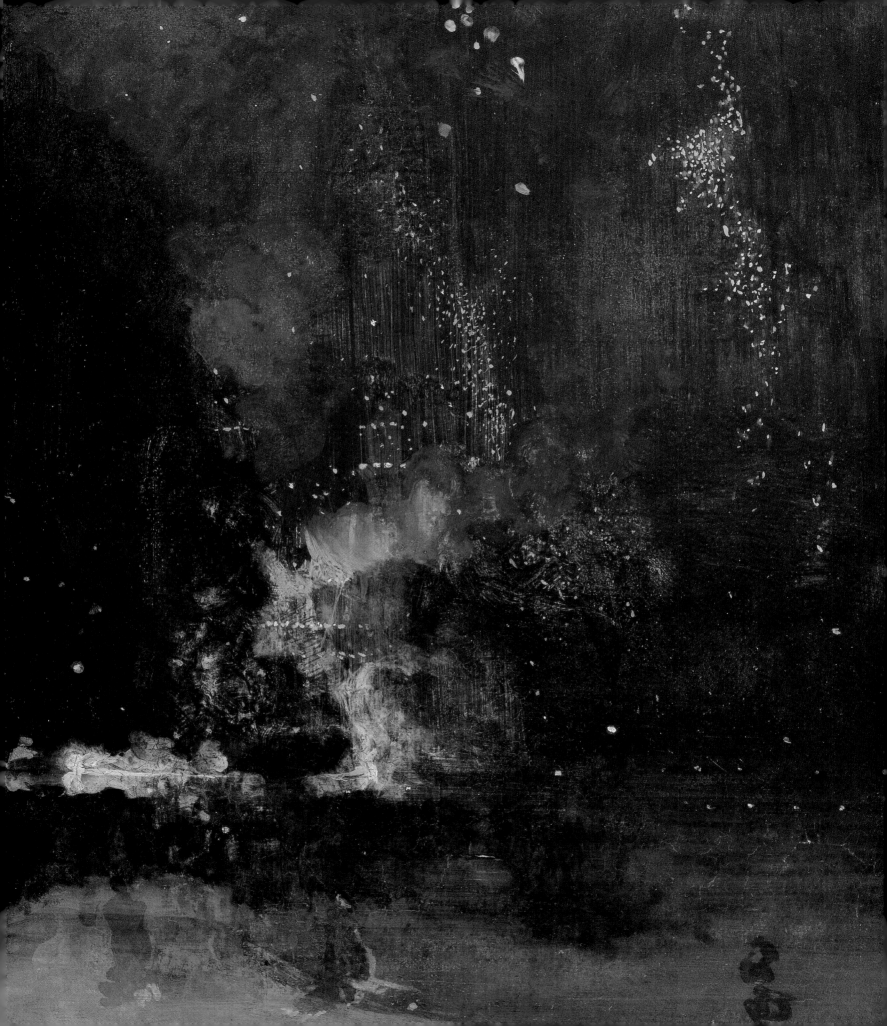

Eric Denker

"Something Still Better Round the Corner"

The story of Whistler in Venice is the tale of his fall from grace, his exile, and his triumphant redemption. The chain of events that would lead Whistler inexorably to Venice began in July 1876, when the artist first solicited subscriptions to a set of Venetian etchings that he was planning to undertake in the autumn. Lack of interest on the part of patrons, combined with another more attractive opportunity, led to the abandonment of the project. Whistler was generally in straitened monetary circumstances throughout the early part of his career, but a decline in steady patronage during the latter half of the 1870s led to increased financial pressures. Whistler had earned a reputation for being difficult to work with, and for unreasonably long delays in the delivery of commissions. His financial situation deteriorated further, and his notoriety was exacerbated as a result of the dispute between Whistler and his longtime patron, Liverpool shipping magnate Frederick Leyland.

In 1876, Leyland commissioned the artist to paint a set of panels for the staircase as part of the decoration of his new London residence. During the summer Whistler worked on the hall and stairs, and by September he had persuaded Leyland to allow him to make minor changes in the dining room. Whistler's retouching evolved into wholesale alterations after Leyland's departure from London at the end of the summer. The artist unleashed his creative talents, gilding shelves, painting over Leyland's precious imported leather wall hangings, and adding peacocks and peacock feather motifs to the decorations. The result was his most brilliant decorative scheme, the Peacock Room. Unfortunately, the decoration was thoroughly at odds with what the patron had requested. Leyland reacted angrily to the unendorsed changes in the original commission, and to Whistler's insolence. A dispute over the terms of payment arose when the artist demanded twice the original contracted amount, leading to a permanent breach between the artist and his most important patron. Whistler became increasingly infamous as a result of the Peacock Room decorations and the adverse publicity of his quarrel with Leyland.

In 1877, Whistler hoped to attain much-needed sales from his contributions to an exhibition at the new Grosvenor Gallery in London. The initial exhibition opened in May, and included works by respected academic artists and by independent avant-garde painters. Whistler, whose time had been devoted to the decorations of the Peacock Room, sent eight older paintings, including his portrait of Thomas Carlyle, and his *Nocturne in Black and Gold: The Falling Rocket* (fig. 1). The Nocturne was one of the artist's most abstract compositions to date, evoking a night scene of fireworks exploding above the dim lights of Cremorne Gardens, a celebrated amusement park in Chelsea.

Fig. 1 James McNeill Whistler, *Nocturne in Black and Gold: The Falling Rocket* c. 1875, oil on canvas, 42½ × 23¾ in. (108 × 60.3 cm), detail, The Detroit Institute of Arts, gift of Dexter M. Ferry

The eminent Victorian writer John Ruskin published a singularly harsh review of the Grosvenor exhibition in the working-class journal *Fors Clavigera*, questioning Whistler's artistic integrity. The now famous condemnation led to the Whistler–Ruskin libel suit of 1878:

> For Mr. Whistler's own sake, no less than for
> the protection of the purchaser, Sir Coutts
> Lindsay ought not to have admitted works
> into the gallery in which the ill-educated
> conceit of the artist so nearly approached the
> aspect of wilful imposture. I have seen, and
> heard, much of Cockney impudence before
> now; but never expected to hear a coxcomb
> ask two hundred guineas for flinging a pot
> of paint in the public's face.[1]

On November 25, 1878, the Whistler *v.* Ruskin trial began. The suit focused attention on the artistic debates of the day, and provided many memorable exchanges. Despite the notoriety of the trial, the actual presentation of the case took only eight hours, and the jurors needed just two hours the following day to reach a decision. The jury found in favor of the plaintiff, Whistler, agreeing with the artist that Ruskin had committed libel. However, the jury awarded Whistler only one farthing instead of the one thousand pounds that he had sought in the action. Whistler also was required to pay his own court costs, which normally would have been paid by the defendant. The judge had interpreted the jury's award as a reproach to Whistler for having brought the matter to trial, and consequently directed that the two sides must each absorb their own expenses. The decision contributed to Whistler's bankruptcy in May of the following year, a substantial price to pay for the largely symbolic victory.

Whistler was reeling from financial insolvency, and a dearth of new patrons resulting from adverse publicity, when the Fine Art Society approached him about a commission. The agreement called for the artist to go to Venice for three months and to etch twelve plates, returning in time for December holiday sales. Under the circumstances, Whistler readily accepted the opportunity to leave London, and the bankruptcy sale of his possessions, to escape to Venice.

Whistler arrived in Venice in September of 1879, equipped with etching plates and materials, and a supply of pastels and colored paper. Although he had agreed to finish the plates by December, it soon became clear that his return would be delayed. A brief documented chronology of his time in Venice begins with his arrival on September 19, joined by his mistress Maud Franklin a month later. Initially they lived not far from the Grand Canal, in an unidentified location near the canal of the Rio di San Barnaba. In the 1880s this was a poor section of Venice, in the *sestiere* (district) of Dorsoduro, not far from the large, picturesque Campo Santa Margherita. They would remain in this area for the next eight months, near the church of Santa Maria Gloriosa dei Frari, a Franciscan church commonly referred to simply as the Frari. Whistler spent his first months wandering the narrow streets of Venice, becoming acclimated to the unique environment of the lagoon city while also pondering how to approach the etching commission. On Christmas Day Whistler attended Midnight Mass in the Basilica of San Marco.

In May, Whistler first came into contact with Frank Duveneck and his students, who were spending the summer in Venice (see pp. 36–38). In June, Whistler visited Otto Bacher and the Duveneck "boys" at the Casa Jankowitz in the *sestiere* of Castello, a working-class district near to the public gardens on the wide quay of the Riva degli Schiavoni. Sometime

late in June, the artist and his mistress moved from the area of the Frari across the Grand Canal to the Casa Jankowitz in the eastern part of the city. Duveneck and the "boys" returned to Florence at the end of the summer, but Whistler and Maud stayed on until early November before returning to London. By that time Whistler had amassed a substantial body of work in etching and in pastel that would serve to re-establish his career and reputation.

The autumn and winter of 1879–80 was unusually cold, and Whistler and Maud suffered without the modern conveniences of London. In an early letter to his sister-in-law Helen, Whistler lamented how he missed London, and complained about the Italian language, the Venetian food, and how the cold was limiting his progress on the etching commission.[2] Subsequently he wrestled with the subject-matter of Venice, overwhelmed by the incredible visual riches of the city. Venice had been the object of artistic description for the better part of two centuries, including a substantial number of contemporary British depictions. Whistler was always in pursuit of a different and personal approach to subject-matter, employing an innovative technique to exploit his singular vision. The painter Sir Henry Woods, one of Whistler's British colleagues in Venice, told the Pennells that "he was continually wandering and looking among the endless mass of material for some inspiring motive."[3] Whistler's goal was to develop his own approach to the city in a way that would distinguish his work from the anecdotal sentimentality of established Victorian imagery. His achievement relies in part on his original conception of a Venice that was known to contemporary Venetians: the long vistas, the back alleys, the quiet canals, and the isolated squares of the everyday life of the city in the nineteenth century. Integral to the expressive power of both the etchings and the pastels is the immediacy of these observations. Whistler's

formal vocabulary is equally original, although we will see that the means for rendering his vision varied greatly in the two distinctly different media.

According to the surviving correspondence, as well as to contemporary accounts, Whistler found it difficult to hold and draw on the copper etching plates during the extreme cold of the winter of 1879–80.[4] While he made some progress on the etchings, increasingly he turned to pastel, which was easier to control under adverse conditions. Years later, Woods reported to the Pennells: "I remember his remarkable energy—and actual suffering—when doing those beautiful pastels, nearly all done during the coldest winter I have known in Venice, and mostly towards evening, when the cold was bitterest! He soon found out the beautiful quality of colour there is here before sunset in winter."[5] Although commissioned by the Fine Art Society to produce only a dozen etchings, during his fourteen months in Venice Whistler executed close to one hundred pastels. The artist must have anticipated that Venice would prove a good subject for the radiance of pastel, since he carried toned paper and materials on his journey from London. The Venetian pastels are among Whistler's signal achievements in a career distinguished by originality of approach and aesthetic experimentation. As a group they are characterized by the freshness of the artist's perceptions, his sensitivity to design, and his incredibly deft manipulation of this subtle and demanding medium.

Whistler drew the pastels on uniformly small sheets of colored paper, most often of a brown that varies from pale to rich tones. Occasionally he also used a dark, grayish paper. Draftsmen first used toned paper for drawings in the Renaissance, when artists were exploring the potential for illusionistic representation of form on a two-dimensional surface. The use of the toned sheet allows the artist to apply both lighter and darker pigments to the paper, the lighter

marks appearing to emerge and the darker areas receding optically. Whistler sometimes used the pastel and the paper in this fashion, but he also employed the tone of the paper as a strong pictorial element in the flat, decorative patterns of the design. He preferred paper that was slightly rough, with a toothy surface which provided sufficient friction to draw pigment from the pastel. Whistler varied the sharpness and angle of the edges of the pastels, and the pressure he exerted, for a broad variety of subtle pictorial effects.

Whistler's Venetian output included a small number of other works on paper in addition to the etchings and pastels; these included watercolors, and drawings in pencil, pen and ink, and chalk. A number of the drawings appear to have been executed in one sitting, the motifs quickly sketched from life. *Santa Maria della Salute* (pl. 19) is one example: here, Whistler employed an unusually simple technique of cross-hatching to render the buildings on either side of the mouth of the Grand Canal in an elegant, spare drawing. A crayon drawing, *Nocturnal Note: Venice*, presently in the National Gallery of Art, Washington, D.C., was drawn with similar economy but with a freer line. Whistler's *Bead-stringers* (pl. 32), on thin brown paper, is a more elaborate pencil drawing that appears to have been drawn in one sitting, perhaps as an early sketch for an etching that he was planning. Although Whistler began most of his images on site, he often returned to them later, reworking them in the original location and in the studio. Since his student days in Paris, he had trained his memory to recall precise details of views, to enable him to reproduce them when not in the presence of the motif. His talents for memorization would have been particularly useful in Venice, where nuances of light change quickly, and where working in a gondola could sometimes prove precarious.

Whistler initiated most of the pastels by drawing outlines with chalk or dark pastels. His Australian follower, Mortimer Menpes, recorded Whistler's description of his working method:

He described how in Venice once he was drawing a bridge, and suddenly, as though in a revelation, the secret of drawing came to him. He felt that he wanted to keep it to himself, lest someone should use it,—it was so sure, so marvellous. This is roughly how he described it: "I began first of all by seizing upon the chief point of interest,—the little palaces and the shipping beneath the bridge. If so, I would begin drawing that distance in elaborately, and then would expand from it until I came to the bridge, which I would draw in one broad sweep. If by chance I did not see the whole of the bridge, I would not put it in. In this way the picture must necessarily be a perfect thing from start to finish. Even if one were to be arrested in the middle of it, it would still be a fine and complete picture."[6]

One of the singular characteristics of Whistler's Venetian pastels and prints is the development of this central motif, the focal point of a design that expands out from the middle but not to the limits of the sheet. His predilection for detailing only the important elements of the design, while leaving the marginal and other areas incomplete, was part of the avant-garde nature of his art. His preference for images of contemporary Venice combined with the novelty of his compositional structure to produce works of startling modernity.

Whistler emphasized the design elements in his imagery by his application of color. He varied the amount and variety of color from sheet to sheet,

James McNeill Whistler,
The Steps, 1880, detail (pl. 9)

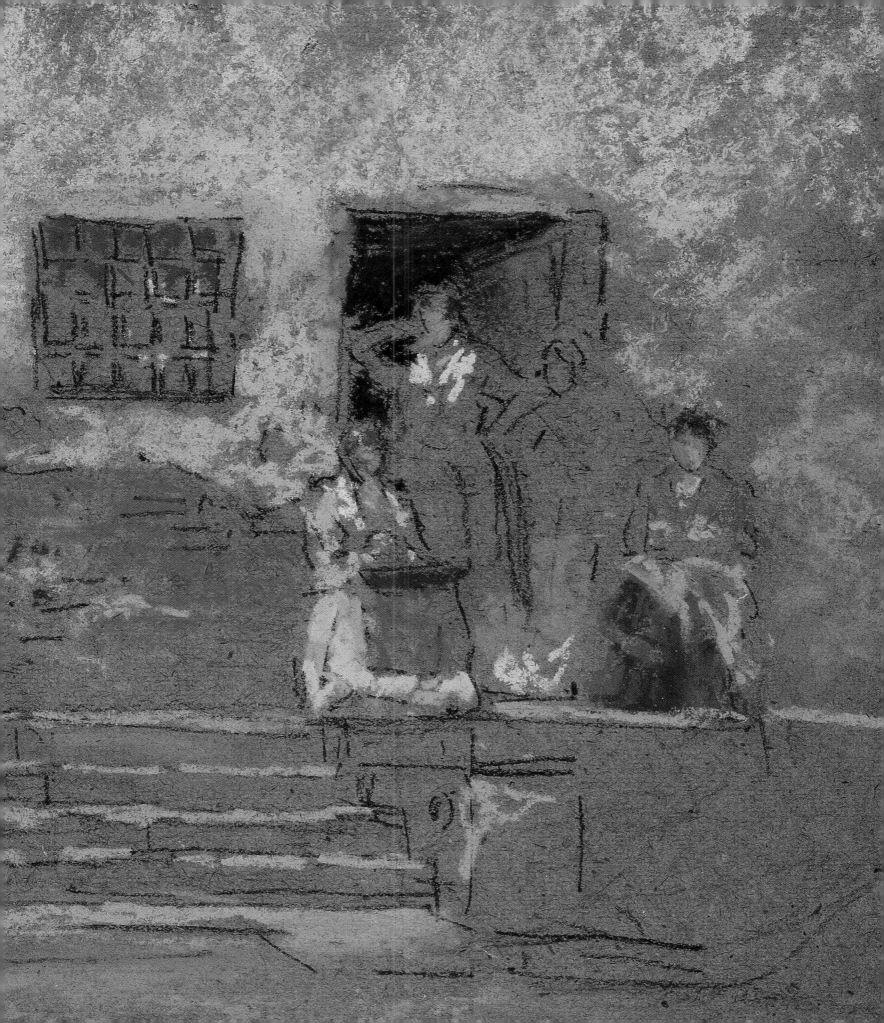

depending on his intent and the demands of the composition. The artist limited his use of color to a few discrete accents in some of the early, wintry pastels such as *Campo Sta. Marta—Winter Evening* (pl. 3), and *The Beggars—Winter* (pl. 1), a drawing related to a rare figural etching. In other works Whistler employed a full range of color, almost obscuring the tone of the paper, thickly scumbling the pastel across the surface in some places, while rubbing and softening the texture in other spots. *The Giudecca; note in flesh colour* (pl. 28) is an example where the artist delighted in the rich color of the pastel, allowing only a small area of paper color to emerge. In most of the pastels, however, Whistler maintained a delicate balance between broad untouched areas of the toned paper and the bold use of color to complement the two-dimensional surface elements. The Freer Gallery's pastels *The Steps* (pl. 9), *The Staircase; note in red* (pl. 7), and *Beadstringers* (pl. 10) are exemplary of this exquisite poise between paper tone and applied color in the Venetian work. Whistler's formal interest is evident in the equilibrium he sought between the depth of his illusionistic space, conveyed through the linear design of the drawing, and the decorative elements of the surface. For example, in the pastels *A Street in Venice* (pl. 5) and *The Tobacco Warehouse* (pl. 21) the artist applied the colors to the sky, the buildings, and the laundry to create a subtle tension between the recognition of the setting and an appreciation of the decorative play of surface tones. He was as cognizant of the importance of color and pattern as he was fastidious in his choice of paper texture and tone.

Whistler's pastels are divided conveniently into several discrete subjects, with some works overlapping into several categories. Within each category we can discern a variety of compositional approaches. Almost half of the extant pastels are panoramas, views of the long quays of the Riva degli Schiavoni or the Zattere,

or distant vistas of the skyline of Venice and the lagoon islands. Whistler tended to position these views on horizontal sheets, exploiting the sense of distance through a broad horizon. *The Church of San Giorgio Maggiore* (pl. 27) and *The Little Riva; in opal* (pl. 18) are typical horizontal compositions in which the paper reinforces the suggestion of a spacious view. Whistler demonstrated a refined sensibility in his selection of appropriate shapes and orientations for each sheet, choices appropriate to the planned image. He sometimes deliberately varied his approach to heighten the dramatic effect. A panorama in a vertical format creates a completely different sense of recession and space. In *Venetian Scene* (pl. 17), Whistler located the Dogana and the church of the Salute toward the top of a vertical sheet, thus creating a sense of deep space but also allowing the tone of the paper to dominate the lower two thirds of the design. Here, the lines of a different drawing are easily discerned in the lower section of the sheet. The artist often reused paper, drawing over and coloring a sheet on which he had begun an earlier sketch. In some cases Whistler made a serious attempt to cover the earlier designs, while in other sheets he seems not to have minded the clear evidence of the detritus of an earlier work. He exhibited the Freer's *Sunset, in red and brown* (pl. 2) in the 1881 exhibition of the pastels at the Fine Art Society of London, despite the obvious earlier sketches on the sheet.

A smaller number of pastels comprise enclosed urban spaces, including the depictions of *campi, campielli,* and *calli,* the squares, courts, and alleyways of Venice. For these compositions, Whistler preferred a vertical orientation that emphasized the isolation of the space, such as in the Venetian courtyard images of the *Corte Bollani* (pl. 26) and the *Court of Palazzo Zorzi* (pl. 25). In these pastels, as in most of the court and street images, the artist represented one corner of an indeterminate space, viewed diagonally from a

central location, truncating the surrounding buildings to increase the sense of enclosure. *Campanile Santa Margherita* (pl. 23) is the most elaborate of these images. The concisely rendered brickwork, unusual in Whistler's Venetian pastels, is set off by the white highlights and pale orange coloring of the adjacent walls. The bell tower and corner of the great urban space, near to where Whistler lived for the first half of his sojourn in Venice, provided the background for the diminutive figures that are articulated in shades of blue, brown, and green. *The Staircase; note in red* (pl. 7) belongs to this category of enclosed spaces as well, the title color set off by the pale blues, yellows, and whites of the rest of the springtime scene.

Whistler employed a design related to the courtyards for his images of *calli*, the streets and alleyways in the labyrinth of Venetian topography. He selected a thin street in the district of Castello for his pastel *Beadstringers* (pl. 10). The artist deliberately chose a narrow sheet of paper for this elongated vertical composition, an alleyway bounded on either side by tall buildings, and closed at the end by a façade bathed in sunlight. Whistler colored the center section of the image with densely applied pastel, and allowed the flat brown color of the paper to metamorphose into the adjacent walls.

Not surprisingly, a percentage of Whistler's pastels focus on the ubiquitous canals and bridges of the lagoon city. His canal views are among his most conventional Venetian works. His pastels *Canal, San Cassiano* (pl. 24) and *A Venetian Canal* (pl. 22) are typical, charming vistas down the waterways to distant house and bridges. *The Old Marble Palace* (pl. 11) is an interesting and unique variation on the canal views. From diagonally across the water, Whistler depicted a series of buildings fronting on a canal, drawing the central façade of the narrow, five-story palace in elaborate detail. The artist applied a restricted palette of whites, grays, and dense blacks to pick out the details of windows, and the marble coursing on the angle of the building. These neutral tones are offset by the touches of orange on the windows, the whites of the sky, and the greens of the water. By minimizing the color and details of the buildings on either side, Whistler emphasized the vignette in the center. The format of the sheet complements the design, reinforcing the unusual elongation of the vertical composition. Whistler's admiration for the narrow vertical format derives from his early interest in Japanese scrolls and woodblock prints.

Whistler regularly executed close-ups of façades and doorways, sometimes on terra firma and sometimes bordering on canals. His pastel *The Steps* (pl. 9) is a view across a narrow canal toward an unprepossessing façade along a *fondamenta*, a walkway that follows the edge of a canal. Whistler placed himself at a right angle to the façade, seizing upon the inherently geometric elements of the steps, the doorways, and the windows to fashion a scene of harmony and beauty. He added a variety of whites, blues, yellows, and grays to the familiar, prosaic elements of the backdrop, both enlivening the unfolding scene of daily life and creating a design of subtle balance. Whistler's pastel of the screen in front of San Giovanni Apostolo et Evangelistae (pl. 8) is the most refined of his drawings in Venice. Once again the artist positioned himself at a right angle, perpendicular to the façade, to exploit the geometry of the portal, the windows, and the decorations of the courtyard beyond. His application of a limited range of pastel, white, beige, gray, and a few darker accents in the shadows, allows the strength of his draftsmanship to emerge.

In both pastel and etching Whistler generally eschewed certain subjects: landmarks of architecture, interiors, and large-scale figural scenes are unusual in his Venetian œuvre. As in the pastels, his innovation

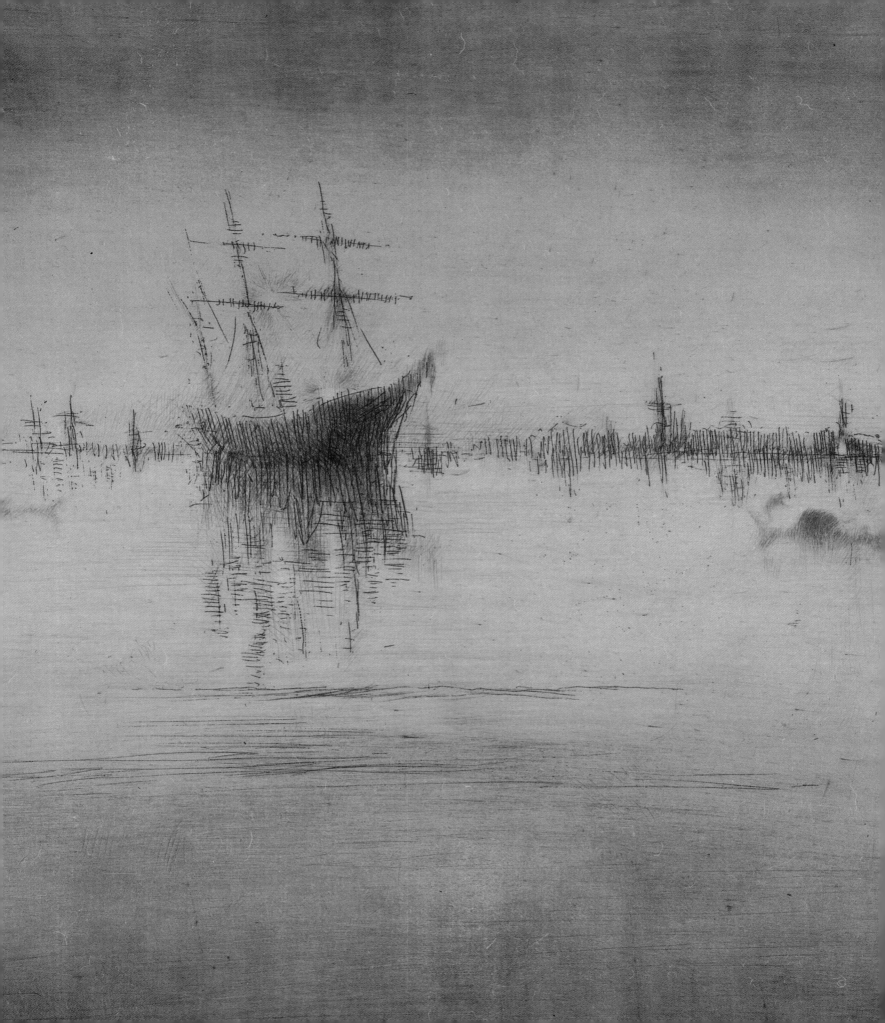

in printmaking was in terms of both subject and style. In his etchings, Whistler programmatically distanced himself from artists whose major focus was the familiar tourist monuments of the city. He recorded few images of the Piazza San Marco, the Basilica, or the Palazzo Ducale, only occasionally taking the measure of the Grand Canal. When he recorded a notable site—as in *Piazzetta* (pl. 36), or the prints *The Riva, No. 1* and *No. 2* (pls. 40, 55), for example—he drew the image directly from the motif on to a prepared etching plate, allowing the normal reversal of the printing process unexpectedly to render the scene in mirror image. Whistler often sought out unconventional views of familiar motifs, to add a sense of spontaneity. His image of the Rialto Bridge (pl. 66) is a typical example, being viewed from the end rather than the traditional view of the bridge in profile. In approaching his subjects in this way Whistler was looking both for something new, and to confound the expectations of those sentimental Victorian viewers whose fascination with the city subsumed their respect for the quality of the artist. In the etchings, as in the pastels, Whistler continued his predilection for more intimate, local views that were part of the daily experience of the Venetians. He searched for picturesque but characteristic motifs, such as his etching *Turkeys* (pl. 48) with its image of a woman by a well. His subjects included narrow lanes with overhanging buildings, wellheads in isolated courtyards and deserted squares, the attractive bridges that connect the network of tiny islands, and the graceful curves of small canals as they wend their way through the poorer neighborhoods. Whistler's preferred Venetian subjects remained the same whether he was creating prints or pastels.

Many of the etchings are panoramic views, across or along an expanse of water. The vistas of the distant city, seen across the basin and the lagoon, mostly retain the same horizontal format, with large, minimally detailed areas representing the sky above and the water below. *Little Venice* (pl. 75), *San Giorgio* (pl. 49), and *Nocturne* (pl. 76) are representative examples of Whistler's lagoon views of this type. In addition to the etched line work of these compositions, Whistler sometimes added additional surface tone by selectively wiping the copper plates, leaving a thin film of greasy ink on parts of the image. When he printed the plates, these veils of ink suggested variant light effects, of different times and different conditions, on the same scene. The prints were sometimes heavily toned, in some places almost obscuring the line work, as in the impressions *Nocturne: Shipping* (pl. 77) and *Nocturne: Salute* (pl. 78). At other times, Whistler might leave only the thinnest essence of ink across the surface, as in *La Salute: Dawn* (pl. 70). Sometimes he left a layer of ink only on a specific area of an image, contrasting cleanly wiped portions of the plate with the darker areas of tone, as in the etchings *Long Lagoon* (pls. 58, 59) and *Long Venice* (pl. 67). Whistler's selective inking created unique works of subtly differentiated atmosphere and mood. The examples of *Nocturne: Palaces* (pls. 50, 51) included here are particularly dramatic examples of Whistler's variable surface inking.

Occasionally, Whistler would compose scroll-like panoramic views in vertical formats, as in *The Little Lagoon* (pl. 34) and *Upright Venice* (pls. 52–54). The early state of *Upright Venice* shows that the artist first conceived of a daring vertical, with the church of the Salute and the junction of the Grand Canal and the Giudecca Canal occupying the upper quarter of the sheet. This early stage in the development of the etching is similar in format to the pastel of *Venetian Scene* (pl. 17). Whistler only introduced the lower part of the landscape in the second state of the etching, allowing the broad expanse of white paper in the middle of the sheet to suggest the intervening water of the basin of San Marco.

James McNeil Whistler, *Nocturne*, 1879–80, detail (pl. 76)

One of Whistler's favorite Venetian subjects was the close-up of a palace fronting on a small canal, seen straight on from across the water. Although he used this format for a number of pastels, it was employed even more regularly in his etchings. *The Doorway* (pls. 37, 38), *Garden* (pl. 65), and *The Dyer* (pl. 74) are pre-eminent examples of the artist's engagement with this theme. The views are from across a canal of indeterminate width, and Whistler gives no visual indication of the size or structure of the remainder of the buildings. Instead, using vertical formats, he focused upon the inherent geometric shapes of the openings in the façades of the buildings, and the decorative patterns of the surface. Whistler played these two-dimensional effects against the sense of depth created by parallel planes beyond the doorframes, spaces defined by light emanating from courtyards and windows in the enclosures. *The Traghetto, No. 2* (pl. 39) is an interesting variation on the theme. In a broad open space with a few leafy trees, Whistler represented a large archway daringly left of center. The dark mass of the passageway is balanced by several windows on the façade and a group of men seated around a table to the right. The light at the end of the archway silhouettes a gondolier rowing on a canal, a seated figure at the end of the tunnel, a hanging lamp, and a *felze*, the traditional top to a gondola that provided shelter for its passengers. Whistler located himself and the viewer in the middle of what appears to be a broad street, or the end of a square. In fact, Whistler has radically reconfigured the space. The actual location is a small, almost claustrophobic courtyard near the church of Santi Apostoli.[7] The artist had his back pressed up against the far wall of the square; just out of view to the left is an exterior staircase leading to the next level, and just out of view to the right is the end wall. *The Balcony* (pls. 60, 61) is another etching that shows Whistler's creative manipulation of space. The

artist again placed the viewer at a right angle, perpendicular to a palace viewed from across an expanse of water. Clearly his primary concern was the balance and arrangement of windows and doors, of glass and grillwork, and of the arched windows and the balustrade. Whistler invested the building with an unusual monumentality, showing it almost three stories high, from an impressive distance across the canal. Owing to its scale, researchers long sought the palace along the Grand Canal. In reality, the building lies on a small canal, the Rio de San Pantalon, in a corner of the district of Santa Croce. The palace is small and the canal is narrow, at complete odds with Whistler's presentation. This extreme modification of space was a regular feature of Whistler's Venetian prints. By starting in the center of the sheet and working outward, Whistler freely revised the conventional delineations of pictorial space. His compositions rendered the indispensable features of each motif, whether it was a distant view of the buildings of Venice shimmering on the lagoon, a close-up image of an archway leading to a murky canal, or a view of a doorway in a waterside façade.

The importance of detail is an aspect of Whistler's subject-matter often overlooked in an appreciation of the artist's achievement. Although Whistler's paintings are characterized by his concentration on overall effects of balance and harmony, the artist's prints are often exquisitely detailed, with delicate nuances between one stage and another as he continued to develop his imagery. Two states of *Doorway and Vine* (pls. 43, 44) illustrate the subtle differences in Whistler's manipulation of seemingly inconsequential detail. In the earlier version (pl. 43) the two figures in the windows are young girls, and the male figure silhouetted in light at the end of the doorway leans casually against the wall. Whistler later redrew the figures in the window to be older, and changed the man

in the doorframe to adopt a more sinister, active pose. At first glance, these details seem insignificant, but they subtly alter the mood of the prints.

In examining Whistler's Venetian graphic œuvre, other significant stylistic tendencies emerge. From his earliest work in Paris his etchings had been characterized by a radical economy of means, and the Venetian plates evidence a further reduction of line-work to its barest necessity. His graphic shorthand, developed over a twenty-year period, and indebted to Rembrandt, gave a freshness and sparkle to the canals and streets of the city. Whistler's effective use of selective wiping and thin veils of ink to suggest various lighting and natural conditions has been mentioned above. His concern for nuances of light in etched landscapes, likewise, advanced during this time.

Whistler's singular habit of trimming his Venetian etchings to the plate mark is another aspect of his attention to detail. British collectors placed a high value on the breadth of the surrounding margin on contemporary prints. By cropping each impression to the plate mark, except for a small tab left for his butterfly signature, the artist dictated the way in which his etchings would be seen and exhibited. From the late 1860s, Whistler began to sign his paintings and prints with a new signature comprising his initials, "JMW." These letters were combined into the form of an insect that at first resembled a dragonfly, but soon developed into a butterfly. At about the same time, Whistler adopted this motif as his signature in his correspondence, and he later often referred to himself as "the butterfly." The design of the butterfly evolved over time; eventually it became a versatile symbol that represented the artist as well a serving as his signature.

Whistler finally left Venice in November 1880 and returned to London, where he immediately set about printing the twelve etchings he owed the Fine Art Society. The initial exhibition of the twelve Venetian etchings opened in the small back room at the Fine Art Society on December 1, 1880. Although it was well covered in the daily periodicals and art journals of the time, the show was not a great financial success. As Margaret F. MacDonald detailed in her recent volume on Whistler's Venetian work, reviews of the show were mixed, with some critics recognizing and appreciating Whistler's novel approach, while others continued to be unable or unwilling to recognize his achievement.[8] Although critics remained divided on Whistler's etchings and pastels, many contemporary artists quickly perceived and embraced the freshness of the artist's vision. Whistler's broad influence on the art of his contemporaries and later generations of artists is the subject of the following essays.

NOTES

Chapter title: Edith Bronson quoted in Elizabeth Robins and Joseph Pennell, *The Life of James McNeill Whistler*, 1st edn, London (William Heinemann) 1908, I, p. 263.

1. John Ruskin, "Letter 79: Life Guards of New Life," *Fors Clavigera*, 7, July 1877, as collected in E.T. Cook and Alexander Wedderburn (eds.), *The Works of John Ruskin*, London (George Allen) 1903–1912, XXIX, p. 160.

2. Glasgow University Library, henceforth abbreviated as GUL, Whistler Letter W681, as quoted in Margaret F. MacDonald, *Palaces in the Night: Whistler in Venice*, Aldershot, Hampshire (Lund Humphries) 2001, pp. 141–47.

3. Pennell 1908, p. 263.

4. GUL, Whistler Letters W681, LB3/8, as quoted in MacDonald 2001, pp 142–44.

5. Pennell 1908, p. 263.

6. Mortimer Menpes, *Whistler As I Knew Him*, New York (Macmillan Company) 1904, pp. 22–23.

7. Alastair Grieve, *Whistler's Venice*, New Haven CT and London (Yale University Press) 2000, p. 84. I am indebted to Alastair Grieve's identifications for the sites of Whistler's etchings and pastels throughout the essays.

8. MacDonald 2001, pp. 93–97, 101–107.

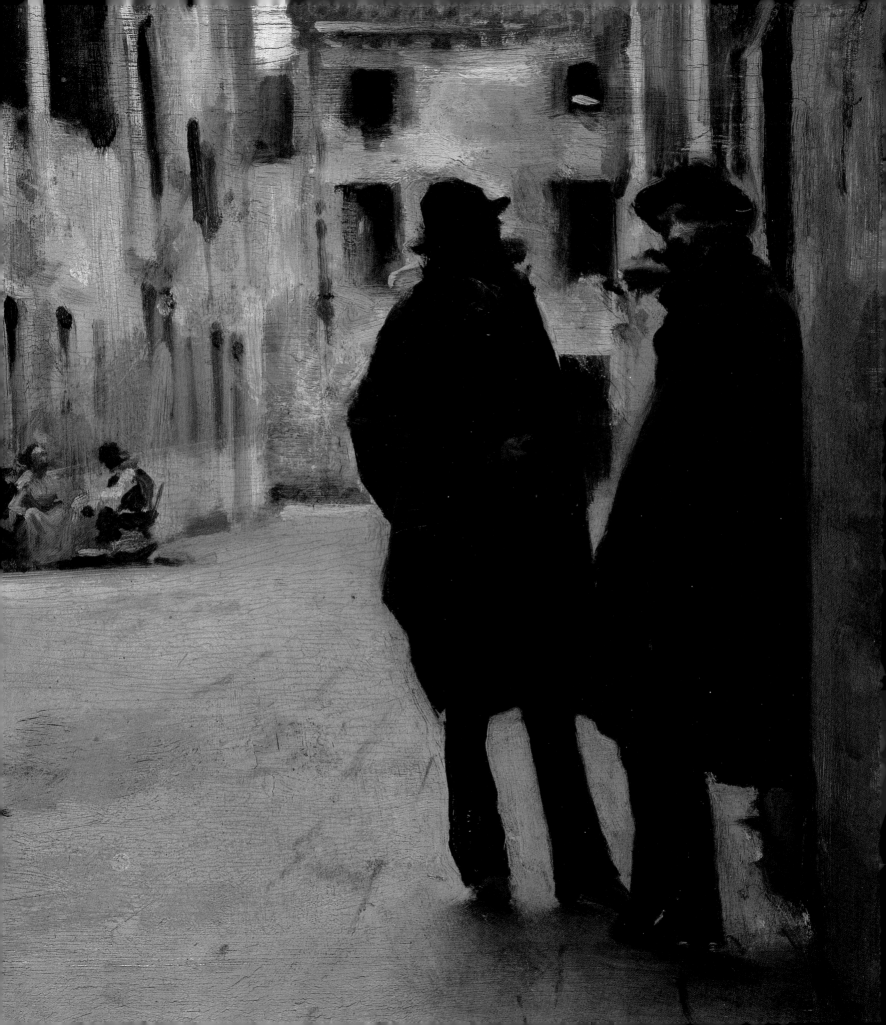

Eric Denker

Whistler and Sargent circa 1880

*"The two great American painters today are Messieurs Whistler and Sargent.
Whistler older, but always young; and Sargent, a youth whose talent is like an older master."*
Paul Lebrosse, *La Revue Illustrée,* 1886[1]

In his review of the Paris Salon of 1886, Paul Lebrosse put into print what many critics recognized by the end of the 1880s, acknowledging the importance of these two expatriate artists. The French writer did not suggest that they were alike in either their art or their personalities, limiting himself to describing their individual contributions to the Salon. That they should be identified by the writer and his contemporaries as American was a phenomenon of genealogy and self-identification rather than of experience. John Singer Sargent was born in Florence in 1856 of American lineage, and by the time of the Lebrosse review had spent less than six months in America. In 1876, he had attended the Centennial exhibition in Philadelphia and visited with relatives. Whistler, born in Lowell, Massachusetts, in 1834, lived in St. Petersburg, Russia, with his family from the age of nine to fifteen, spent six years in America in school, including time at the West Point Military Academy, and, after working briefly in Washington, D.C. and Baltimore, he left the United States in 1855, aged twenty-one, never to return. However, throughout their lives each steadfastly insisted on his identification as American, one of many areas in which their lives and art intersect.[2] Sargent first appears to have become aware of Whistler's paintings in about 1880, while living in Paris. Later that same year they almost undoubtedly met in Venice, where the younger artist seems quickly to have understood the nature of Whistler's vision of the ancient city. A careful examination of Sargent's œuvre during this period yields fascinating comparisons with the older American's paintings, etchings, and pastels.

Sargent and Whistler do not at first appear to have much in common. Whistler, a generation older, was of Southern background, impatient, belligerent and yet querulous, and flamboyant. Sargent came from New England stock, was well mannered and quiet, patient, and always a gentleman. Whistler was outspoken and eloquent in speech and in print, often sarcastic and critical, embracing the opportunity publicly to engage his enemies. Sargent was reticent, sometimes awkward in speech, rarely wrote, and sought to please. Whistler was litigious, constantly quarreled with friends and foes, and craved public attention for himself and his art. Sargent was generous in spirit, faithful to friends, and shunned the public eye, particularly in his private life. Sargent had precocious success and was recognized as a major talent when still in his twenties, while the older Whistler struggled long and arduously for proper recognition, which only came in his fifties, and then only begrudgingly from his adopted countrymen.

At the same time, the two American artists had much in common. Both Whistler and Sargent spent their formative artistic years training in Paris with academicians, where both came to revere old master painting as exemplified by Velazquez, Hals, and Rembrandt.

John Singer Sargent, *Street in Venice*, 1882, detail (pl. 87)

Fig. 2 James McNeill
Whistler, *Symphony in White
No. 1: The White Girl*, 1863,
oil on canvas, 84½ × 42½ in.
(214.6 × 108 cm), Harris
Whittemore Collection,
National Gallery of Art,
Washington, D.C.

Fig. 3 John Singer Sargent,
The Spanish Dance,
1879–80, oil on canvas,
35¼ × 33¼ in.
(89.5 × 84.4 cm), Hispanic
Society of America, New
York

Fig. 4 John Singer Sargent
Fumée d'ambre gris, 1880,
oil on canvas, 54¾ × 35¾ in.
(139.1 × 90.8 cm), Sterling
and Francine Clark Institute,
Williamstown MA

Later, each made the decision to leave France to live and work in London, while continuing to pursue success in the Salons in Paris. In fact, both achieved notoriety for paintings that were shown in Paris: Whistler with his painting *Symphony in White, No. 1: The White Girl* (fig. 2), exhibited in the Salon des Refusés in 1863 when he was twenty-nine; Sargent with *Madame X* (fig. 17), shown in 1884 when he was twenty-eight. Whistler and Sargent both sought commissions primarily as portraitists, although their œuvres encompass much more varied subjects. They were the first two Americans to have their work purchased by the French government for the country's prestigious state collections. And both Whistler and Sargent loved Venice.

A number of Sargent's early paintings indicate his familiarity with the older American artist, although the exact circumstances of his seeing the work are undocumented. *The Spanish Dance* (fig. 3) of 1879–80 is a nocturnal scene of exuberant merrymaking, with musicians and dancers shrouded in the obscurity of darkness. Sargent placed small bursts of light in the sky above, fireworks briefly illuminating the scene. A comparison with Whistler's earlier *Nocturne in Black and Gold: The Falling Rocket* (fig. 1, p. 10) of about 1875 is inevitable. The similarity of the subjects—night-time celebrations set off with fireworks—is paralleled in an aesthetic approach that sacrifices clarity in detail for the evocation of mood and mystery. In the nocturne, Whistler approached the edge of the precipice of non-representational art as closely as did

any nineteenth-century painter. *The Spanish Dance* is Sargent's closest encounter with abandoning representation for an art of solely formal qualities. Though we cannot presently ascertain when Sargent might have seen Whistler's work, the fame of the nocturne, the *cause célèbre* of the Whistler–Ruskin libel suit, would have made it well known at the time.

In Morocco in January 1880, Sargent began work on *Fumée d'ambre gris* (fig. 4), an exotic image of a young woman enveloped in voluminous drapery, trapping the smoke from an incense burner. Sargent sent a photograph of the painting to his friend Vernon Lee, saying that "It [the photograph] is very unsatisfactory because the only interest of the thing was the colour." One of the leading authorities on Sargent has written: "While that is not strictly true, nevertheless the colour scheme of white on white is the most striking feature of the painting. It is a tone poem demonstrating Sargent's outstanding technical skills and his aesthetic sensibility."[3] Once again, an instructive comparison to an earlier Whistler painting can be made: *Symphony in White, No. 1: The White Girl*, which had been a sensation at the Salon des Refusés in Paris in 1863. In each painting a single figure in a white outfit is set against a white backdrop, and the play of subtle tones in the skin, the costumes, and the setting are crucial to the impact. Whistler and Sargent both called attention to the delicate variations of white by the foil of the richly colored carpets and rugs beneath the women's feet. Although no record

exists of Sargent seeing the Whistler painting, *Symphony in White, No. 1: The White Girl* was well known, having been reproduced both photographically and as a wood engraving by Timothy Cole. In both instances, the night scenes and the women in white, the parallels are unmistakable. When Sargent traveled to Venice the following autumn, he was already familiar with Whistler's idiom, thus setting the stage for an engagement that would continue for the next twenty-three years.

Whistler arrived in Venice in September 1879, on commission from the Fine Art Society in London to do a set of twelve etchings (see pp. 11–21). Sargent arrived the following September, almost exactly a year later. In Venice he joined his parents and his sister Emily, who had taken rooms at the Hôtel d'Italie, now the Bauer Grunwald, on the Campo San Moisè. While in Venice, he and his family regularly visited his distant cousin, an expatriate from Boston, Daniel Sargent Curtis. Early in 1880 Curtis, with his wife, Ariana Wormeley, and their son Ralph, had leased an apartment in the nearby Palazzo Barbaro on the Grand Canal, which they would later purchase. Although undocumented, there is good anecdotal evidence to suggest that Whistler and the twenty-four-year-old Sargent met at this time, almost undoubtedly in the Curtis home. L.V. Fildes, in his reminiscences on his father Luke's life and letters, relates that Whistler experienced some trepidation on hearing of the imminent arrival from Paris of a brilliant, young American painter in Venice, John Singer Sargent.[4]

Sargent's early Venetian period has been the object of widespread and substantial investigation in recent literature.[5] Scholarship has established the significance of Sargent's early work, both in terms of its aesthetic accomplishment and its position within a fuller consideration of his work. However, writers have been hampered by the preponderance of undated works from this period, preventing a full understanding of the artist's development during this time. In the absence of additional documentation, the exact chronology of Sargent's work remains a mystery. Our purpose here is not to engage in this discussion but to suggest the ways in which Whistler's vision of Venice informed Sargent's work during this crucial period. In this context, Sargent's arrival in Venice a year later than Whistler, and after most of Whistler's work and all of his aesthetic views had crystallized, is the single relevant detail. Whistler had been etching and creating pastels for thirteen months when Sargent arrived on the scene.

Whistler was a regular guest on the American community's salon and dinner circuit, splitting time between the Palazzo Alvise of Katherine De Kay Bronson and the Curtises' Palazzo Barbaro. Whistler is first mentioned by the family in a letter of October 13, 1879, written by Daniel Curtis to his sister Mary: "Whistler sat 2 yds off last evening in Piazza, so could see & hear him. He wears a little straw hat—& is ordinary of looks & speech & is small of structure."[6] The description was illustrated by a sketch. Whistler was a frequent visitor to the Palazzo Barbaro during his stay in Venice, as revealed in several sketched portraits by Ralph Curtis, Sargent's cousin. Curtis had vivid memories of Whistler, as recorded by Joseph and Elizabeth Pennell:

> Very late, on hot *sirocco* nights, long after the
> concert crowd had dispersed, one little knot of
> men might often be seen in the deserted Piazza
> San Marco, sipping refreshment in front of
> Florian's. You might be sure that was Whistler,
> in white duck, praising France, abusing
> England, and thoroughly enjoying Italy.[7]

After his arrival in 1879, during a particularly harsh winter, Whistler had struggled to develop a new and

Fig. 5 John Singer Sargent
Venetian Interior, 1880–82,
oil on canvas, 26⅞ × 34¾ in.
(68.3 × 88.3 cm), Carnegie
Museum of Art, Pittsburgh

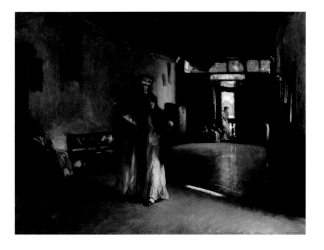

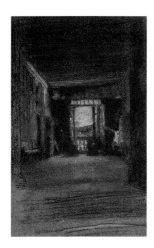

Fig. 6 James McNeill
Whistler, *The Palace in
Rags*, 1879–80, chalk and
pastel on brown paper,
16 × 11 in. (40.6 × 27.9 cm),
private collection

innovative approach to depicting the city. He defined his enterprise as rendering "a Venice of the Venetians."[8] His unique achievements in subject and style are detailed on pages 11–21, but a review is helpful. In his subject-matter, Whistler intentionally distanced himself from artists whose major focus was the familiar tourist monuments of the city. When he treated a notable site—the etching *The Piazzetta* (pl. 36), for example—he drew it directly on to a prepared etching plate so that the normal reversal of the printing process would render the scene in reverse. To add a sense of spontaneity to his work, he also sought out unconventional views: his image of the Rialto Bridge (pl. 66) viewed from the end is one typical example. In approaching his subjects in this way Whistler was looking for something novel, and to deflate the expectations of those contemporary English collectors whose fascination with Venice overwhelmed their aesthetic sensibilities. The artist matched his singular vision of the city through stylistic innovation. In his etchings and pastels, he extracted the essential architectural elements and urban spaces of his imagery, eliminating unnecessary detail and irrelevant information.

In examining Whistler's Venetian œuvre, other significant stylistic tendencies emerge. He utilized the spare graphic vocabulary that he had developed over a lifetime vividly to evoke life in the water-borne city. His use of thin washes of tone to suggest varying conditions of light and shadow added to the sense of immediacy conveyed by the images. The extreme reconfiguration of space was also crucial to Whistler's achievement in the Venetian prints and pastels. As detailed above, by starting in the center of the sheet and working outward, he freely eliminated the conventional limits of pictorial space. Whistler was thoroughly modern in his emphasis upon the two-dimensional design elements of his pastels and etchings.

Whistler was never shy, and according to Bacher and other members of the Duveneck circle he regularly showed his works to gatherings of friends and colleagues in Venice. It is probable that the young Sargent not only first met Whistler in Venice, but also had an opportunity to see the innovative Venetian work as well.

Scholars have regularly used the term "Whistlerian" to describe the early Venetian works of John Singer Sargent. The adjective is employed vaguely to evoke the influence of Whistler's idea of an emphasis on characteristic and contemporary realist imagery, in contrast to the traditional representations of monumental Venice. In this context, the two watercolors *Campo dei Frari* (pl. 89) and *Canal Scene* (pl. 88), both in The Corcoran Gallery of Art, are generically Whistlerian. Only on occasion has a Sargent painting been compared to a specific Whistler work.[9] The absence of a Sargent painting and drawing catalogue raisonné has hindered the examination of the artist's work in reproduction, and the opportunity to extract stylistic developments in his work. Recent exhibition catalogues are useful in allowing a more careful consideration of individual works, and trends within Sargent's career, and include a surprising number of correlations between specific works of Whistler and the related images of the younger artist.

Fig. 7 John Singer Sargent, *Venise par temps gris*, 1880–82, oil on canvas, 20 × 27½ in. (50.8 × 69.8 cm), private collection, courtesy of Adelson Galleries, Inc., New York

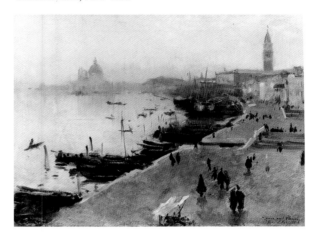

Both in his interior scenes and in his various approaches to cityscape, Sargent's Venetian imagery exhibits an aesthetic and compositional knowledge of Whistler's works. The most obvious and often cited comparison is between the younger painter's renderings of darkly atmospheric palaces, for example *Venetian Interior* (fig. 5), and Whistler's pastel *The Palace in Rags* (fig. 6).[10] Some writers have suggested that the setting for each work is the Palazzo Rezzonico, where Whistler rented a studio when he first arrived in Venice. Though Sargent also took a studio in the building later, a visual comparison of the works to the site is unpersuasive. However, the relationship between the images is convincing. Each is an extended view into the long central *portego* of a palace, the large room that opens on to a small balcony over a canal. In both cases, the artist conveys the light entering from the far windows, above and below the balustrade, penetrating into the darkness and obscurity of the interior. Sargent's differing aesthetic is emphasized by the substantial female figures that inhabit his deep space, although the similar geometric construction of the illuminated windows and doorframes echoes Whistler's design.

Interiors are unusual in Whistler's Venetian work, despite the extended, miserable winter of 1879–80 that would have kept him inside. As detailed on pages 11–21, he preferred the cityscape and landscape of the island city, from an array of vantage points. A favorite view during the latter part of his stay was the long vista from the rooms of the Casa Jankowitz toward the quay in front of the Palazzo Ducale, sometimes extending to the church of Santa Maria della Salute in the distance. Whistler made numerous works from the western windows of the boarding house, including the pastels *View in Venice, looking towards the Molo* (private collection), *Sunset, in red and brown* (pl. 2), *Venetian Scene* (pl. 17), and the etchings

Upright Venice (pl. 53), and, most significantly, *The Riva, No. 1* (pl. 40). In the latter etching, Whistler used a horizontal format to capture the angle of the Riva, and the low skyline of the long sweep along the walkway as it approaches Piazza San Marco. Sargent used a similar point of departure for his early oil, *Venise par temps gris* (fig. 7). The painting, also set from a high vantage point, encompasses the view looking west from beyond the canal of the Greci, following the graceful curve of the quay as it parallels the basin of San Marco. The depiction in each work of anonymous individuals strolling along the Riva, and the gondolas and working boats in the basin, convey a sense of quotidian Venetian life. The right two-thirds of Sargent's painting almost exactly reproduce Whistler's composition. In both works, the diagonal of the Riva dominates the lower half of the composition, though Sargent widened the scope of his view to include the church of Santa Maria della Salute at the mouth of the Grand Canal. Sargent's painting differs significantly from Whistler's image of the Riva, being invested with a stronger sense of transient weather conditions, of wintry light in the morning of an overcast day. While Whistler's particular images of the Riva do not include these subtleties of light, it should be noted that one of his major achievements, in a number of the Venice prints, was the use of veils of

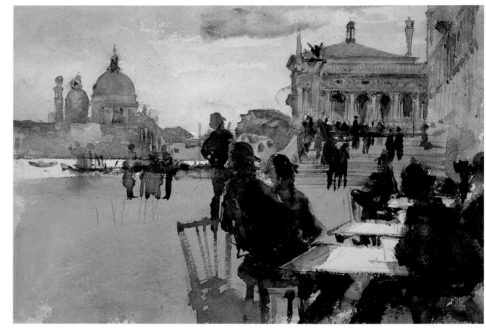

ink on the surface of his plates to suggest subtly changing light and atmosphere.

An additional Sargent view along the Riva suggests an even closer parallel to Whistler's work. Sargent's watercolor *Café on the Riva degli Schiavoni* (fig. 9) is a view of the wide quay in front of the Palazzo Ducale, the Molo, from the tables of the Café Orientale. The restaurant was a popular meeting place for Whistler and Duveneck and his students, especially when they could not afford the more opulent pleasures of the cafés in the Piazza. Whistler rendered a similar view from just slightly further down the quay, in front of the Piazzetta, rotated slightly to his left, in one of his rare Venetian watercolors, *Santa Maria della Salute, Venice* (fig. 8). Once again there is a remarkable similarity to the construction of the images. Each begins with a close view of men at outdoor tables in the foreground, continuing with a series of other figures occupying the middle ground, and ending with a forceful image of the Baroque domes of the church silhouetted against the sky. Despite the similarities of the design, Sargent conveyed a more visceral human presence.

Whistler executed relatively few paintings in Venice, so comparisons with Sargent's works are most relevant not in their stylistic approach to painting but in their selection of Venetian subject-matter, and the affinities in formal construction. The strongest parallels between the two artists' works are to be found within a series of small-scale representations of façades on unremarkable canals, of unprepossessing doorways, and of nondescript, anonymous courtyards. Whistler had a penchant for vignettes of doors, windows, and passageways penetrating into otherwise solid masses of wall. He frequently capitalized on the tension between solid and void, surface and depth, detail and economy. Whistler focused on two-dimensional surface effects by representing his subjects straight on, parallel to the picture plane, to exploit the inherent geometry of doors and windows against the shapes of the paper or the plate on which he was working. His etching *The Doorway* (pl. 38) is an outstanding example of this tendency in his work. Sargent's later watercolor *Venetian Passageway* (fig. 10) reflects a similar construction. In each case, the artist sat in a nearby boat and looked at his subject from slightly below. The murky canal commands the lower third of each composition, and a short flight of stairs leads to an opening in the surrounding façade. The dark atmosphere of the rectangular aperture in the center is relieved by natural light from an opening in the background. The two artists lavished attention on the decorations of the walls around the doorways: Sargent on the rope column and diamond grille of the window,

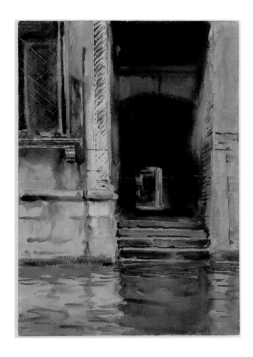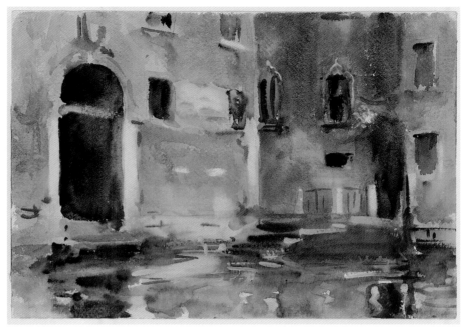

Whistler on the grill in the arch above the door, and on the similar diamond grille-design adjacent to the door. Alastair Grieve has identified Whistler's subject as the doorway of the early Renaissance Palazzo Gussoni on the canal Rio della Fava. Sargent's watercolor depicts the corner of the Palazzo Giustiniani Faccanon at the underpass, or *sottoportego*, of the Calle del Calice, perhaps not coincidentally a few yards further south on the same canal.

The unique topography of Venice, built on more than one hundred islands, has always offered a larger number of oddly angled passageways and irregularly shaped buildings than any other Italian city. This is part of the inherent charm and picturesque quality of La Serenissima. Whistler drew another etching of the canal facades on the canal of the Rio della Fava, *Two Doorways* (pl. 41), but further north, where it meets the Rio del Fontego dei Tedeschi beyond the Ponte San Antonio. In comparison to his usual approach, he depicted the rounded façade of a Venetian palazzo as it curves gently around the corner and out of view. Possibly inspired by Whistler's etching, Sargent conveyed a similar interest in the unusual curves and angles of the canals in his watercolor *Venice* (fig. 11).

Sargent's watercolor was undoubtedly based on a direct experience of the unidentified motif, not on the Whistler etching, but his approach to the subject

seems to indicate a knowledge and familiarity with the older master's designs. A parallel approach informs a number of other examples of Whistler and Sargent's Venetian imagery. Whistler's etching *Turkeys* (pl. 48), for example, depicts two figures near a wellhead in a small courtyard. The subject has recently been identified as the Corte Delfina near the Via Giuseppe Garibaldi, in Castello.[11] Sargent's painting *Venetian Water Carriers* (fig. 12) depicts a similar scene, represented in a space reminiscent of the courtyard in the Whistler etching.

One final Venetian parallel occurs between the two artists in works that represent an unusually important and recognizable location. In 1880, Whistler rendered the ornate pastel *San Giovanni Apostolo et Evangelistae* (pl. 8), one of his most elaborate Venetian drawings. In this work he depicted the portal of the elegant marble screen carved by Pietro Lombardo, which separates the *calle* from the Campiello della Scuola, the courtyard of the confraternity of the Scuola Grande and the church of San Giovanni Evangelista. Whistler composed the pastel with much the same approach as that which he had applied to other doors and portals in Venice. Sitting close by, at a right angle to his subject, he achieved a harmonious design of great balance by focusing on the central motif of the screen and eliminating unnecessary

Fig. 10 John Singer Sargent, *Venetian Passageway*, c. 1905, watercolor, gouache, and graphite on white paper, 21¼ × 14½ in. (53.9 × 36.8 cm), The Metropolitan Museum of Art, New York

Fig. 11 John Singer Sargent, *Venice*, c. 1903, watercolor, gouache, and graphite on white paper, 9⅞ × 13⅞ in. (25.1 × 35.2 cm), The Metropolitan Museum of Art, New York

29

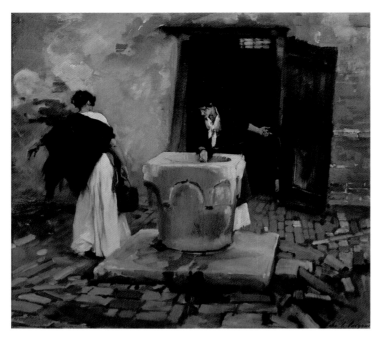

Fig. 12 John Singer Sargent, *Venetian Water Carriers*, c. 1880–82, oil on canvas, 25⅜ × 27¾ in. (64.4 × 70.5 cm), Worcester Art Museum MA

Fig. 13 John Singer Sargent, *Courtyard of the Scuola San Giovanni Evangelista*, 1913, oil on canvas, 22½ × 28¼ in. (57.1 × 71.7 cm), Fogg Art Museum, Harvard University Art Museums, Cambridge MA

design elements to the left, right, and above. He concentrated on the delicate carving of the portal, and the stunning details of the early Renaissance façade of the Scuola Grande in the courtyard beyond. Sargent represented the same screen more than thirty years later in an oil painting, *Courtyard of the Scuola San Giovanni Evangelista* (fig. 13). Sargent sat at the same angle as Whistler, but moved further from the screen. Consequently, Sargent's image, while a stunning evocation of space in front of the screen, conveys less of the ornate detail of the finely carved marble and the interior courtyard than does the earlier Whistler pastel.

The preponderance of visual evidence indicates that the youthful Sargent must have been aware of Whistler and his work from the time of his arrival in Venice, and been inspired by the older artist's innovations. The precocious Sargent fused his understanding of Whistler's work with his own extraordinary skills to produce a remarkable series of paintings that belie the older master's influence, an influence that would resurface even in Sargent's later years.

The two artists' paths regularly converged in the years following their first meeting in Venice. In the early 1880s, Whistler and Sargent began to appear regularly together in a number of public exhibitions, most importantly in the annual Salon in Paris. The young Sargent was living in Paris at the time, and

viewed the Salon as the central arena of artistic achievement, while Whistler had never lost the ambition to establish his reputation in the artistic capital of Europe. They exhibited in the Salon each year from 1882 through 1886, and continued intermittently through 1890. Many of their submissions to the Salon were full-length portraits of woman. While both artists painted landscapes and genre scenes, each was primarily a portraitist seeking the regular and lucrative commissions of important patrons. Although no documents assert that they viewed one another's works in the annual Paris shows, their submissions to the Salon occasionally suggest an interesting counterpoint, a mutual awareness of the accomplishments of the other. That Sargent admired Whistler's prowess as a portraitist at the time is evident from a letter that Mary Cassatt wrote in 1883.[12] In the spring of that year Cassatt's brother Alexander commissioned a portrait of his wife, Lois, from Whistler, *Arrangement in Black No. 8: Portrait of Mrs. Cassatt* (fig. 14). The painting was largely finished by September, when Lois visited Whistler's Tite Street studio in the company of Sargent. In the October 14 note to her brother, Mary Cassatt wrote: "After all, I don't think you could have done better, it is a work of art, and as young Sargent said to Mother, this afternoon, it is a good thing to have a portrait by Whistler in the family."[13] Curiously,

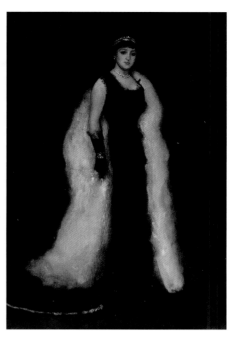

the possibility of Sargent painting the portrait appears not to have arisen.

Whistler returned to the Salon in 1882, after an absence of fifteen years. He exhibited *Arrangement in Black: Lady Meux* (fig. 15), his first commission for a full-length portrait following his return from Venice. Despite the critical praise that accrued from his recent exhibitions of Venice etchings and pastels, at the time Whistler was still infamous in England for his difficulties with patrons and critics. The well-known quarrel with Frederick Leyland over the Peacock Room, and the widely reported Ruskin libel suit, had made Whistler notorious, and commissions were not readily available to the irascible American painter. In 1881 Mr. Henry Meux, shortly to assume the baronetcy, approached Whistler to do a portrait of his young wife, whose reputation was as tarnished as Whistler's. Mrs. Meux, Valerie Susie Langdon, had been a dancer and an actress in various disreputable establishments when she met her future husband, the descendant of a wealthy family of brewers. Her husband's family was appalled at the secret marriage, and polite Victorian society steadfastly refused to receive her. As a result, the insouciant Whistler was the ideal choice to execute a portrait of the indecorous Mrs. Meux. He depicted the brewer's wife wearing a provocatively low-cut, revealing black gown, with long, black gloves, staring out unrepentantly at the viewer. Whistler's portrait is a stunning essay in contrast, with the dominant black tonality of the dress and background acting as a foil for the flesh tones and the white of the full-length stole, and setting off the glittering diamonds of the tiara, necklace, and bracelet. The portrait is a brilliant collaboration between artist and subject, a work of smoldering psychological intensity and palpable physical presence. Sargent, who showed four works at the 1882 Salon, could not have failed to notice Whistler's work. That same year he conceived of his own daring portrait of a similar type and tenor, though it was two years before the project came to fruition.[14]

Sargent had submitted annually to the Salon beginning in 1877 at age twenty-one. He first garnered attention in 1878 for the *The Oyster Gatherers of Cancale* (The Corcoran Gallery of Art), and the following year he was awarded a second-class medal for the portrait of his teacher, *Carolus-Duran* (Sterling and Francine Clark Institute, Williamstown, Massachusetts). During the next five years, Sargent exhibited a succession of accomplished full-length figure paintings in the Salon, including *Madame Pailleron* (The Corcoran Gallery of Art) and *Fumée d'ambre gris* (fig. 4) in 1880, *Madame Ramon Subercaseaux* (private collection) in 1881, *El Jaleo* (Isabella Stewart Gardner Museum, Boston), *Woman with the Rose* (The Metropolitan Museum of Art, New York), and two Venetian watercolors in 1882. In 1883, the year Whistler was awarded a third-class medal at the Salon for his *Arrangement in Grey and Black No. 1: Portrait of the Artist's Mother* (fig. 16), Sargent exhibited his tour de force of group portraiture, *The Daughters of Edward Darley Boit* (Museum of Fine Arts, Boston). As Richard Ormond has argued, each painting was precisely calculated to increase Sargent's burgeoning Parisian reputation by

Fig. 14 James McNeill Whistler, *Arrangement in Black No. 8: Portrait of Mrs. Cassatt*, 1883–85, oil on canvas, 75¼ × 35¾ in. (191.1 × 90.8 cm), private collection

Fig. 15 James McNeill Whistler, *Arrangement in Black: Lady Meux*, 1881, oil on canvas, 76½ × 51¼ in. (194.3 × 130.1 cm), Honolulu Academy of Arts

Madame X, the painting was even more provocative, with one of Madame Gautreau's straps slipped from her shoulder onto her right arm. Critics and salon visitors alike expressed shock at the painter's portrayal of such frank sexuality. Sargent was disappointed by the painting's reception, and in the ensuing controversy he attempted to mollify critics by repainting the strap over the shoulder—a minor concession, though one that the combative Whistler never would have considered. Sargent's indiscretion was to produce and exhibit an aggressively modern image of femininity. As with the Whistler portrait of Lady Meux, the portrait is a brilliant mediation between artist and subject, both capturing a likeness and producing an icon of impenitent, transcendent beauty.

In 1877, Whistler began showing at the Grosvenor Gallery when it first appeared on the London art scene as an alternative exhibition space to the more staid Royal Academy shows. It was in the Grosvenor Gallery that Whistler exhibited his *Nocturne in Black and Gold: The Falling Rocket* (fig. 1), the painting that Ruskin saw and subsequently slandered, leading to the famous libel trial of 1878. Until 1884, Whistler exhibited his work annually in the summer shows except for the year he was absent in Venice. Sargent first exhibited at the Grosvenor Gallery in the summer group show of 1882, perhaps at Whistler's suggestion. Whistler showed seven paintings, including two of his landscape nocturnes, while the younger artist submitted two of his Venetian interiors and a sketch. By coincidence, Whistler simultaneously was exhibiting three of his Venetian etchings, along with his portrait of Lady Meux, at the Salon in Paris. Another American expatriate, Henry James, reviewed the Grosvenor exhibition, mentioning both artists. James, who in earlier criticism had shown no sympathy for Whistler's painting, wrote appreciatively and at some length on the artist, detailing his interests in

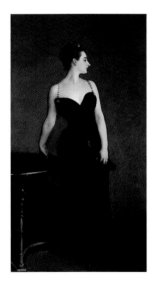

exploiting his bravura style and the modernity of his subjects.[15] His 1884 portrait of Madame Pierre Gautreau, exhibited as *Madame X* (fig. 17), brought his youthful ambitions to their apogee.

Significantly, the portrait of Madame Gautreau was not a commission. According to Sargent's early biographer, Sir Leslie Charteris, the artist admired the young Parisian celebrity, and sought her permission for a work that paid homage to her renowned beauty.[16] Madame Gautreau, of questionable reputation, was a regular feature on the French society pages, and was well known prior to her appearance in Sargent's painting at the Salon. The young painter's selection of her as the subject of a Salon painting, and his approach to the portrait, was a calculated act of provocation. Sargent depicted Madame Gautreau full length, wearing a daringly low-cut, sleeveless black dress. The painter used the neutral background to emphasis her noted profile and to set off her attractive, shapely form. The rich blacks of the dress set off the pale, delicate flesh tones, as well as the diamond crescent in her hair and the glittering straps against her skin. As originally shown in the Salon as

form and composition, and complimenting his entries. He mentions the younger artist briefly in the same review: "Mr. Sargent, whose only defect is a certain papery texture, contributes a charming little gray Venetian interior, with figures."[17] First seen together in the Paris Salon and in the Grosvenor Gallery summer show in 1882, Whistler and Sargent's work regularly appeared in the same group shows during the following twenty years.

In March 1886, Sargent decided to move to London, a choice that his older colleague had made in 1859. In June of 1887, Sargent leased 33 Tite Street in Chelsea, a studio Whistler had used for three years after returning from Venice in 1881. For the next sixteen years, they were neighbors as well as casual friends and rivals. Letters preserved in the Whistler Archives in Glasgow reflect their ongoing relationship and collegiality after Sargent settled in England. Sargent admired Whistler for both his wit and his work. According to Whistler's biographers, Joseph and Elizabeth Pennell, Sargent is reported to have said that "there is more talent in Whistler's little finger than in his [Sargent's] whole body."[18] Sargent's biographer Charteris quoted Sargent as saying: "Whistler's use of paint was so exquisite that if a piece of canvas were cut out of one of his pictures one would find that it was in itself a thing of beauty by the very texture and substance into which it had been transformed by his brush."[19] This admiration is most clearly manifested within the painting and watercolors that Sargent executed in the years just prior to, during, and beyond the Venetian experience of 1880.

NOTES
1. Paul Lebrosse, "Revue de Salon," *La Revue Illustrée*, 1886.
2. See Nicolai Cikovsky with Charles Brock, "Whistler and America," in *James McNeill Whistler*, exhib. cat. by Richard Dorment, Margaret F. MacDonald, *et al.*, London, Tate Gallery, 1994, pp. 29–38, for Whistler's ties to America; Stanley Olson, "On the Question of Sargent's Nationality," in *John Singer Sargent*, exhib. cat. by Patricia Hills, Linda Ayres, *et al.*, New York, Whitney Museum of American Art, 1986.
3. Richard Ormond in *John Singer Sargent*, exhib. cat., ed. Elaine Kilmurray and Richard Ormond, Washington, D.C., National Gallery of Art, 1999, p. 88.
4. L.V. Fildes, *Luke Fildes, R.A.: A Victorian Painter*, London (Michael Joseph) 1968, pp. 66–68.
5. See Marc Simpson, *Uncanny Spectacle: The Public Career of the Young John Singer Sargent*, with essays by Richard Ormond and H. Barbara Weinberg, Williamstown MA, Sterling and Francine Clark Institute, 1997; Kilmurray and Ormond 1999; Donna Seldin Janis, "Venice," in Warren Adelson *et al.*, *Sargent Abroad: Figures and Landscapes*, New York (Abbeville Press) 1997, pp. 181–216; Linda Ayres, "Sargent in Venice," in *John Singer Sargent* 1986.
6. Letter in Ormond Family Collection.
7. Letter from Ralph Curtis, quoted in Elizabeth Robins and Joseph Pennell, *The Life of James McNeill Whistler*, 1st edn, London (William Heinemann) 1908, I, pp. 273–74.
8. Pennell 1908, p. 265.
9. Linda Ayres, "Sargent in Venice," in *John Singer Sargent* 1986, p. 54; Ormond, in *John Singer Sargent* 1999, p. 80.
10. Ormond, in *John Singer Sargent* 1999, p. 80; Alastair Grieve, *Whistler's Venice*, New Haven CT and London (Yale University Press) 2000, pp. 74–75.
11. Grieve 2000, pp. 128–31.
12. Mary Cassatt to Alexander J.C. Cassatt, October 14, 1883, as cited in Andrew McLaren Young, Margaret F. MacDonald, Robin Spencer, and Hamish Miles, *The Paintings of James McNeill Whistler*, 2 vols., New Haven CT and London (Yale University Press) 1980, I, p. 137.
13. Cited in Nancy Mowll Matthews, *Cassatt and Her Circle: Selected Letters*, New York (Abbeville Press) 1984, pp. 172.
14. Evan Charteris, *John Sargent*, London and New York (Charles Scribner's Sons) 1927, p. 59.
15. Ormond, in *John Singer Sargent* 1999, pp. 25–28.
16. Charteris 1927, p. 59.
17. Henry James, "London Pictures," 1882, as reproduced in Henry James, *The Painter's Eye: Notes and Essays on the Pictorial Arts*, Madison (The University of Wisconsin Press) 1989, p. 213.
18. Elizabeth Robins and Joseph Pennell, *The Whistler Journal*, Philadelphia (J.B. Lippincott Company) 1921, p. 35.
19. Charteris 1927, pp. 21–22.

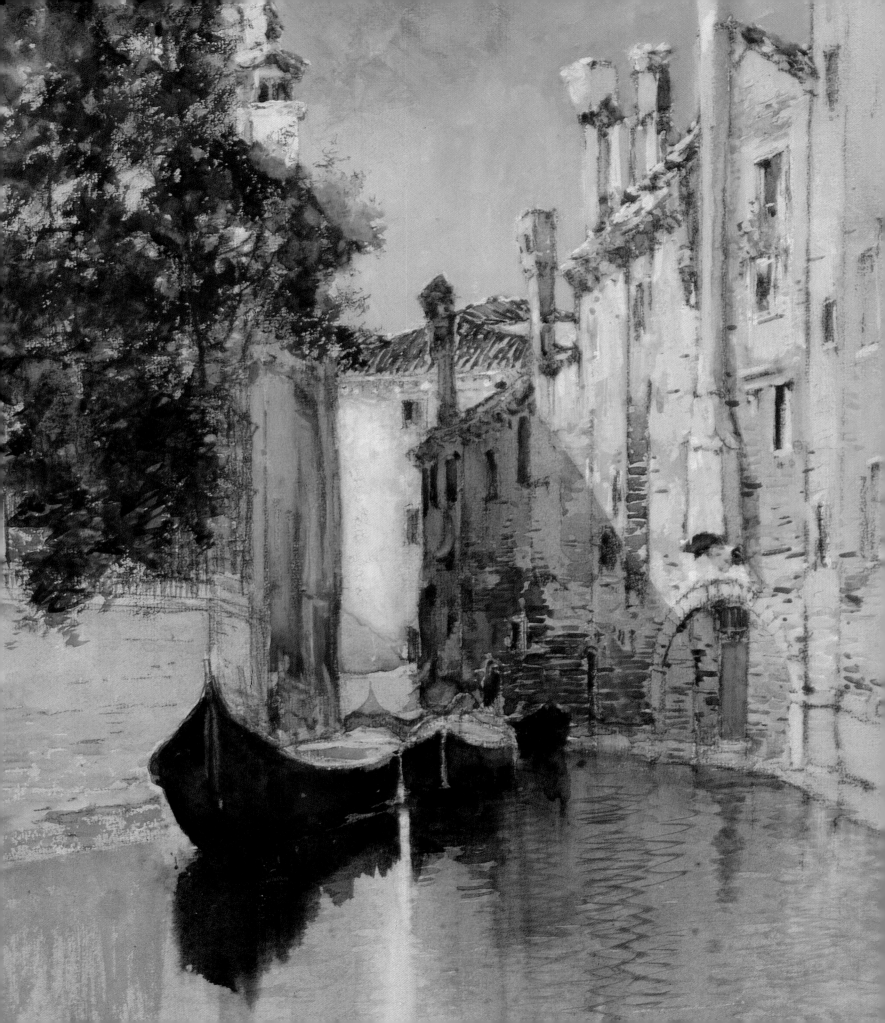

In the Wake of the Butterfly: Whistler and His Circle

Eric Denker

and

Emilie K. Johnson

The opening essay examined Whistler's innovative achievements in both his choice of subjects and his stylistic approach to Venice. His groundbreaking perception was of a hitherto under-appreciated aspect of the city, a "Venice of the Venetians" as he called it. One author recently defined Whistler's content as "*Venezia minore*, a lesser Venice, the Venice of her own day-to-day inhabitants."[1] The artist's interests led him to the less trafficked alleyways, the deserted canals, and the peripheral squares of the city for his vignettes of urban life. However, Whistler also executed prints of the Piazzetta, of the Rialto Bridge, of vistas of the grand promenades of the Riva degli Schiavoni and the Zattere, and numerous views that included the well-known churches of San Giorgio Maggiore and Santa Maria della Salute. How then did his perception of the city significantly differ from those who came before, and what aspects of that vision most affected the artists who came in the wake of "The Butterfly?"

Placing Whistler in the larger context of Venetian view painting is a precursor to defining his influence on his contemporaries and later artists. Painters and printmakers had been regularly depicting Venice for two hundred years by the time of Whistler's arrival in September of 1879. Beginning in the late seventeenth century, Luca Carlevaris responded to the demands of aristocratic visitors to the city for *vedute* of recognizable Venetian scenery. In the eighteenth century, Antonio

Canaletto, Bernardo Bellotto, and Francesco Guardi all specialized in paintings that captured the city's familiar views and major monuments for the upper-class foreign patrons who made Venice an important destination on the Grand Tour. Canaletto's paintings and prints of the city were intended for the tourist market and focused on the major attractions of La Serenissima, the self-styled most serene republic. His etching *Library of San Marco, Venice* (pl. 79) is a view of the western side of the Piazzetta, looking south from the corner of the Basilica of San Marco. Canaletto conscientiously drew the details of Sansovino's important Renaissance masterpiece between the Loggetta, or guardhouse, of the Campanile to the right, and the column of St. Theodore and the basin of San Marco, beyond to the left. The artist drew the east side of the same square as a complementary view, *The Proclamation Stone near the Palazzo Ducale, Venice* (pl. 80), with the Doge's Palace on the left and the church of San Giorgio Maggiore seen in the distance across the basin. Canaletto painstakingly drew a mirror image on a prepared etching plate, so that the natural reversal of the printing process would produce a correct view. He understood that visitors and collectors would recognize these landmarks, so he was careful accurately to record the familiar scene.

Prior to the advent of photography, prints were the most readily available and popular form of reproducing

Francis Hopkinson Smith, *Venetian Canal*, c. 1885, detail (pl. 121)

landscape and city views. With one notable exception, the Canaletto etchings included here are all scrupulous transcriptions of the actual sites (pls. 79–83). Exceptionally, his *Imaginary View of the Church of San Giacomo di Rialto, Venice* (pl. 84) combines a view of the church based on observation with a fantasy of Classical columns on the left. *Capricci* such as this were an established genre of Venetian *vedute*, much admired by local collecting circles for their sense of artistic invention. The other images by Canaletto are both aesthetically pleasing and serve as a useful record of precisely how the city appeared at this moment in its history. In his view *The Procuratie Nuove and San Geminiano, Piazza San Marco, Venice,* (pl. 83), Canaletto recorded the far end of the Piazza in 1744, prior to the Napoleonic intervention that opened a passageway on the western side of the great square. The artist's contemporary and follower, Francesco Guardi, similarly traded in images that portrayed the important monuments of the city, as in The Corcoran Gallery of Art's *Santa Maria della Salute* (pl. 85). Guardi imbued his Venetian scenes with a greater sense of dramatic light and atmosphere than did Canaletto. In the early nineteenth century, after the fall of the Republic in 1797, British artists such as Turner and Bonington brought a greater interest in the effects of light and color to the limpid atmosphere of the lagoon city. However, they remained faithful to the focus of the previous era in their choice of recognizable subjects, including the Grand Canal, the Rialto Bridge, and the monumental buildings around Piazza San Marco. The interest in the traditional *vedute* of the city continued uninterrupted through the nineteenth century, contemporaneous with the more modern approach of Whistler and Sargent. Thomas Moran's *View of Venice* (pl. 86) is a Turneresque vision of the Palazzo Ducale and the Piazzetta from across the Basin of San Marco. The watercolor also demonstrates Moran's sense of

invention, since it is an impossible view—a fictitious amalgam of two different sights in Venice: the Dogana seen from one angle, and the Piazzetta from another.

Whistler rejected the idea of merely documenting the most famous buildings of Venice, marginalizing their appearance in his work. When the Basilica, the Palazzo Ducale, and the church of Santa Maria della Salute are depicted in his work, they are seen in the distance as part of an ensemble, a component of a design that transcends their individual recognition. In his etchings, Whistler further conveyed his disdain for their reception as nostalgic mementos of a visit to the city by his refusal to draw his designs in reverse on the plates, so that the final result is a mirror image.

Evidence of Whistler's influence on his contemporaries and later generations can be divided into three categories: the artists who were in Venice with Whistler, contemporary printmakers who associated with him or who viewed his work soon after his return to London, and later generations of painters and printmakers who encountered Whistler's work after his reputation was well established. The previous essay examined Whistler's interaction with John Singer Sargent, the youthful American expatriate. Sargent was only one of the many artists with whom Whistler came into contact while living in Venice. Frank Duveneck and his students, the so-called Duveneck "boys," were mentioned briefly in the narrative of the opening essay, but deserve a more thorough consideration.

Frank Duveneck, a Kentuckian, attended the Royal Academy in Munich from 1869 until 1874, returning intermittently over the succeeding five years. During this period he twice visited Venice, the second time in 1877 in the company of his friend and colleague William Merritt Chase. In 1878, Duveneck began to teach private art classes in Munich, shortly thereafter moving his students to Florence. He stayed in Florence until April 1880, when a decision was

made to move the class to Venice for the summer months. Duveneck would follow this pattern for the next two years, wintering in Tuscany and summering in the lagoon city.

Duveneck lived on the Riva degli Schiavoni in the Casa Kirsch, an inexpensive rooming house not far from the church of the Pietà, about halfway between the Piazza San Marco and Whistler's residence at the Casa Jankowitz. He met Whistler in the late spring, through his students. Encouraged by Otto Bacher, one of his students, Duveneck began etching while in Venice in the summer of 1880.[2] His views of the Riva degli Schiavoni along the Basin of San Marco are among his earliest prints and, according to Bacher, influenced Whistler to adopt this approach in both of his etchings of the Riva (pls. 40, 55).[3] Whistler may, in turn, be responsible for Duveneck's choice not to reverse the designs on the plate, since the views are mirror images of the sites. In *Riva Degli Schiavoni, No. 1* (pl. 90), Duveneck represented the view from his balcony looking west in the direction of the Piazza San Marco. While his composition is essentially the same as Whistler's, the strong diagonals in Duveneck's etching lead the eye to the prominent and identifiable Palazzo Ducale, an important attraction to visitors. Whistler's focal point, in contrast, is an insignificant and anonymous structure, and the broad swath of the Riva is only minimally detailed in front of it. The novice etcher's image is heavily worked and clearly defined in comparison to Whistler's more delicate and evocative design. Duveneck's *Riva Degli Schiavoni, No. 2* (pl. 91) is a vertical composition of the complementary view of the Riva, looking east in the direction of the public gardens. He was inspired by Whistler's format in *Upright Venice* (pl. 53), but the incredibly dense shading of the stonework of the quay is very unlike the economy of means that characterizes Whistler's Venetian imagery. The church façade

in the upper part of Duveneck's plate, just beyond the bridge, is that of San Biagio; adjacent to it, and to the right of the mast, are the windows of the Casa Jankowitz, where Whistler lived during the summer and autumn of 1880. Duveneck's later Venetian etchings (pls. 93, 94) are more assured in their draftsmanship, but continue to be more boldly drawn and heavily bitten then Whistler's nuanced views. *Narrow Street* (pl. 92) has a greater affinity to Whistler, in both the subject—an anonymous back lane—and in its unfinished state, which appears similar to a Whistler vignette.

Duveneck came to Venice accompanied by a group of students who had already been identified in Florence as the Duveneck "boys." The group included John White Alexander, Otto Bacher, Charles Abel Corwin, Ralph Curtis, George Edward Hopkins, Harper Pennington, Julius Rolshoven, Julian Story, and Theodore Wendel.[4] The Duveneck "boys" mostly lodged in and near the Casa Jankowitz, an inexpensive pension found by Corwin in the picturesque Castello district. The Casa Jankowitz catered to students and foreign artists, and others that became associated with the group include Robert Frederick Blum, and the slightly older Ross Turner. According to Bacher's memoirs of their time together, *With Whistler in Venice*, Whistler first came into contact with the group in the late spring of 1880, when he was still living in Dorsoduro in the vicinity of the Frari. Bacher noted that the artist soon returned to draw pastels and etchings from their windows.[5] The rooms of the five-story pension had marvelous views of the city and the lagoon, which immediately attracted Whistler's attention. Shortly after, the older American artist moved to Casa Jankowitz, partly for the striking views, partly to have access to a printing press that Bacher had brought with him, and partly for the camaraderie of the "boys." As mentioned earlier,

several of Whistler's pastels and etchings, including *Upright Venice* (pl. 53), record the panoramic view from these windows reversed, as usual, in the prints. Robert Blum, a young American artist working in Venice in the summer of 1880, recorded Whistler sketching from one of these windows in *No doubt this is "Jimmy"* (fig. 18).

Whistler was gregarious, always enjoyed an audience and, in turn, the "boys" idolized the accomplished and flamboyant artist. Bacher and others recall

how Whistler would display his latest work to the students as well as to others in the expatriate community.[6] Inevitably, a number of the younger artists responded to Whistler's approach to Venetian imagery. His new approach to the subject-matter of Venice was appreciated quickly, but his centralized composition based on the vignette, and his lighter handling of the etching needle that left broad areas of the plate untouched, was not immediately adopted.

The American artist Otto Henry Bacher (1856–1909) produced an extensive body of prints of Venice that manifest Whistler's influence in subject and format. Bacher began etching in 1876, later studying in Munich with Duveneck in 1878. His prints, therefore, reflect the influence of both his teacher and Whistler. In Bacher's etching *Lavanderia* (pl. 95), he adopted Whistler's subject of the partial view of an anonymous palace opening on to a canal. An isolated figure of a launderer stands in the doorway. Whistler utilized this format many times, including *The Doorway* (pl. 38), *Garden* (pl. 65), and, perhaps the most similar of these images, the lovely vignette *The Dyer* (pl. 74). The attraction of Whistler's subject-matter can also be seen in Bacher's *Ponte del Pistor* (pl. 99). The view is taken looking down an unremarkable stretch of the Rio del Piombo toward a small bridge in the distance, near where Whistler drew two of his Venetian images, *The Doorway* and *Two Doorways* (pls. 37, 41). The influence of Duveneck is apparent in the heavier drawing, the deeper biting of the lines, and the more elaborate sense of finish in Bacher's composition. These same stylistic characteristics are recognizable in Bacher's other etchings of the time, as in the richly atmospheric *In Venice By Moonlight* (pl. 97), and in *View of the Castello Quarter* (pl. 100). Bacher also produced several horizontal panoramas of the Riva from the Casa Jankowitz, including *View from Whistler's*

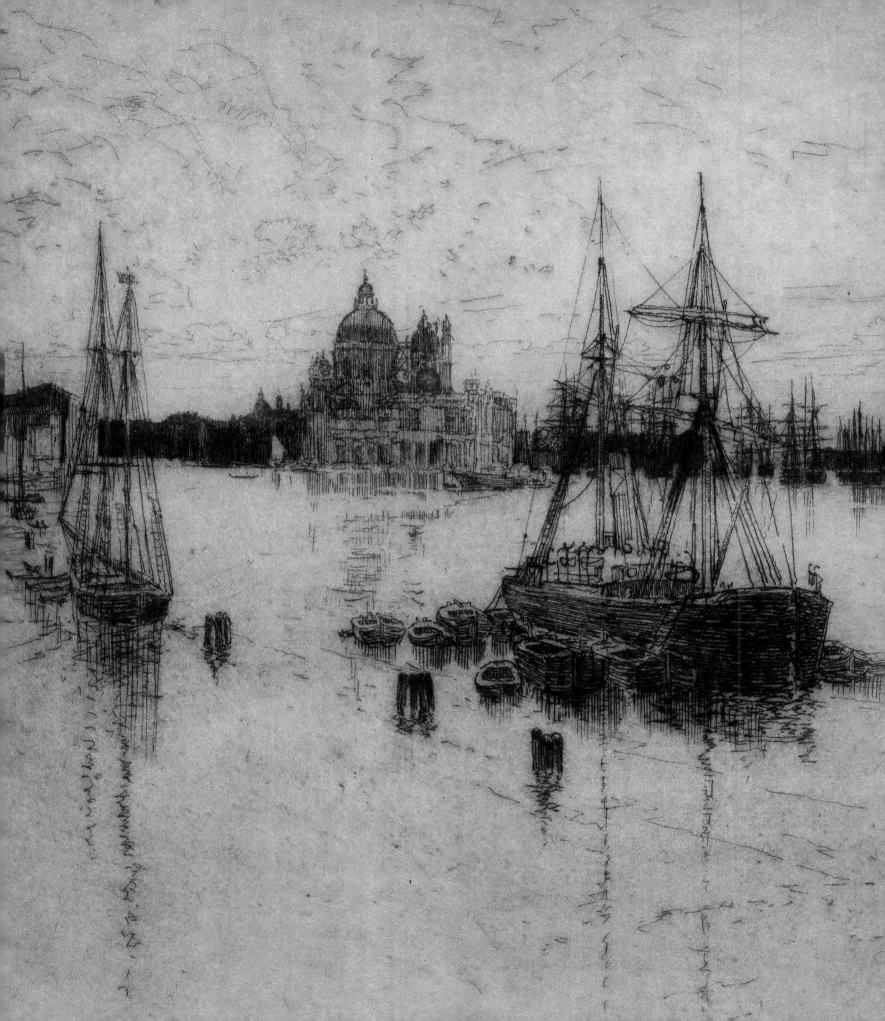

of important Whistler sites. Pennell's drawing *Venice Quadri* (pl. 118) is a scene in the Piazza San Marco of one of the hoary cafés that Whistler and his circle regularly frequented. *Casa Jankowitz, Whistler's Rooms in Venice* (pl. 119) is a rendering of the famous boarding house where the Duveneck "boys" and Whistler lived during the summer and early autumn of 1880. For the last ten years of Whistler's life the Pennells regularly saw Whistler in London, and after his death they wrote the first comprehensive biography of the artist.[12]

Many American and British artists working in the 1880s and 1890s showed an inclination toward Whistler's modest images of the "Venice of the Venetians". Charles Edward Holloway (1838–1897) was a British watercolorist who visited Venice in 1875 and 1895. Whistler probably met him in about 1880, and he executed a portrait of his Chelsea neighbor in 1896–97, shortly before Holloway's death, in 1897. According to the Pennells, the two men were particularly close in the mid-1890s, and Whistler was instrumental in the arrangements for Holloway's funeral.[13] Holloway's 1895 lithograph *A Street in Venice* (pl. 120), published in *Studio* magazine, is a very Whistlerian approach to the subject of a Venetian *calle* opening on to a canal. The central motif of the alleyway is well defined, while the façades to either side are left evocatively unfinished. The American artist Francis Hopkinson Smith (1838–1915) visited Venice regularly over the last two decades of the century and produced watercolors of great charm, such as his *Venetian Canal* (pl. 121) of 1885. We have no record of direct contact between Smith and Whistler, but the subject-matter and the format have parallels with Whistler's earlier works. Whistler's Venetian images struck a responsive chord in many artists of this period, regardless of the medium.

In the aftermath of Whistler's death, his vision of Venice continued to resonate through the succeeding generations of artists visiting Venice and producing images of the remarkable city. American and British artists, in particular, held Whistler in high esteem. By 1908 the Pennells could write: "And yet to-day, when two or three artists gather together of an evening at Florians, or the Quadri, or the Orientale, it is of Whistler they talk. When the prize student arrives and has sufficiently raved, they say 'Oh, yes, but you will have to do it better than Whistler!'"[14]

John Marin (1870–1953) arrived in Venice for a six-week stay in April of 1907. The thirty-six-year-old American had been etching for less than two years prior to his visit to Venice, having executed approximately fifty sketchy scenes of Paris and Amsterdam. He stayed with his family in the Pension Gregory on the Grand Canal, not far from the Piazza San Marco. Charles Bittinger, Marin's older stepbrother, later reported that, while in Venice, the artist refused to accompany the family to an exhibition of Whistler's work for fear that he might be overly influenced by Whistler's imagery.[15] No evidence exists for an exhibition of Whistler's work at the Accademia at that time, and the reference is a calculated bit of misdirection, since many of Marin's prints are clearly dependent on the precedent of Whistler's Venetian style and subjects. Marin drew twenty plates during his stay in Venice, all quite small, and each is Whistleresque in style to some degree. His view across a canal, *Window, Venice* (pl. 126), draws on the geometry of the windows, the steps of the bridge, and the arched Gothic doorway of this anonymous building seen straight on from across the bridge. Marin understood both Whistler's use of the vignette and his calligraphic style, which suggests the picturesque dilapidation of the wall rather than defining each bit of surface. Marin's etching of *Sestiere di Dorsoduro, Venice* (pl. 124) isolates one palace on a canal in the Dorsoduro district, barely suggesting the surrounding buildings. The

Whistlerian formula emerges again in Marin's two canal prints of the *Ponte di Donna Onesta, Venice* (pl. 122) and *Della Fava, Venice* (pl. 123). Two other Marin prints have subjects in the San Rocco area of the city, and bear an even closer relationship to specific Whistler works. Marin's etching *From Ponte S. Pantaleo, Venice* (pl. 125) includes a side view of the palace that Whistler depicted in *The Balcony* (pl. 61). A short distance away, Marin did an etching of the Campiello San Rocco (pl. 128) from the foot of the Ponte San Rocco. In 1879–80, Whistler had executed a pastel of exactly the same subject, *Under the Frari* (M771, private collection). In addition to the Whistleresque subject-matter, note Marin's use of surface tone in the upper and lower parts of the composition. Marin was not immune to the more famous tourist attractions of the city, representing the church of Santa Maria della Salute, the Basilica of San Marco (pl. 127), the Palazzo Dario, and the Palazzo Ducale, but even these are rendered in Whistler's broken line-work and calligraphic style.

The view etcher Ernest David Roth (1879–1964) was born in Stuttgart, Germany, and emigrated to America aged five. Roth studied at the National Academy of Design. His first etchings date to 1905, inspired by a trip to Venice. Over the following three years he executed thirty etchings of the city, a subject he returned to often during his career. His earliest prints include *The Gate, Venice* (pl. 130) and *Reflections, Venice* (pl. 129), two quintessentially Whistlerian images. In both of these small plates, Roth placed the viewer across the canal from truncated façades, emphasizing the heavily wrought dark shapes of the doors and the windows and their reflections in the canal. The influence of Whistler's Venetian subjects and formats is considerable, but the style is closer to the heavier line-work and deeper linear shadows of Whistler's late Amsterdam prints. Roth's

Campo Santa Margherita (pl. 132) from the following decade, while retaining the artist's strong draftsmanship, exhibits a greater balance between the areas of light and tone. The same characteristics are found in Roth's later Venetian works, *Campo San Boldo* (pl. 131) of 1924 and *The Stones of Venice* (pl. 133) of 1926. The latter is Roth's masterpiece, a depiction of the corner of the Palazzo Mastelli on the Rio de la Madonna dell'Orto, in the northern section of Cannaregio. Whistler's influence is seen in the viewpoint and in the cropping of the subject, but Roth always carried his motif to the edge of the sheet, giving equal amounts of finish to the central and peripheral elements.

As with Marin and Roth, the Scottish artist James McBey (1883–1959) is a generation younger than Whistler's earliest followers, Menpes and Pennell. McBey was a great admirer of Whistler's work, and first came into contact with his etchings in galleries in Scotland. Margaret F. MacDonald characterized McBey's style as not unlike Whistler's, a "similar combination of loose vertical lines and ink tones to convey mysterious palaces half lost in darkness."[16] McBey first went to Venice in September 1924 and, after an extended stay the following year, produced thirty-two plates of the city. Unlike Whistler and many of his followers, the Scottish artist believed that the etched view should be seen with the natural orientation of the subject, so that the plate should be drawn in reverse. McBey turned his back on the scene he was drawing, and drew his image looking into a rear view automobile mirror that he had mounted on his easel.[17]

In his lyrical etching *Barcarole* (pl. 134), McBey conveyed the sense of an almost deserted canal at dusk, as the last daylight dissipates. An isolated gondolier, rearing back in full song, sings the *barcarole* of the title. The artist contrasted the darker line-work of the architecture with the broad swath of water that dominates the lower half of the image. McBey toned

the broad, un-etched areas of the water with incredible subtlety to create delicate effects of light and shadow. A slight tonal change is McBey's only indication of where the water ends and where the buildings begin. He employed his etched lines sparingly in the architecture, creating networks of vertical lines that represent deep shadows. He silhouetted the heavily shaded gondola and gondolier against the lightly toned paper, providing the viewer with a sense of movement and scale. The expanse of the empty canal, in stark contrast to the surrounding buildings, is responsible for the elusive visual tension of the work. *Barcarole* is a calmly mysterious and romantic image, akin to the effects that Whistler realized in his heavily veiled, darker Venetian scenes such as *Nocturne: Palaces* (pl. 50) and *Nocturne: Shipping* (pl. 77).

Echoes of Whistler's vision of Venice are found in many of McBey's prints. His *Sottoportico* (pl. 135) is descended from Whistler's images of isolated doorways on fragments of palaces along canals. *The Riva at Dusk* (pl. 136) is a variation on the Whistlerian theme of the long views along the Riva that culminate in the church of the Salute. His image of the Palazzo dei Camerlenghi (pl. 137), however, is a more original design, resisting an easy correspondence with Whistler's formats. McBey's view, from the Rialto Bridge looking north on the Grand Canal, is an asymmetrical composition that juxtaposes the great mass of the building on the left with the line of gondolas and the façades of the palaces along the banks of the waterway.

Whistler's approach to Venetian subjects was as important an influence on photography as it was on printmaking. Margaret F. MacDonald and Alastair Grieve both call attention to Whistler's influence on the work of the Scottish photographer James Craig Annan (1864–1946).[18] The American photographer Alfred Stieglitz (1864–1946) admired the work of Annan, and they shared an interest in Whistler's redefinition of Venice subjects. Stieglitz visited Italy in the summer of 1887, and returned to Venice seven years later in 1894. His photographs of this period demonstrate a clear understanding of Whistler's interest in the picturesque canals and abstract formal elements of Venice.[19] In several cases Stieglitz's photographs bear an uncanny resemblance to Whistler's formats and presentation. Stieglitz's image *On the Piazza, 6 a.m.* (pl. 138) focuses on the base of the column of San Marco in the Piazzetta, and the figure on the steps below. As in Whistler's etching of *The Piazzetta* (pl. 36), the truncated column is in the foreground, with a recognizable major building in the distant background, here the church of Santa Maria della Salute. Stieglitz, too, generally avoided the major monuments of tourist Venice. Most of his photographs are of subjects similar to those that Whistler had selected. Stieglitz's image of *A Venetian Canal* (pl. 143) is a typical example, focusing on an unidentified waterway, with a bridge in the distance, beyond the reflections in an expanse of still water. *Gondola Under a Bridge* (K.227, private collection) and *Quiet Canal* (pl. 69) are comparable Whistler images. The doorway on the right side of the latter, from the Palazzo Sanudo van Axel, appears in the Stieglitz photograph *A Venetian Doorway* (pl. 140). Stieglitz's photograph *Venice* (pl. 142) utilizes another Whistleresque formula, looking straight across a canal at a partial view of a palace with a doorway and windows that front on the water, and a laundry line that provides other interesting shapes in the geometry of the design. Precedents are found in Whistler's etchings *San Biagio* (pl. 45) and *Fish-Shop, Venice* (pl. 73), as well as in the pastel *The Palace; white and pink* (private collection). Stieglitz's photograph *Reflections* (pl. 141) is similarly constructed, although the compositional element of the diagonal façade is closer to

Whistler's etching of *Two Doorways* (pl. 41) than it is to the straight-on views mentioned above.

Whistler's prints and pastels captured the flavor of Venice in an unprecedented way, significantly affecting his contemporaries and later generations of image-makers who sought to describe modern Venice for themselves. Many painters and printmakers sought to emulate the example of the American expatriate, some in the acquiring of his presentation and approach, others in the nuances of his economic style. In the end, it was Whistler's expressive vocabulary and his exquisite sense of design that informed his etchings of Venice and that remain remarkably fresh a hundred years after the artist's death.

NOTES

1. John Julius Norwich, "Whistler's Etchings of Venice," in Margaret F. MacDonald *et al.*, *James McNeill Whistler: The Venetian Etchings*, Venice, Querini-Stampalia Foundation, 2001, p. 16.

2. Josephine W. Duveneck, *Frank Duveneck: Painter—Teacher*, San Francisco (John Howell Books) 1970, p. 89.

3. Otto Bacher, *With Whistler in Venice*, New York (The Century Company) 1908, p. 144.

4. Duveneck 1970, p. 74.

5. Bacher 1908, pp. 12–14.

6. Elizabeth Robins and Joseph Pennell, *The Life of James McNeill Whistler*, 1st edn, London (William Heinemann) 1908, I, pp. 271, 273.

7. Bacher 1908, pp. 123–25.

8. *Ibid.*, pp. 117–18.

9. Thomas Robert Way, *Memories of James McNeill Whistler, the Artist*, New York and London (John Lane) 1912.

10. Margaret F. MacDonald, *Palaces in the Night: Whistler in Venice*, Aldershot, Hampshire (Lund Humphries) 2001.

11. Mortimer Menpes, *Whistler as I Knew Him*, New York (MacMillan Company) 1904, p. 89.

12. Pennell 1908, no page numbers.

13. *Ibid.*, pp. 187–88.

14. *Ibid.*, p. 261.

15. Carl Zigrosser, *The Complete Etchings of John Marin: A Catalogue Raisonné*, Philadelphia (Philadelphia Museum of Art) 1969, p. 11.

16. MacDonald 2001, p. 137.

17. Martin Hardie, "The Etched Work of James McBey," in *Print Collector's Quarterly*, 1938, XXV, p. 427.

18. MacDonald 2001, pp. 137–40; Alastair Grieve, *Whistler's Venice*, New Haven CT and London (Yale University Press) 2000, p. 193.

19. Sarah Greenough, *Alfred Stieglitz: The Key Set*, 2 vols., Washington (National Gallery of Art) 2002, I, p. xix.

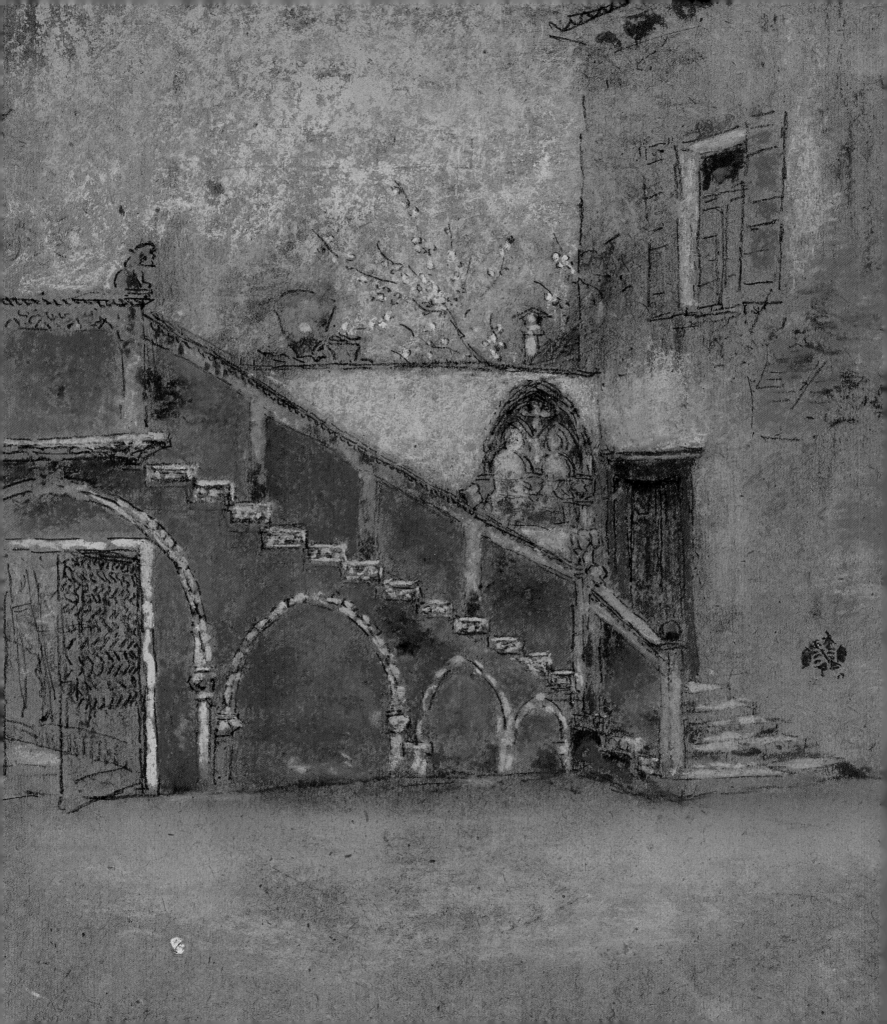

Kenneth John Myers *The Freer Gallery of Art Pastels*

Charles Lang Freer (1854–1919), founder and principal benefactor of the Freer Gallery of Art, was a self-made millionaire and a self-taught aesthete. Born to working-class parents in the Hudson River port town of Kingston, New York, he dropped out of school aged fourteen to work in a local cement plant. By 1880, Freer had moved to the Midwest, where he settled in the rapidly growing city of Detroit, Michigan. Freer lived in Detroit for the rest of his life, making a substantial fortune in the manufacture of railroad freight cars and pharmaceuticals. Freer began to collect art in 1883, starting with contemporary European prints. He purchased his first work by Whistler—an etching—in 1887. In 1890, Freer traveled to London where he met Whistler. The meeting changed Freer's life, and set the pattern for his future collecting. According to Freer, it was at this meeting that Whistler first drew his attention to the beauties of Asian art, and encouraged him to start collecting it. Freer and Whistler eventually developed a close friendship, which lasted until the artist's death in 1903. A highly self-disciplined collector, Freer ignored many areas of art in order to collect a few areas in great depth. By the time of his death, in 1919, he had amassed the world's most comprehensive collection of works by Whistler, together with exceptional collections of contemporary American "tonalist" paintings, Asian ceramics, Japanese paintings, and Chinese paintings, bronzes, and jades. Freer gave these collections to the people of the United States in 1906. The Freer Gallery of Art opened in 1923.[1]

Whistler spent fourteen months in Venice in 1879–1880, where he completed about ninety pastels. In January 1881, he included fifty-three of these in an exhibition titled *Venice Pastels* at the Fine Art Society in London. Although Freer did not meet Whistler until nine years after this exhibition, he recognized the beauty and the importance of the pastels and eventually gathered an unrivaled selection of them. Fifteen of Whistler's Venice pastels are at the Freer, including ten of the fifty-three included in the 1881 exhibition.[2]

WHISTLER'S VENICE PASTELS

The late 1870s were financially disastrous for Whistler. He alienated his most important patron, Frederick Leyland, used up a small fortune on his libel suit against the art critic John Ruskin, and overspent on a new home he was building in London. Unable to meet expenses, the artist went bankrupt in May 1879. In desperate need of money, Whistler contracted with a prestigious London gallery, the Fine Art Society, to produce twelve etched views of Venice, taking a substantial cash advance against future sales.[3]

Whistler arrived in Venice in late September 1879 Although he expected to complete the twelve required etchings within two or three months, he fell

James McNeill Whistler, *The Staircase; note in red*, 1880, detail (pl. 7)

Fig. 19 James McNeill Whistler, *Study for "Symphony in Flesh-colour and Pink: Mrs. F.R. Leyland,"* c. 1871–74 (M431), fabricated chalks on brown paper, 10⅝ × 7 in. (27 × 17.8 cm), Freer Gallery of Art, Washington, D.C., gift of Charles Lang Freer

in love with the city and repeatedly deferred his return to London. Whistler ended up staying in Venice for fourteen months, until November 1880. By early October he had taken inexpensive lodgings and completed his first etchings. Generally working outside, in the open air, Whistler etched through the end of November, when the weather turned exceptionally cold. Whistler at first tried to ignore the cold weather—in a late January 1880 letter to the Fine Art Society he humorously described himself as "standing in the snow with a[n etching] plate in my hand and an icicle on the end of my nose"—but he soon became sick and stopped etching altogether. As he explained near the end of the same letter: "I am frozen—and have been for months—and you cant [*sic*] hold a[n etching] needle with numbed fingers—and beautiful work cannot be finished in bodily agony." The arctic weather also made it difficult to work with oil paints or watercolors, but had less impact on the use of pastels, which are sticks of powdered pigment bound with an aqueous binder such as gum arabic. Whistler completed most of his Venice pastels that winter—between late November 1879 and the early spring of 1880. In a letter of May 2, 1880, to his son, Charles Hanson, Whistler reported that he had completed "about sixty in all." By the time he left Venice, he had finished at least eighty. The Fine Art Society had not commissioned any pastels, but Whistler was so pleased with his work that he could not help bragging, assuring his dealers that his pastels were "totaly [*sic*] new and of a brilliancy very different from the customary watercolor—and will sell—I don't see how they can help it—." A month later, he was still bubbly with excitement, writing his sister-in-law that the Fine Art Society "is preparing *fifty* frames! for the pastels which are, and remain even in my present depression, lovely! Just think, fifty—complete beauties!—and something so new in Art that every body's

mouth will I feel pretty soon water—Tissot I daresay will try his hand at once—and others too."[4]

In the mid-nineteenth century, when Whistler first began to use pastels, academic art theory and practice drew a clear distinction between completed works of art in which the entire surface of the image was worked with a consistent style and degree of "finish," and preliminary sketches or studies. Most of Whistler's early pastels are preparatory drawings, in which he experimented with alternative settings, poses, and color schemes for projected oil paintings. As with *Study for "Symphony in Flesh-colour and Pink: Mrs. F.R. Leyland"* (fig. 19), most are on rough dark papers, generally brown but sometimes gray or beige. Whistler generally drew the outline of his subject in black or gray chalk before adding white or colored highlights. Because Whistler did not intend to exhibit these studies, he rarely bothered to blend his colors, and often left large areas of his paper support blank. A smaller number of Whistler's early pastels were conceived as complete works of art suitable for sale and exhibition. Although many of these pastels may have been started as life drawings or studies, Whistler finished them by adding color to the negative spaces, and using a "stump" (a cigar-shaped implement made of rolled paper, leather, or felt) or his finger to soften and blend colors. One of the most beautiful of these is *Resting* (fig. 20), which was probably exhibited at Charles and Walter Dowdeswell's gallery in London in 1884 or 1886.[5]

Whistler finished a few of his Venetian pastels by blending his colors and filling the negative spaces with color, but in comparison to such finished pastels as *Resting*, the Venice drawings are strikingly sketchy, with large areas of paper left blank, and colors unblended. Almost as soon as he began the Venice pastels, Whistler seems to have realized that he could use the color of his paper to establish his major value, using black chalk to establish his design and colored

pastels as grace notes. The mature style is already evi-
dent in *Campo Sta. Marta—Winter Evening* (pl. 3)
which was probably one of the first of the pastels to be
completed. There are eight or nine pinholes in the
upper left and right corners of the drawing, suggest-
ing the number of sessions Whistler must have spent
working on it. The trees in the distance are without
leaves, while the foreground and buildings shimmer in
the gloom of an early winter evening, evoked by the
reddish-purple of the brown paper. Whistler saved his
colors to indicate light effects, using scumbles of
cream, peach, and blue pastel to evoke the dazzling
hues of the winter sunset, horizontal strokes of these
colors to mark the wavy reflections of the sky in the
foreground canal, and a few thicker strokes to estab-
lish the glint of the sunset off the façades of the
shadowed building. In *Campo Sta. Marta—Winter
Evening*, as in many of the earliest of the Venice
pastels, Whistler used only a few colors. As the year
progressed he began to glory in color, acquiring a
greater variety of pastels and using them to establish
more complex visual harmonies. Thus, in *The Steps*
(pl. 9), he used white, beige, orange, brick-red, green-
turquoise, blue, and black pastels to evoke the play of
summer light against the decaying plaster of the wall
behind the steps leading up from the foreground canal.

Whistler finally left Venice in November 1880,
returning to London where he immediately set about
printing the twelve etchings he owed the Fine Art
Society. The initial exhibition of the twelve etchings
opened in the small back room at the Fine Art
Society on December 1, 1880.[6] The first exhibition of
the pastels opened in the larger front room at the
Society on January 29, 1881, and ran until the end of
March. Whistler designed the installation, arranging
for "a low skirting of yellow gold, than [*sic*] a high
dado of dull yellow green cloth, then a moulding of
green gold, and then a frieze and ceiling of pale red-

dish brown." Most of the pastels were hung in frames
of "rich yellow gold," but to break the monotony
about a dozen were placed in "green gold" frames
scattered about the room. The twelve etchings were
again hung in the back room.[7] The pastels sold much
better than the etchings. Shortly before the exhibition
closed, Whistler's mistress, Maud Franklin, wrote a
friend that the pastels were priced at twenty to sixty
guineas each, that the first day's sales totaled four
hundred pounds, and that the gallery had already
grossed more than one thousand pounds.[8]

The pastel exhibition was widely noted in local
newspapers and magazines. Whether to praise or to
blame, most of the contemporary reviewers empha-
sized the lack of conventional finish. Writing in the
British Architect, Whistler's friend E.W. Godwin
began his review by explaining that "Most of the pas-
tel or coloured chalk drawings we have hitherto seen
have been worked with the stump. In these by Mr.
Whistler every touch of every bit of colour is laid on
direct with the chalk." Admitting that "some of the
drawings at first sight look like slight scribbles in blue,
white, and black on brown or grey paper, just as if
made in a moment to jot down a passing effect,"
Godwin insisted that what appears "slight is the evi-
dent outcome of much thought, the scribble has no
scribbling in it, and the colour is often attained by
interweaving other colours, and breaking it all in
lovely though measured spray over the brown or grey
field." The reviewer in the London *Times* thought
that Whistler's drawings were "far more artistic and
interesting" than most pastels, but pedantically
insisted that they should not be described as pastels,
since "in a true pastel the ground of the picture is
entirely covered with the coloured chalk employed,
this being generally obtained by making it rough like
the surface of fine sand, the use of this being to enable
the artist to blend the crude, powdery colour of his

Fig. 20 James McNeill
Whistler, *Resting*, c. 1870–73
(M381), fabricated chalks on
brown paper, 5⁵⁄₁₆ × 3 in.
(13.5 × 7.6 cm), Freer
Gallery of Art, Washington,
D.C., gift of Charles Lang
Freer

crayons, and thus give the soft gradations in light and shade and colour without any distinct outline." Many, if not most, of the reviewers were less open-minded, condemning Whistler's pastels for their lack of finish. The reviewer for *The World* spoke for many of the aesthetically conservative critics when he concluded that Mr. Whistler is "too soon satisfied with mere intimations and suggestions; he holds his hand while completeness is yet far off; his impressions are slight, or he indicates them too faintly, vaguely, and incoherently. How many of these pastels suffer from the vacant spaces 'to let' of plain untinctured brown paper, from indecision of line, from lack of foreground, from the absence, indeed, of industry and conscientious workmanship!"[9]

BUILDING THE FREER COLLECTION OF WHISTLER'S VENICE PASTELS

The growth of Freer's collection of Venice pastels parallels the growth of his Whistler collection as a whole. From 1887, when he purchased his first work by Whistler, until 1896, Freer's collecting focused on recent works, mainly prints but also including occasional oil paintings, watercolors, and pastels. Most of Freer's early acquisitions came either from New York dealers or directly from Whistler himself. By the time Freer started collecting Whistlers, most of the best Venice pastels had already been sold. Freer purchased *Venice* (pl. 11), his first, and for many years his only, Venice pastel at Wünderlich's gallery in New York, in 1893. One of the barest of the pastels, *Venice* was not included in the 1881 exhibition at the Fine Art Society. An evening view from the Riva deglia Schiavoni looking south to the church of San Giorgio Maggiore, it was probably completed late in Whistler's stay, since the sky is touched with a wide range of colors, including greenish-blue, lilac, blue, lemon, and orange.

The pace and scale of Freer's purchases of Whistler's work accelerated rapidly after 1896, when

Freer became significantly wealthier and Whistler encouraged him to develop a comprehensive collection. Freer collected Whistler's work at a feverish pace from 1897 until 1906, by which time he had acquired the vast majority of the Whistlers now in the Gallery. Most of the works that Freer bought during this period came from British or Scottish collectors who had formed the first generation of Whistler collectors.[10] Freer acquired his first major Venice pastels in 1902, when he purchased *San Giovanni Apostolo et Evangelistae* (pl. 8; Fine Art Society Exhibition No. 12), *The Beggars—Winter* (pl. 1; Fine Art Society Exhibition No. 32), and *The Staircase; note in red* (pl. 7; Fine Art Society Exhibition No. 35). Freer obtained *San Giovanni Apostolo et Evangelistae* from the Scottish collector Sir William Burrell; the other two pastels were included in a major collection of thirty-one small oils, watercolors, and pastels he bought from the pioneering English collector Sir Henry S. Theobald, who had purchased them in London in the 1880s and 1890s. Freer next added to his holdings of Venice pastels in 1904, when he purchased *A Street in Venice* (pl. 5) at the London art gallery Colnaghi's. *A Street in Venice* is a remarkably delicate winter scene—note the bare branches leaning over the walls at the right—in which the whites of fluttering laundry harmonize with the pale pinks of the alleyway walls and the vivid blues that echo between the distant wedges of the sky and the nearer slivers of windows.[11]

Freer acquired five more Venice pastels in 1905. Four of them were included in a large collection of prints, drawings, and paintings that Freer bought from the printer Thomas Robert Way, the son of Whistler's long-time printer and friend Thomas Way. The Way purchase included *Venice Harbour* (fig. 21), one of the very few watercolors that Whistler attempted in Venice, and four Venice pastels: *The Old Marble Palace* (pl. 11; Fine Art Society Exhibition No. 22), *Beadstringers*

(pl. 10; Fine Art Society Exhibition No. 45), *Venice: Sunset* (pl. 14), and *Venice: Sunset on Harbour* (pl. 16). *Venice: Sunset* is a double-sided work—with a drawing of beadstringers (pl. 15) on the reverse. The final 1905 acquisition was *Blue and silver—The Islands, Venice* (pl. 15), which Freer purchased from W. Baptiste Scoones, who had bought it out of an 1884 exhibition of Whistler's work at the Dowdeswells' gallery in London. An exquisite drawing probably completed shortly before Whistler's departure from Venice, *Blue and silver—The Islands, Venice* had not been included in the 1881 exhibition at the Fine Art Society, perhaps because of the smudge at the lower right.[12]

The 1905 purchases were the last Venice pastels that Freer bought. Other Venice pastels by Whistler continued to appear on the art market, so Freer's failure to pursue them is best understood as part of a general shift in his collecting priorities. By the end of 1906, Freer seems to have decided that he had succeeded in amassing the comprehensive Whistler collection he had set out to create. From that time until his death in 1919, he focused most of his energies and financial resources on building his collections of Asian art, and on arranging for the design and construction of his museum. Freer did not completely stop his pursuit of Whistler's work—he continued to buy especially important or unusual works—but the pace at which he acquired Whistlers slowed to a relative trickle. During this last phase in the growth of the Freer collection, several major Whistler acquisitions came by donation. The most important of these gifts came in 1917, when Freer's lifelong friend and business associate Frank J. Hecker donated a major early painting, *The Music Room: Harmony in Green and Rose*, and Louisine Havemeyer contributed five wonderful Venice pastels that she had purchased directly from the artist.[13]

The Havemeyer gifts are a fitting capstone to Freer's spectacular collection of the Venice pastels.

Fig. 21 James McNeill Whistler, *Venice Harbour*, 1879–80 (M726), watercolor on paper, 4¹³⁄₁₆ × 12¹⁵⁄₁₆ in. (12.2 × 32.8 cm), Freer Gallery of Art, Washington, D.C., gift of Charles Lang Freer

The daughter of a prosperous merchant named George William Elder, Louisine Havemeyer, née Elder, was born in New York City in 1855. After her father's death in 1873, her mother took her to Paris, where she became close friends with the expatriate American painter Mary Cassatt. Under Cassatt's guidance, Miss Elder began spending her allowance money on progressive French art. In about 1877 she became one of the first American collectors to acquire work by Degas and Monet, buying Degas's *Ballet Rehearsal* (The Nelson-Atkins Museum of Art, Kansas City) and Monet's *Drawbridge* (Shelburne Museum, Shelburne, Vermont). Miss Elder met Whistler in London in the summer of 1881. Impressed by Whistler's portrait *Harmony in Grey and Green: Miss Cicely Alexander* (Tate Britain, London), which she saw at the Grosvenor Gallery, Miss Elder asked her chaperone to arrange a meeting with the artist. The self-confident Miss Elder and her chaperone arrived at Whistler's Tite Street studio, where Miss Elder charmed Whistler, telling him that "Miss Cassatt is my best friend, and I owe it to her that I have a Pissarro, a Monet, and a Degas." The famously irascible artist must have been in an exceptionally friendly mood, or in need of cash, because when Miss Elder asked whether he had anything she

could buy for "just thirty pounds," he pulled out a portfolio of Venice pastels, and offered to sell her five important ones: *Nocturne—San Giorgio* (pl. 13; Fine Art Society Exhibition No. 18), *The Steps* (pl. 9; Fine Art Society Exhibition No. 23), *Sunset, in red and brown* (pl. 2; Fine Art Society Exhibition No. 25), *Winter Evening* (pl. 4; Fine Art Society Exhibition No. 50), and *Campo Sta. Marta—Winter Evening* (pl. 3; Fine Art Society Exhibition No. 51). At six pounds apiece, Whistler was giving the young American an extreme discount—especially if he really had been selling them for between twenty and sixty guineas. Whistler arranged for the pastels to be framed, and then personally delivered them to Miss Elder's lodgings. In later years, Miss Elder remembered her encounter with Whistler as one of the great events of her life.[14]

In 1883, Miss Elder married the New York sugar magnate Henry Osborne Havemeyer. Together, they amassed the world's first great collection of French Impressionist art. The Havemeyers also collected Old Master paintings and Asian art—and it was through their interest in Asian art that the Havemeyers met Freer, probably in the early 1890s. The friendship between Freer and Mrs. Havemeyer blossomed after 1911, when Freer suffered a stroke and began to spend much of every year in New York City. In a memoir of Freer published shortly before the Freer Gallery of Art opened in 1923, Mrs. Havemeyer recalled her long-ago meeting with Whistler, and emphasized how much both the Whistler pastels and Freer's friendship meant to her. Just as Freer's gift of his collection and museum memorialized his friendship with Whistler, so Mrs. Havemeyer's gift of her prized Venice pastels memorialized her friendship with Freer and her respect for his patriotic desire to establish a "national museum in our capital."[15]

NOTES

1. See especially, Thomas Lawton and Linda Merrill, *Freer: A Legacy of Art*, Washington, D.C. (Freer Gallery of Art) 1993; and Helen Nebeker Tomlinson, *Charles Lang Freer, Pioneer Collector of Oriental Art*, 4 vols., PhD diss., Cleveland, Case Western Reserve University, 1979. For "Tonalism," the best general introduction is still "*The Color of Mood: American Tonalism 1880–1910*, exhib. cat. by Wanda M. Corn, San Francisco, M.H. de Young Museum, 1972.

2. For Whistler's work in Venice, see especially, Margaret F. MacDonald, *Palaces in the Night: Whistler in Venice*, Aldershot, Hampshire (Lund Humphries) 2001; Alastair Grieve, *Whistler's Venice*, New Haven CT and London (Yale University Press) 2000; Robert H. Getscher, *Whistler and Venice*, PhD diss., Cleveland, Case Western Reserve University, 1970. For current holdings of the pastels, the most up-to-date list is MacDonald 2001, pp. 152–54, but see also the detailed catalogue entries in Margaret F. MacDonald, *James McNeill Whistler: Drawing, Pastels, and Watercolours: A Catalogue Raisonné*, New Haven CT and London (Yale University Press) 1995, pp. 264–312.

3. The indispensable biographical source is still Elizabeth Robins and Joseph Pennell, *The Life of James McNeill Whistler*, 5th (revised) edn, London (William Heinemann) and Philadelphia (J.B. Lippincott) 1911.

4. Whistler to Marcus B. Huish, n.d. [*c.* January 21–26, 1880]; Whistler to Charles James Whistler Hanson, May 2, 1880; and Whistler to Helen [Nellie] Whistler, n.d. [20 February/March 1880]. All three letters are transcribed in MacDonald 2001, pp. 144, 146, 149–50. The French painter James Tissot (1836–1902).

5. MacDonald 1995, pp. 131–32.

6. For the first exhibition of the etchings, see MacDonald 2001, pp. 16, 93–97; and Kathleen Lochnan, *The Etchings of James McNeill Whistler*, New Haven CT and London (Yale University Press) 1984, pp. 181–83, 211–21.

7. E.W. Godwin, "Notes on Current Events," *British Architect*, February 4, 1881.

8. Mary Maud Franklin to Otto Bacher, March 25, 1881, Freer Gallery of Art Archives. The relevant section of the letter is excerpted in Otto Bacher, *With Whistler in Venice*, New York (The Century Company) 1908, p. 207. A contemporary article in *The Country Gentleman* (February 5, 1881), reported that the pastels were selling "at prices ranging from £20 to £35." Pennell 1911, p. 204, cites Franklin's letter to Bacher, but adds that the total came to eighteen hundred pounds. The difference between the prices quoted in Maud Franklin's letters and the prices given in *The Country Gentleman* suggests that some of these figures may be exaggerated. A guinea is worth slightly more than a pound—twenty-one shillings versus twenty shillings. One pound in 1880 would be equivalent to about $200 in 2002.

9. E.W. Godwin, "Notes on Current Events," *British Architect*, February 4, 1881; "Mr. Whistler's Venice Pastels," *The Times*, February 9, 1881; "Fine Arts: Mr. Whistler's 'Venice Pastels,'" *The World*, February 2, 1881.

10. On Freer's decision to put together a comprehensive collection of Whistler's work, see Linda Merrill (ed.), *With Kindest Regards: The Correspondence of Charles Lang Freer and James McNeill Whistler, 1890–1903*, Washington, D.C. (Freer Gallery of Art) 1995, pp. 24–42.

11. The early history of *A Street in Venice* remains obscure—we do not know where Colnaghi's obtained it from, and we are not sure whether or not it was included in the 1881 exhibition at the Fine Art Society. The current location of No. 41 in the Fine Art Society exhibition, *Note in flesh colour and red*, has never been positively established. Several authors have suggested that *A Street in Venice* may be *Note in flesh colour and red*. There is a nineteenth-century colored reproduction of *Note in flesh colour and red*, and its general design does resemble the general design of *A Street in Venice,* but the resemblance is not exact, and *A Street in Venice* does not have any red in it. Moreover, unlike the vast majority of the pastels included in the 1881 exhibition, *A Street in Venice* is not signed on the front with Whistler's butterfly monogram. Thus, while the identification of *A Street in Venice* with *Note in flesh colour and red* seems possible, it also seems unlikely. For the contemporary reproduction of *Note in flesh colour and red*, see Thomas Robert Way, *Memories of James McNeill Whistler, the Artist*, New York and London (John Lane) 1912, opp. p. 52. The drawing is reproduced in MacDonald 1995, pp. 264–65.

12. In 1904 and 1905 Freer acquired three other pastels of Venice that he believed to be by Whistler. He bought *The Grand Canal, Venice* from the prominent London Gallery of Obach and Co. in 1904. *Quiet Canal* and *Venice Bay* were both included in the large collection purchased from Thomas Robert Way in 1905. Although *The Grand Canal, Venice* and *Venice Bay* are both prominently signed with Whistler's famous butterfly monogram, none of these works is currently accepted as a Whistler. All three are reproduced in *James McNeill Whistler at the Freer Gallery of Art*, exhib. cat. by David Curry, Washington, D.C., Freer Gallery of Art, 1984, plates 244, 245, 254.

13. Hecker purchased *The Music Room: Harmony in Green and Rose* (1860) between 1894 and 1899. Freer was Hecker's major art advisor, and he no doubt played a role in the acquisition. Hecker gave the painting to Freer in June 1917, knowing that it would go to Freer's museum. For provenance information, see Andrew McLaren Young, Margaret F. MacDonald, Robin Spencer, and Hamish Miles, *The Paintings of James McNeill Whistler*, New Haven CT and London (Yale University Press) 1980, I, p. 13; and W. Stanton Howard, "The Music Room," *Harper's Monthly Magazine*, 119, August 1909, p. 424. Howard reports that Hecker purchased *The Music Room* "soon after" Whistler's 1892 exhibition at Goupil's gallery in London, although (as the catalogue raisonné shows), he could not have acquired it before January 1894.

14. Louisine W. Havemeyer, *Sixteen to Sixty: Memoirs of a Collector*, New York (The Metropolitan Museum of Art) 1961, p. 206. Havemeyer was writing decades after her meeting with Whistler, and although her recollections are generally reliable, small mistakes, especially as they relate to dates, are rife. *Sixteen to Sixty* suggests that she purchased the Venice pastels around 1876, but since all five were included in the Fine Art Society exhibition, they must have been purchased after the show closed on March 31, 1881. The MacDonald catalogue raisonné follows The Metropolitan Museum of Art, *Catalogue of Paintings, Prints, Sculpture and Objects of Art, Part II, Paintings and Pastels, Collections of the Havemeyer Family*, New York (The Metropolitan Museum of Art) 1931, which reports that the meeting took place in 1882. But it must have taken place in 1881, after May 1, when Whistler's portrait of Miss Alexander went on public display in the fifth annual Summer Exhibition at the Grosvenor Gallery. The meeting also had to have taken place before September 21, when Whistler sent Miss Elder a farewell letter, wishing her a safe voyage back to America. Whistler's letter is transcribed in Frances Weitzenhoffer, *The Havemeyers: Impressionism Comes to America*, New York (Abrams) 1986, p. 23. Quite a few facts in Mrs. Havemeyer's account make clear that her meeting with Whistler could not have taken place in 1882, including her recollection that Oscar Wilde showed up for tea. Whistler and Wilde seem to have met in the spring of 1881 and were seeing each other regularly by that fall, but Wilde was out of London, on his famous lecture tour of the United States, from December 24, 1881 until early January 1883. See also Gary Tinterow, "The Havemeyer Pictures," in *Splendid Legacy: The Havemeyer Collection*, exhib. cat. by A.C. Frelinghuysen, G. Tinterow, *et al.*, New York, The Metropolitan Museum of Art, 1993, pp. 3–7; and Rebecca A. Rabinow, "Louisine Havemeyer and Edgar Degas," in *Degas and America: The Early Collectors*, exhib. cat. by Ann Dumas and David A. Brenneman, Atlanta, High Museum of Art, Minneapolis Institute of Art, 2000, pp. 34–45. Given the tricks memory plays, it seems likely that Mrs. Havemeyer paid more than the "thirty pounds" she remembered. After all, the less she paid the better the memory and story.

15. The quoted phrase is from Havemeyer 1961, p. 209. For Mrs. Havemeyer's friendship with Freer, see Louisine W. Havemeyer, "The Freer Museum of Oriental Art: With Personal Recollections of the Donor," *Scribner's Magazine*, 73, May 1923, pp. 529–40; and Julia Meech, "The Other Havemeyer Passion: Collecting Asian Art," in *Splendid Legacy: The Havemeyer Collection* 1993, pp. 132–33.

WHISTLER IN VENICE

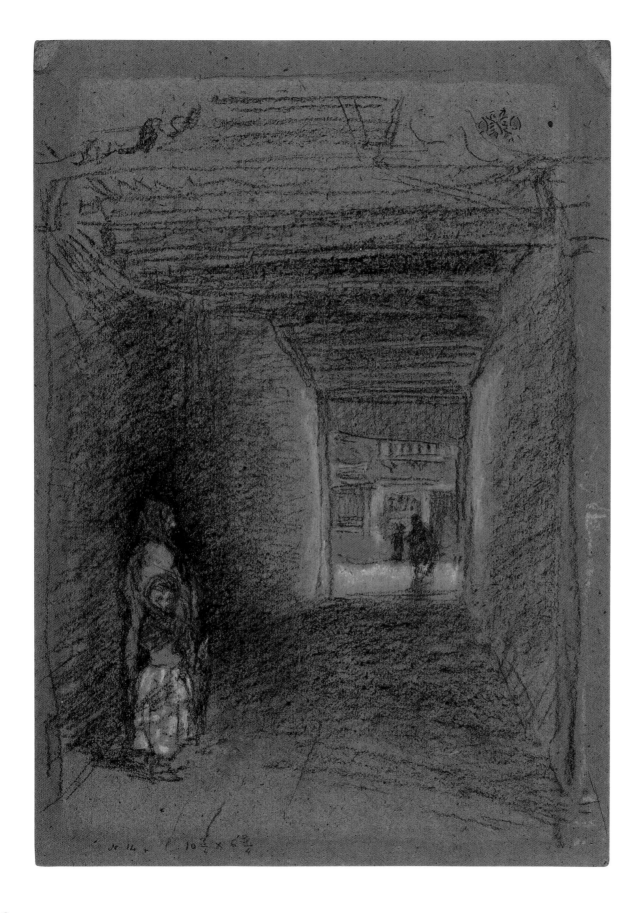

1.
James McNeill Whistler
(1834–1903)
The Beggars—Winter, c. 1879
(M727), chalk and pastel on
brown paper, 11¹³⁄₁₆ × 7¹⁵⁄₁₆ in.
(30 × 20.1 cm), Freer Gallery
of Art, Washington, D.C.,
gift of Charles Lang Freer

2.
James McNeill Whistler
Sunset, in red and brown,
1879–80 (M743), chalk
and pastel on brown paper,
11¹³⁄₁₆ × 7¹⁵⁄₁₆ in.
(30 × 20.1 cm), Freer Gallery
of Art, Washington, D.C.,
gift of Charles Lang Freer

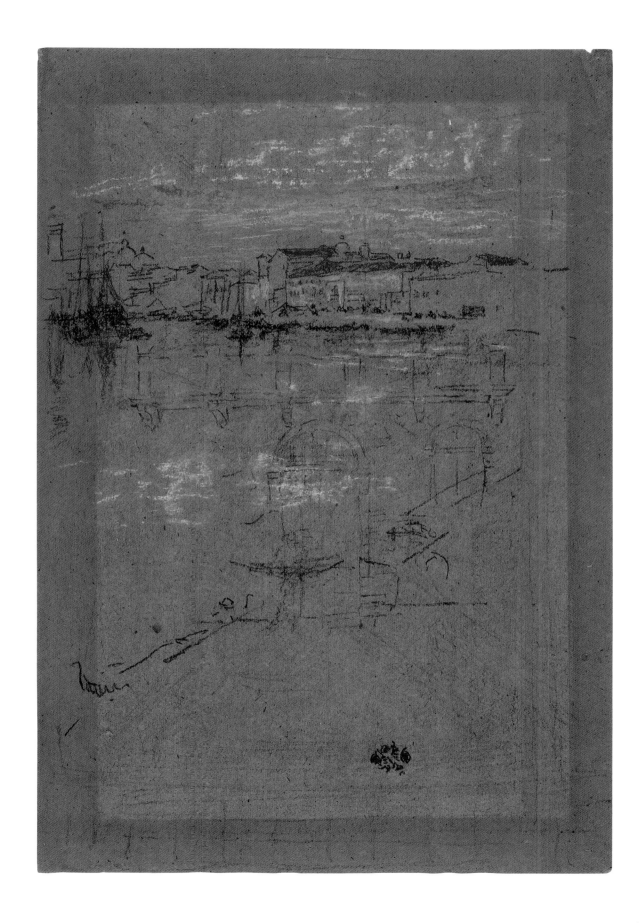

3.
James McNeill Whistler
*Campo Sta. Marta—Winter
Evening*, 1879–80 (M753),
chalk and pastel on brown
paper, 8⅛ × 11 in.
(20.6 × 27.9 cm), Freer Gallery
of Art, Washington, D.C., gift
of Charles Lang Freer

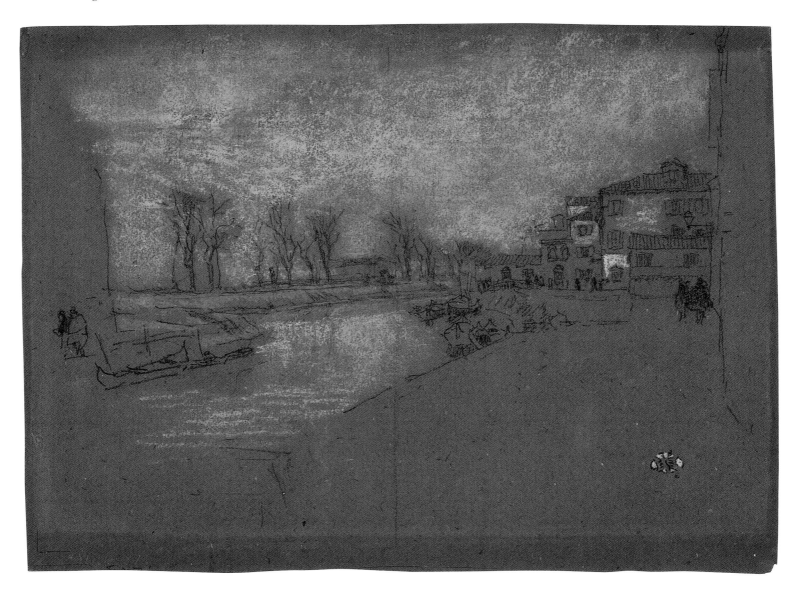

4.
James McNeill Whistler
Winter Evening, 1879–80
(M755), chalk and pastel on
brown paper, 11¹³⁄₁₆ × 7¹⁵⁄₁₆ in.
(30 × 20.1 cm), Freer Gallery
of Art, Washington, D.C.,
gift of Charles Lang Freer

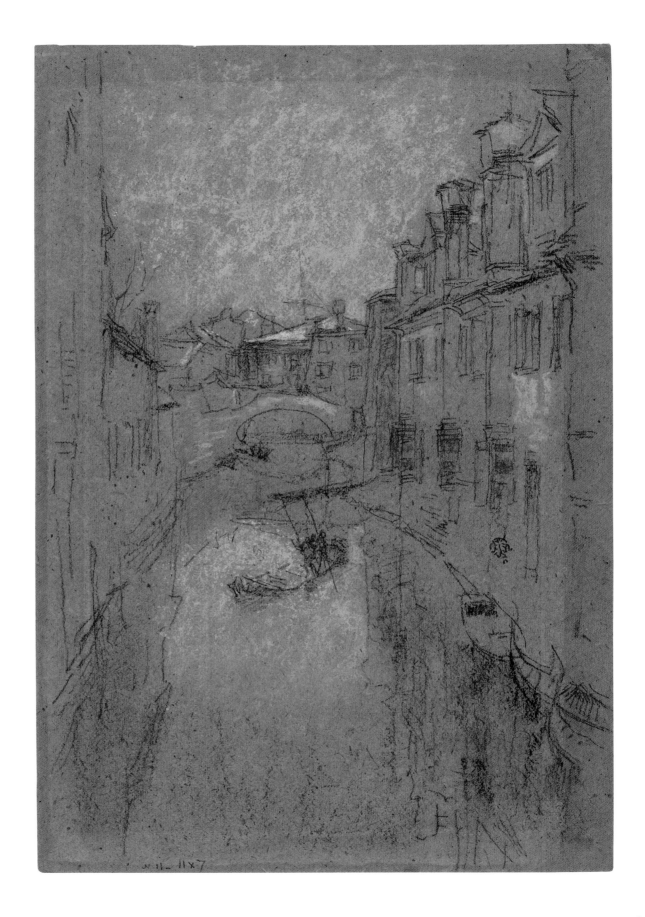

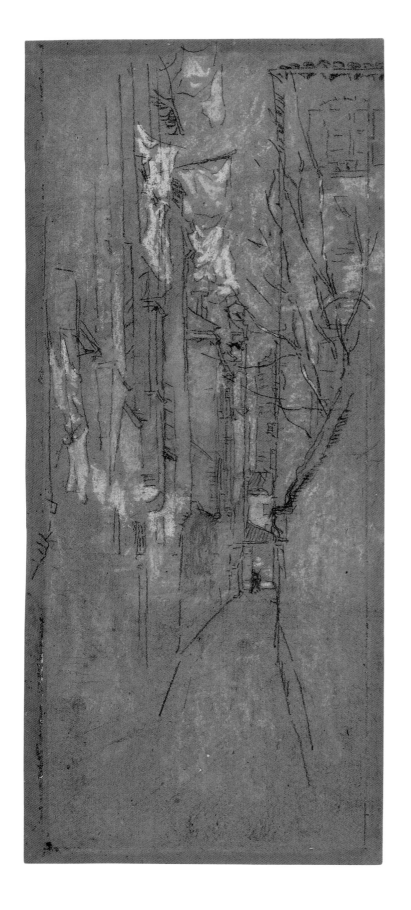

62

7.
James McNeill Whistler
The Staircase; note in red,
1880 (M782), chalk and
pastel on brown paper,
11�5⁄16 × 7¹⁵⁄16 in.
(28.7 × 20.1 cm),
Freer Gallery of Art,
Washington, D.C.,
gift of Charles Lang Freer

5. (FAR LEFT)
James McNeill Whistler
A Street in Venice, 1879–80
(M767), chalk and pastel on
brown paper, 11¾ × 4¹⁵⁄16 in.
(29.8 × 12.5 cm), Freer
Gallery of Art, Washington,
D.C., gift of Charles Lang
Freer

6. (LEFT)
James McNeill Whistler
Bead-stringers, 1880 (M812v),
chalk and pastel on gray
paper, 10⅝ × 4⅛ in.
(27 × 10.4 cm),
Freer Gallery of Art,
Washington, D.C.,
gift of Charles Lang Freer

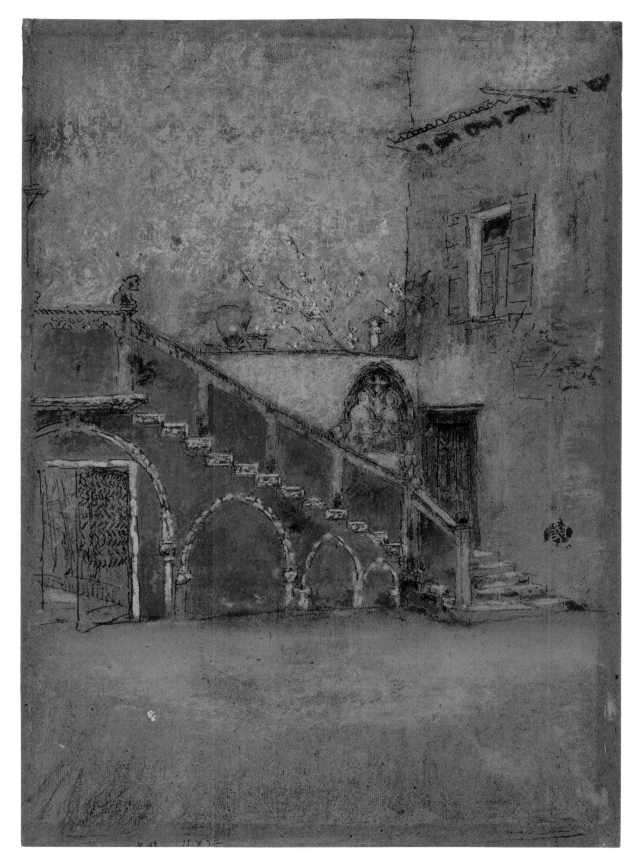

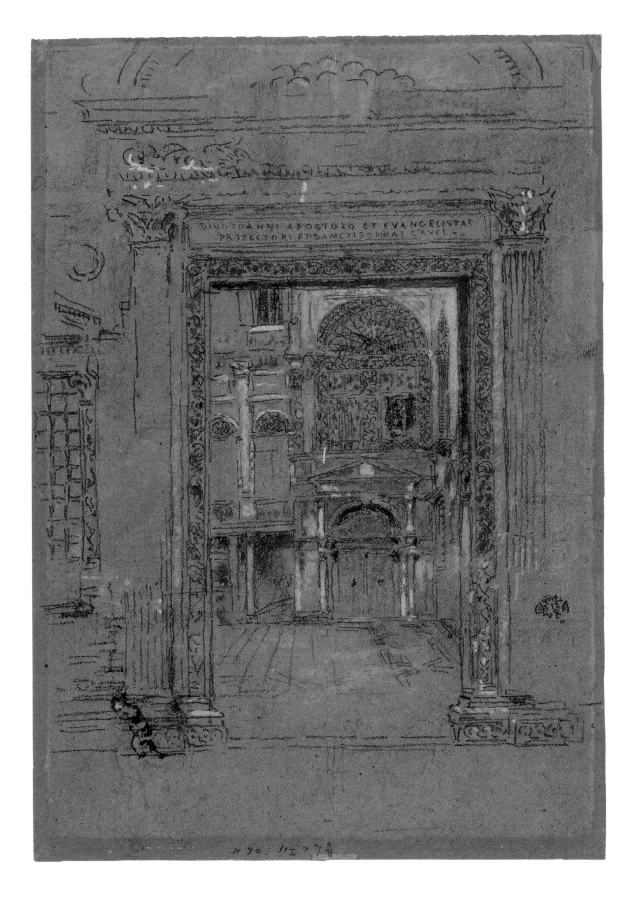

8.
James McNeill Whistler
San Giovanni Apostolo et Evangelistae, 1880 (M783), chalk, pastel, and charcoal on brown paper, 11¾ × 7¹⁵⁄₁₆ in. (29.8 × 20.1 cm), Freer Gallery of Art, Washington, D.C., gift of Charles Lang Freer

9.
James McNeill Whistler
The Steps, 1880 (m786),
chalk and pastel on brown
paper, 7⅝ × 11¹³⁄₁₆ in.
(19.3 × 30 cm), Freer Gallery
of Art, Washington, D.C.,
gift of Charles Lang Freer

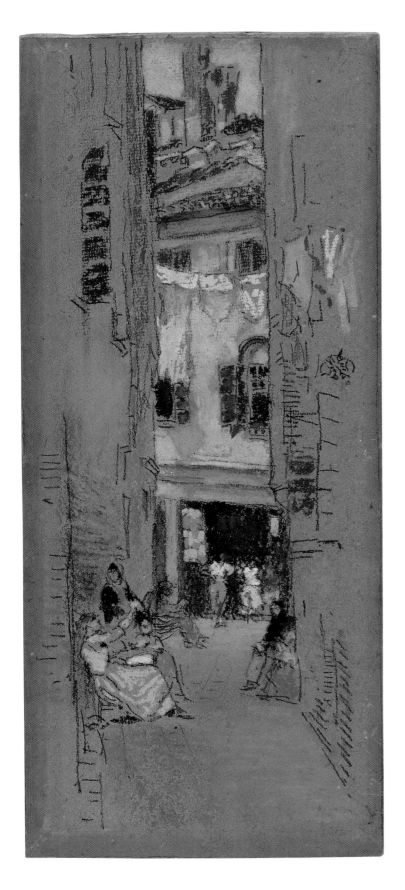

10.
James McNeill Whistler
Beadstringers, 1880 (M788),
chalk and pastel on brown
paper, 10¹³⁄₁₆ × 4½ in.
(27.4 × 11.4 cm),
Freer Gallery of Art,
Washington, D.C., gift of
Charles Lang Freer

11.
James McNeill Whistler
The Old Marble Palace, 1880
(M794), chalk and pastel on
brown paper, 11¹³⁄₁₆ × 6³⁄₁₆ in.
(30 × 15.7 cm), Freer Gallery
of Art, Washington, D.C.,
gift of Charles Lang Freer

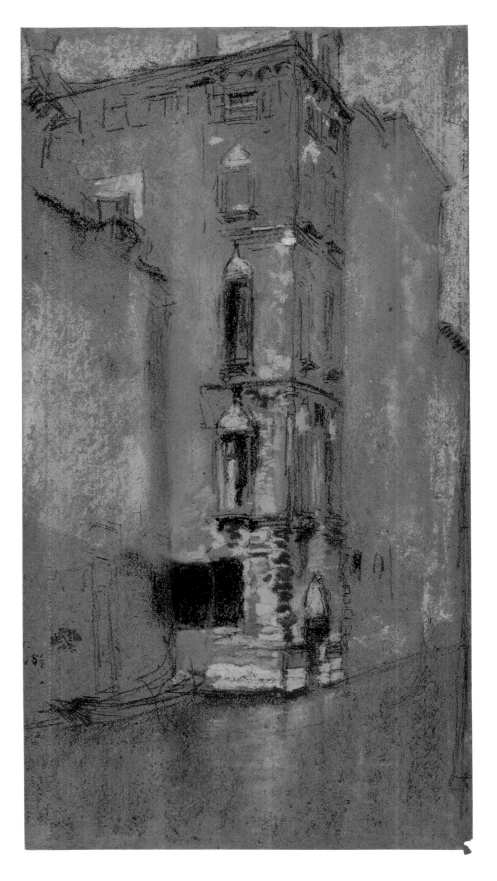

12.
James McNeill Whistler
Venice, 1880 (M802),
chalk and pastel on brown
paper, 7¹⁵⁄₁₆ × 12⅝ in.
(20.1 × 32 cm), Freer Gallery
of Art, Washington, D.C.,
gift of Charles Lang Freer

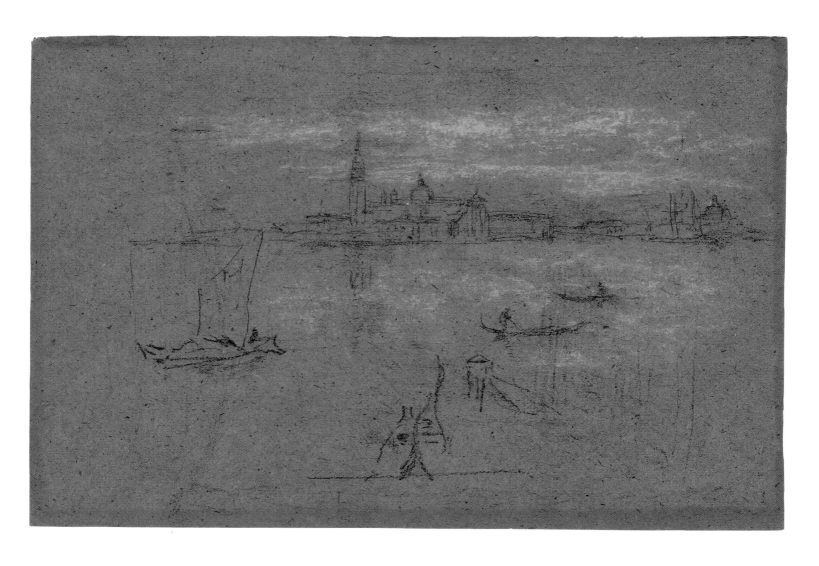

James McNeill Whistler
Nocturne—San Giorgio, 1880
(M803), chalk and pastel on
brown paper, 7¹⁵⁄₁₆ × 11¾ in.
(20.1 × 29.8 cm),
Freer Gallery of Art,
Washington, D.C., gift of
Charles Lang Freer

14.
James McNeill Whistler
Venice: Sunset, 1880 (M812r),
chalk and pastel on gray
paper, 4⅛ × 10⅝ in.
(10.4 × 27 cm),
Freer Gallery of Art,
Washington, D.C.,
gift of Charles Lang Freer

15.
James McNeill Whistler
*Blue and silver—The Islands,
Venice*, 1880 (M822), chalk
and pastel on brown paper,
3⁹⁄₁₆ × 11³⁄₁₆ in. (9 × 28.4 cm),
Freer Gallery of Art,
Washington, D.C., gift of
Charles Lang Freer

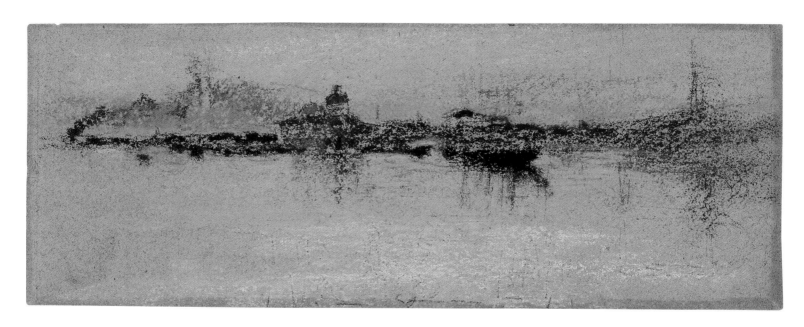

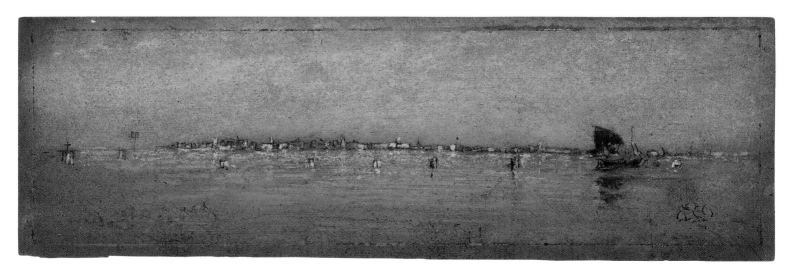

16.
James McNeill Whistler
Venice: Sunset on Harbour,
1880 (M811), chalk and
pastel on gray paper,
6⅛ × 9⅞ in. (15.5 × 25.1 cm),
Freer Gallery of Art,
Washington, D.C., gift of
Charles Lang Freer

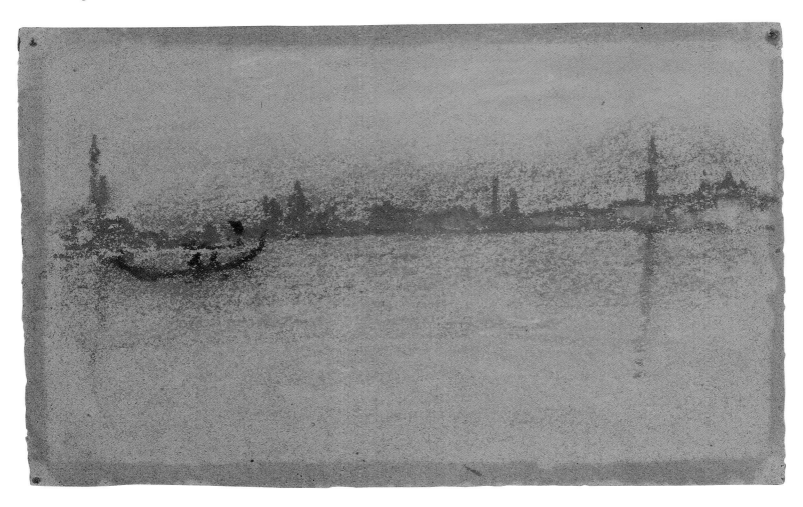

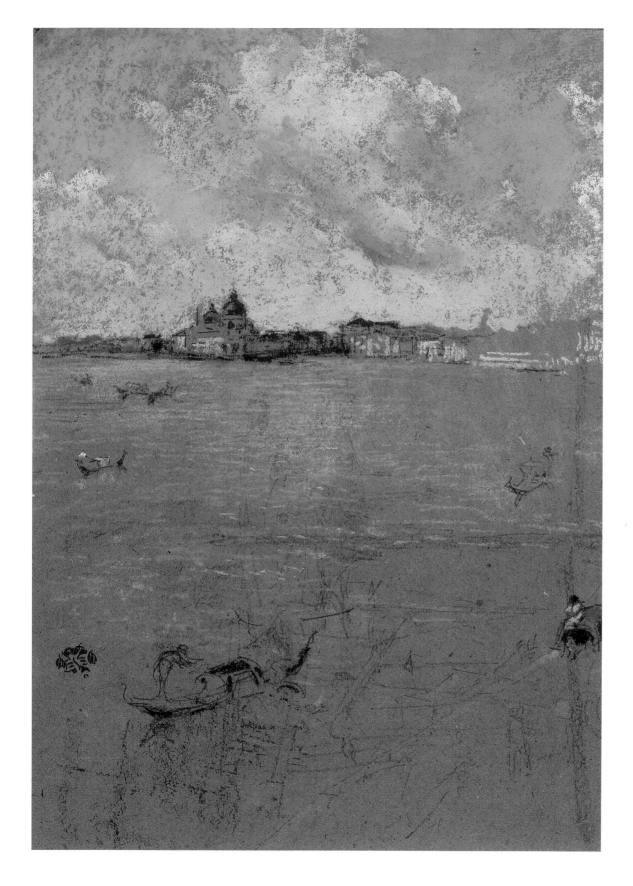

17.
James McNeill Whistler
Venetian Scene, 1879–80
(M744), chalk and pastel on
brown paper, 11⅝ × 7¹⁵⁄₁₆ in.
(29.5 × 20.1 cm),
New Britain Museum
of American Art CT,
Harriet Russell Stanley
Fund 1950.12

18.
James McNeill Whistler
The Little Riva; in opal,
1879–80 (M749), chalk and
pastel on brown paper,
6 × 11⅞ in. (15.2 × 30.1 cm),
Lauren Rogers Museum of
Art, Laurel MS

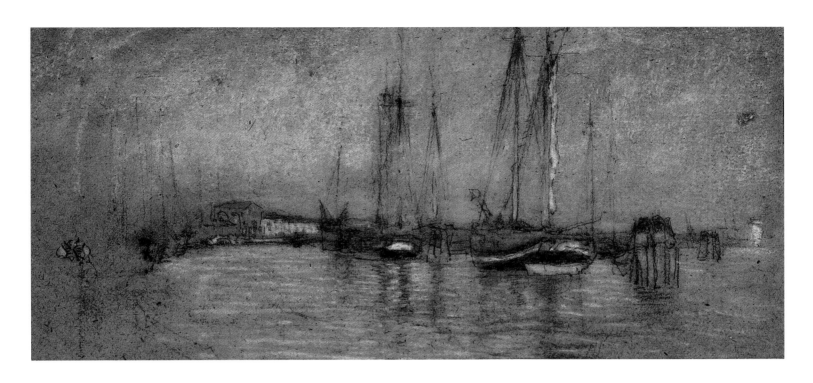

19.
James McNeill Whistler
Santa Maria della Salute,
1879–80 (M735), pen and
brown ink on white paper,
3⅛ × 6¼ in. (7.9 × 15.8 cm),
The Baltimore Museum of
Art, Garrett Collection, by
exchange, BMA NO. 1967.27

20.
James McNeill Whistler
Houses along a Venetian waterfront, 1879–80 (M752r), crayon and pastel on gray paper, 7^{15}/$_{16}$ × 11^{13}/$_{16}$ in. (20.1 × 30 cm), Maier Museum of Art, Randolph-Macon Woman's College, Lynchburg VA

21.
James McNeill Whistler
The Tobacco Warehouse,
1879–80 (M762), chalk
and pastel on brown
paper, 12¹⁄₁₆ × 8⁷⁄₁₆ in.
(30.6 × 21.4 cm),
Hirshhorn Museum
and Sculpture Garden,
Smithsonian Institution,
Washington, D.C., gift of
Joseph H. Hirshhorn, 1966

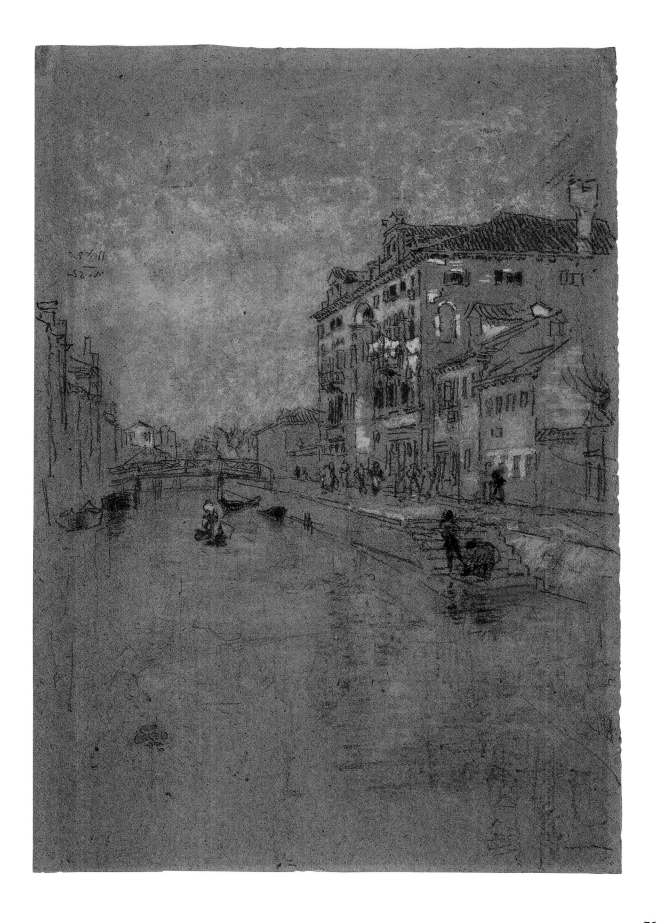

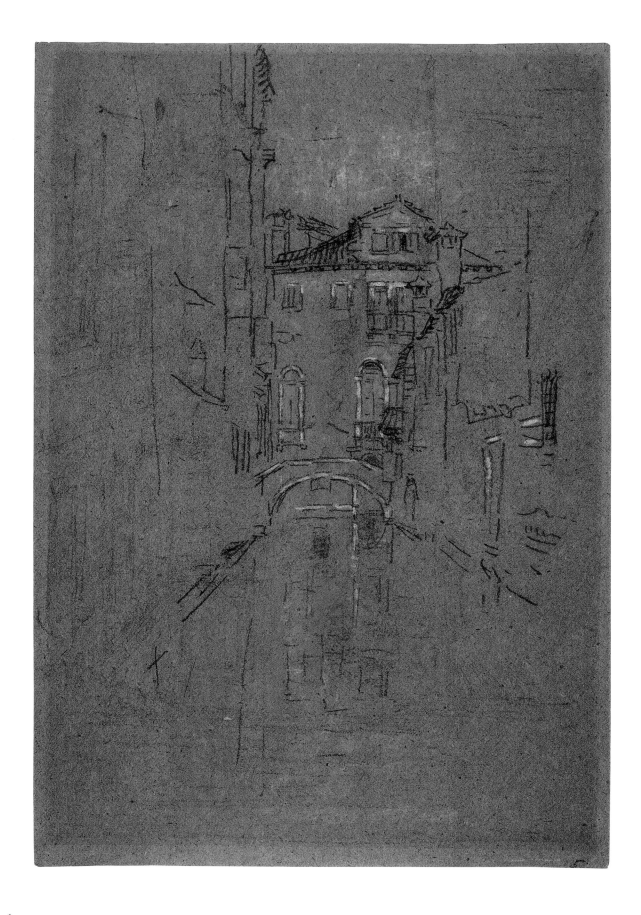

22.
James McNeill Whistler
A Venetian Canal, 1879–80
(M765), chalk and pastel on
brown paper, 11⅞ × 8 in.
(30.1 × 20.3 cm), Hirshhorn
Museum and Sculpture Garden,
Smithsonian Institution,
Washington, D.C., gift of
Joseph H. Hirshhorn, 1966

23.
James McNeill Whistler
Campanile Santa Margherita,
1879–80 (M773), chalk and
pastel on brown paper,
11⅞ × 7⅜ in. (30.1 × 18.7 cm),
Addison Gallery of American
Art, Phillips Academy, Andover
MA, 1928.37, gift of an
anonymous donor

24.
James McNeill Whistler
Canal, San Cassiano, 1879–80
(M778), chalk and pastel on
brown paper, 11½ × 6¾ in.
(29.2 × 17.1 cm),
Westmoreland Museum
of American Art,
Greensburg PA

25.
James McNeill Whistler
Venetian courtyard: Court of
Palazzo Zorzi, 1879–80
(M792), chalk and pastel on
brown paper, 11¾ × 7¹⁵⁄₁₆ in.
(29.8 × 20.1 cm), Dr. and
Mrs. John E. Larkin, Jr.

26.
James McNeill Whistler
*Venetian courtyard: Corte
Bollani*, 1879–80 (M793),
chalk and pastel on brown
paper, 11⅞ × 8 in.
(30.1 × 20.3 cm), Dr. and
Mrs. John E. Larkin, Jr.

27.
James McNeill Whistler
*The Church of San Giorgio
Maggiore*, 1880 (M805),
chalk and pastel on brown
paper, 7¹¹⁄₁₆ × 11⅝ in.
(19.5 × 29.5 cm), The Corcoran
Gallery of Art, Washington,
D.C., bequest of James Parmelee

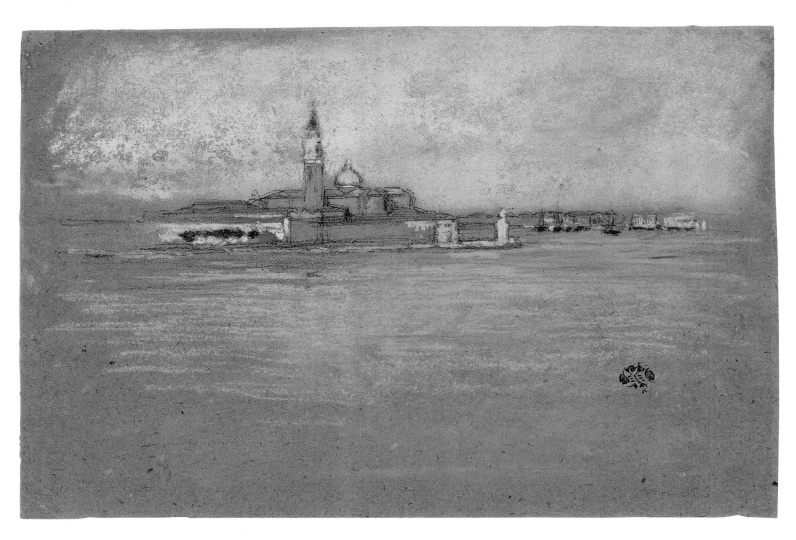

28.
James McNeill Whistler
The Giudecca; note in flesh colour, 1879–80 (M817), chalk and pastel on gray paper, 6¼ × 9¹⁵⁄₁₆ in. (15.8 × 25.2 cm), Mead Art Museum, Amherst College MA, gift of George Pratt, Class of 1893, AC P.1933.314

29.
James McNeill Whistler
San Biagio: flesh-colour and grey, 1879–80 (M818), chalk and pastel on dark-gray paper, 7⁹⁄₁₆ × 11⁵⁄₁₆ in. (19.2 × 28.7 cm), Glen Burnie Historic House and Museum and Julian Wood Glass, Jr. Collections, Winchester VA

30.
Circle of James McNeill Whistler
Venetian Bridge, 1879–80, chalk and pastel on brown paper, 11⁷⁄₁₆ × 8 in. (29 × 20.3 cm), The Corcoran Gallery of Art, Washington, D.C.

31.
After James McNeill Whistler
The Balcony, 1880, pastel
and pencil on paper,
8⅝ × 5⅝ in. (21.9 × 14.3 cm),
Chrysler Museum of Art,
Norfolk VA, gift of Walter B.
Chrysler, Jr., 78.431

32.
James McNeill Whistler
Bead-stringers, 1879–80
(M732), pencil on white
paper, 9¹⁵⁄₁₆ × 7⅜ in.
(25.2 × 18.7 cm), Dr. and
Mrs. John E. Larkin, Jr.

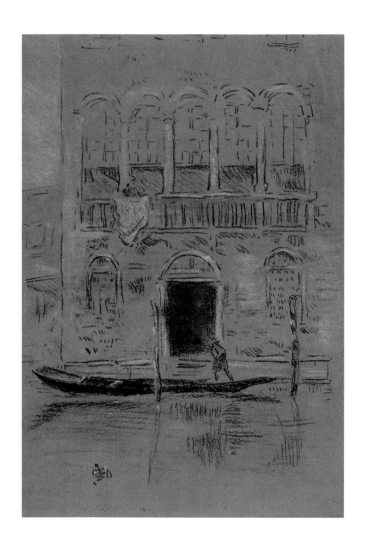

33.
James McNeill Whistler
The Little Mast, 1879–80 (к.185),
etching, 4th state, 10½ × 7⁵⁄₁₆ in.
(26.6 × 18.5 cm), National Gallery
of Art, Washington, D.C., gift of
Mr. and Mrs. J. Watson Webb in
memory of Mr. and Mrs. H.O.
Havemeyer

34.
James McNeill Whistler
The Little Lagoon, 1879–80
(к.186), etching, 8⅞ × 6 in.
(22.5 × 15.2 cm), private
collection

35.
James McNeill Whistler
The Palaces, 1879–80 (K.187), etching
and drypoint, 3rd state, 9⅞ × 14⅛ in.
(25.1 × 35.8 cm), National Gallery of
Art, Washington, D.C., gift of Mr.
and Mrs. J. Watson Webb in memory
of Mr. and Mrs. H.O. Havemeyer

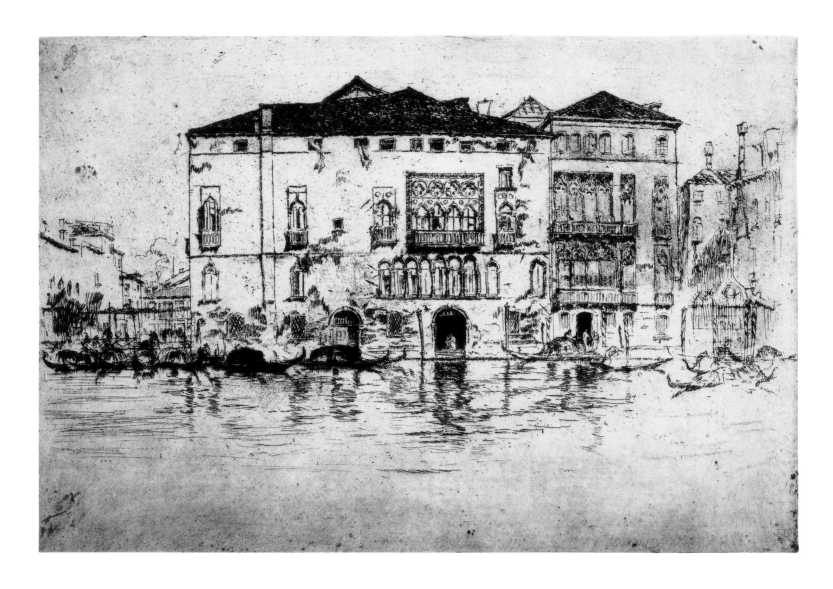

36.
James McNeill Whistler
The Piazzetta, 1879–80
(K.189), etching,
10 1/16 × 7 1/8 in.
(25.5 × 18.1 cm), The
Corcoran Gallery of Art,
Washington, D.C., gift of
Julius Garfinckel

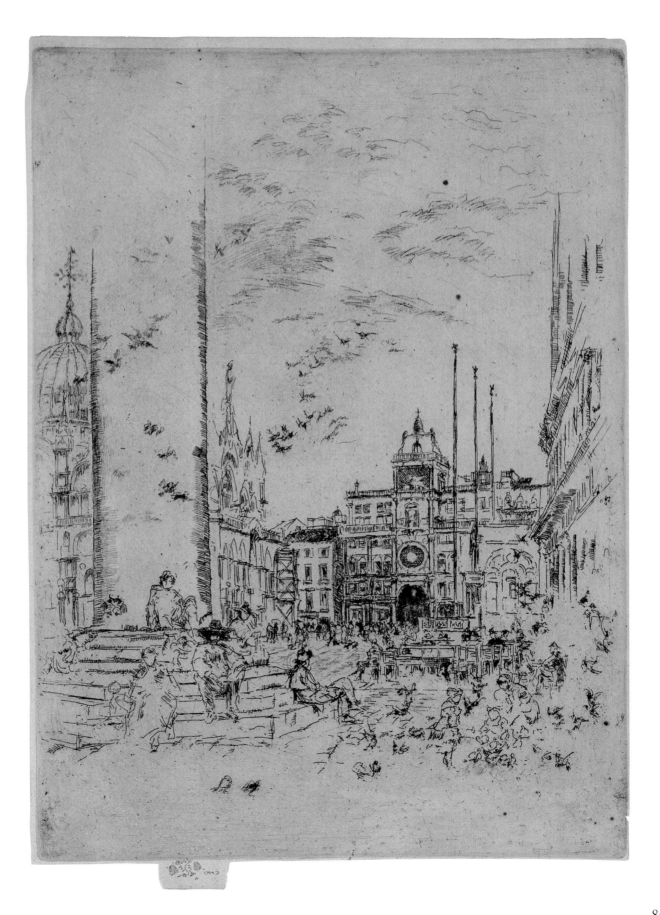

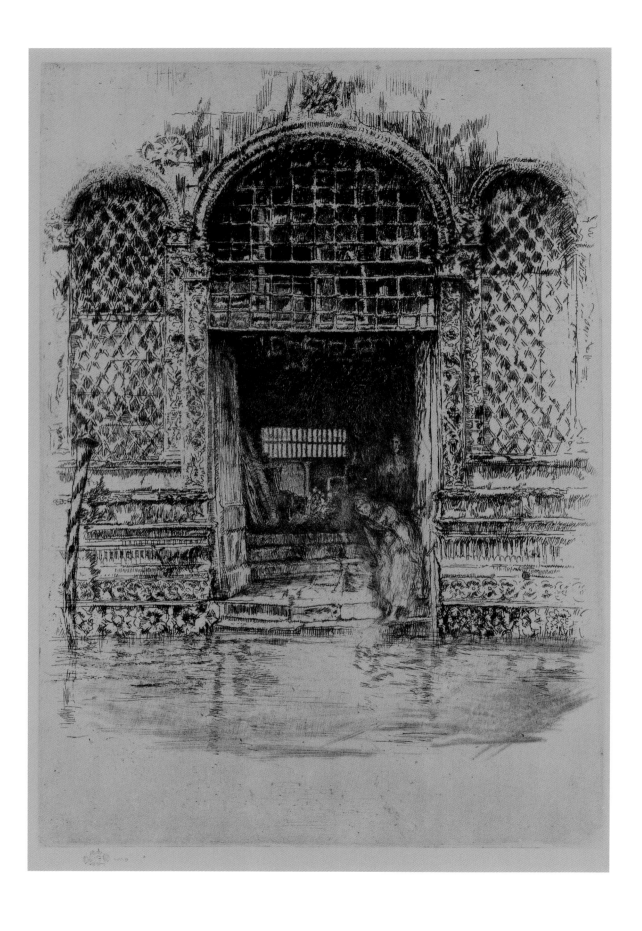

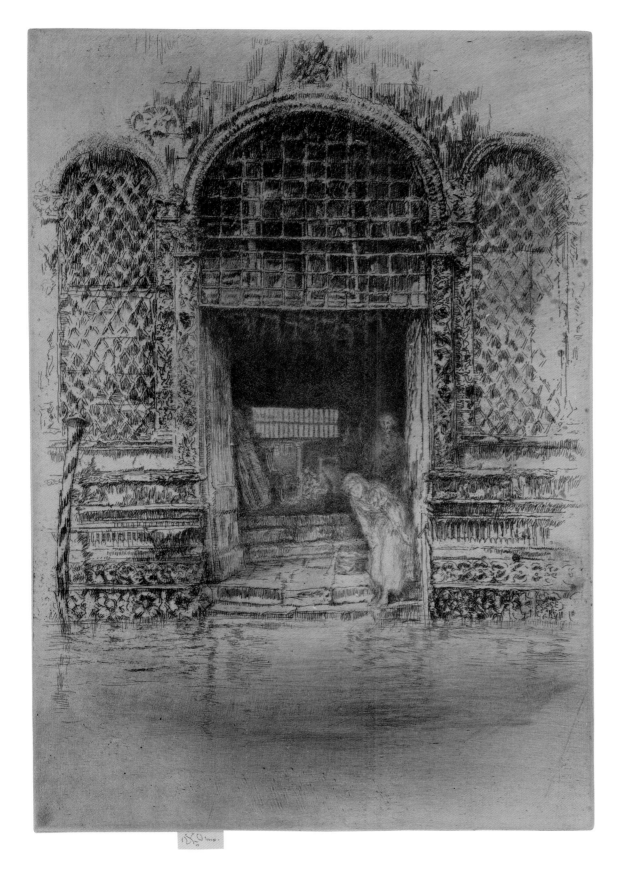

38.
James McNeill Whistler
The Doorway, 1879–80
(K.188), etching, 5th state,
11⁹⁄₁₆ × 8 in.
(29.3 × 20.3 cm),
National Gallery of Art,
Washington, D.C., gift
of Mr. and Mrs. J. Watson
Webb in memory of Mr.
and Mrs. H.O. Havemeyer

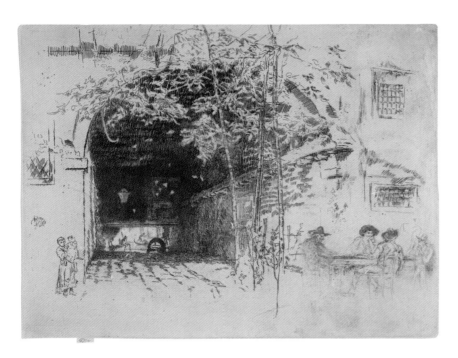

39.
James McNeill Whistler
The Traghetto, No. 2,
1879–80 (K.191), etching
and drypoint, 9⅜ × 11¹⁵⁄₁₆ in.
(23.8 × 30.3 cm), The
Corcoran Gallery of Art,
Washington, D.C.

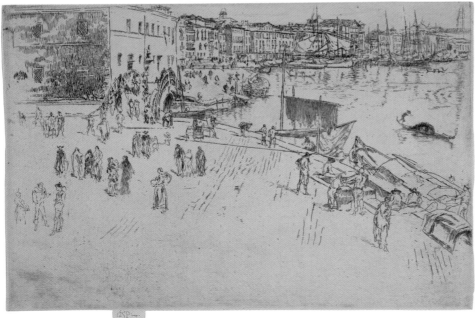

40.
James McNeill Whistler
The Riva, No. 1, 1879–80
(K.192), etching,
8⅜ × 11⅝ in.
(21.2 × 29.5 cm), National
Gallery of Art, Washington,
D.C., gift of Mr. and Mrs.
J. Watson Webb in
memory of Mr. and Mrs.
H.O. Havemeyer

41.
James McNeill Whistler
Two Doorways, 1879–80
(K.193), etching, 4th state,
8 × 11½ in. (20.3 × 29.2 cm),
National Gallery of Art,
Washington, D.C., gift of
Mr. and Mrs. J. Watson
Webb in memory of Mr. and
Mrs. H.O. Havemeyer

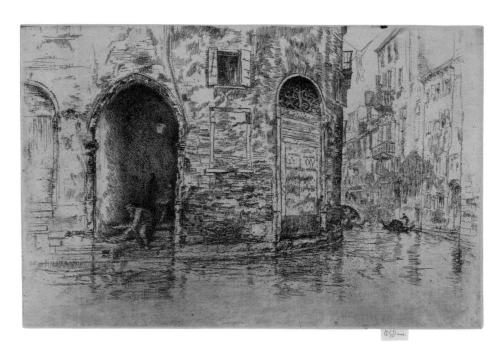

42.
James McNeill Whistler
Two Doorways, 1879–80
(K.193), etching, 8 × 11½ in.
(20.3 × 29.2 cm), National
Gallery of Art, Washington,
D.C., Rosenwald Collection

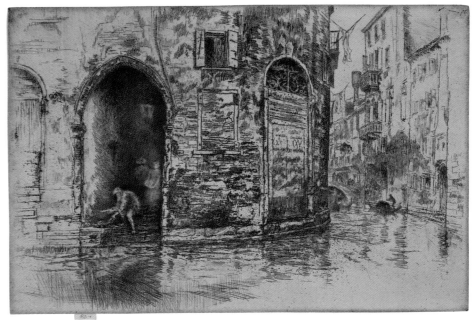

43.
James McNeill Whistler
Doorway and Vine, 1879–80
(к.196), etching, 3rd state,
9¹⁄₁₆ × 6¹¹⁄₁₆ in. (23 × 17 cm),
National Gallery of Art,
Washington, D.C., gift of Mr. and
Mrs. J. Watson Webb in memory
of Mr. and Mrs. H.O. Havemeyer

44.
James McNeill Whistler
Doorway and Vine, 1879–80
(к.196), etching, 9th state,
9¹⁄₁₆ × 6¹¹⁄₁₆ in.
(23 × 17 cm), National
Gallery of Art, Washington,
D.C., Rosenwald Collection

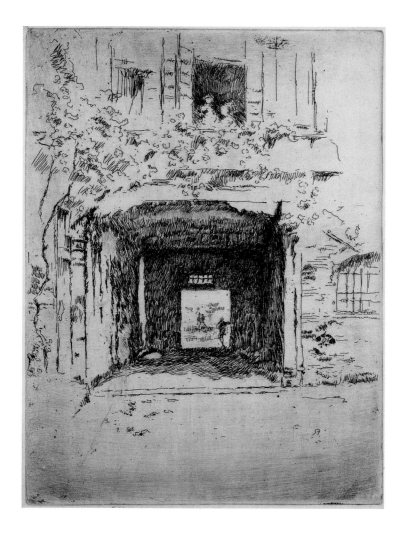

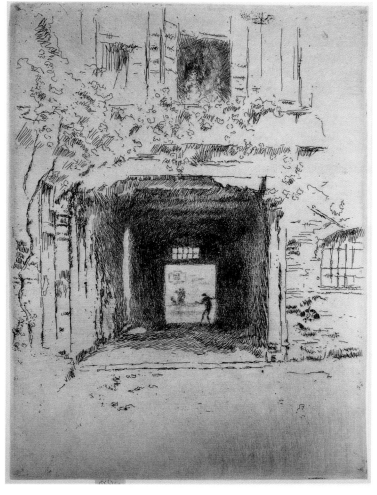

45.
James McNeill Whistler
San Biagio, 1879–80 (K.197),
etching, 3rd state, 8³⁄₁₆ × 11¹³⁄₁₆ in.
(20.8 × 30 cm), National Gallery
of Art, Washington, D.C., gift of
Mr. and Mrs. J. Watson Webb in
memory of Mr. and Mrs. H.O.
Havemeyer

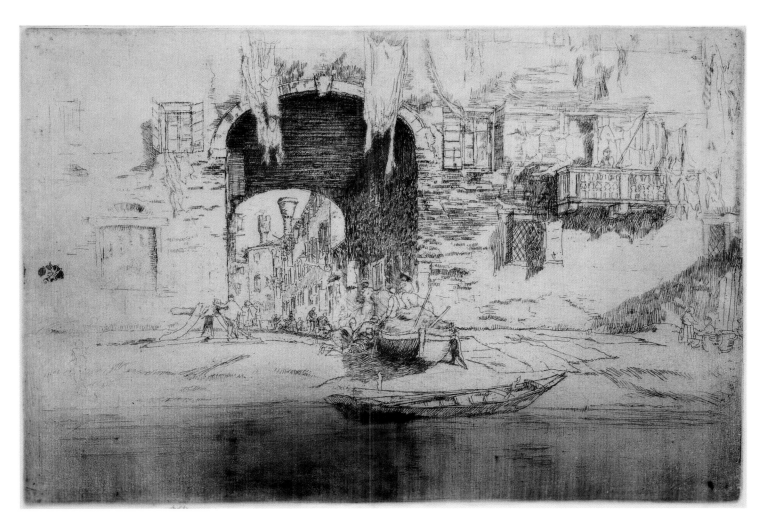

46.
James McNeill Whistler
The Bead-Stringers, 1879–80
(K.198), etching, 9 × 6 in.
(22.8 × 15.2 cm), The
Corcoran Gallery of Art,
Washington, D.C.

47.
James McNeill Whistler
The Mast, 1879–80 (K.195),
etching and drypoint,
5th state, 13⅝ × 6⅜ in.
(34.6 × 16.2 cm), Library of
Congress, Washington,
D.C., LC-USZC4-9915

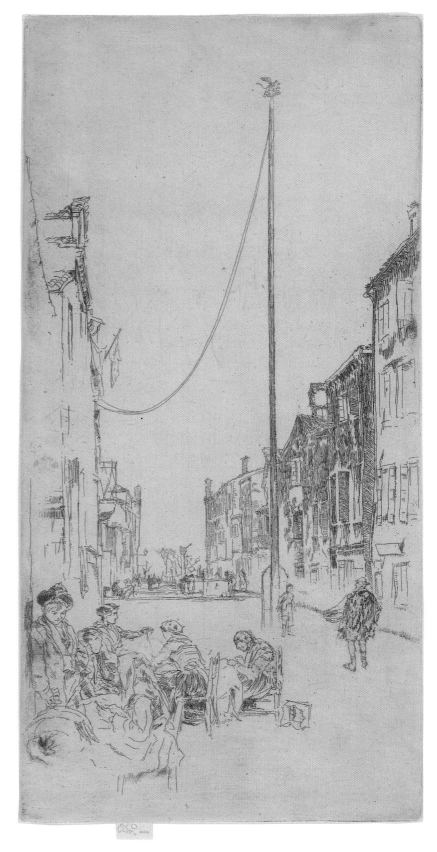

48.
James McNeill Whistler
Turkeys, 1879–80 (k.199),
etching and drypoint,
8¹⁄₁₆ × 5³⁄₁₆ in.
(20.4 × 13.1 cm), Library
of Congress, Washington,
D.C., LC-USZC4-10555

49.
James McNeill Whistler
San Giorgio, 1879–80
(k.201), etching,
8¼ × 12¹⁄₁₆ in.
(20.9 × 30.61 cm), National
Gallery of Art, Washington,
D.C., Rosenwald Collection

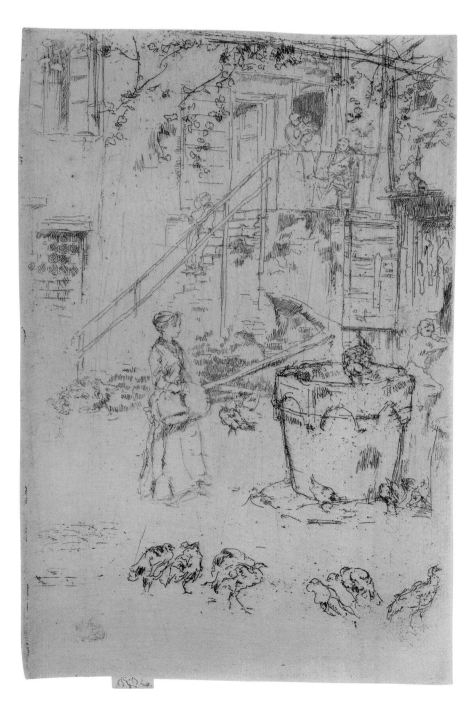

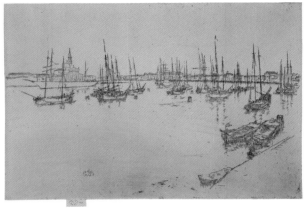

50.
James McNeill Whistler
Nocturne: Palaces, 1879–80
(к.202), etching and
drypoint, 8th state,
11⅞ × 7¹⁵⁄₁₆ in.
(30.1 × 20.1 cm), National
Gallery of Art, Washington,
D.C., Rosenwald Collection

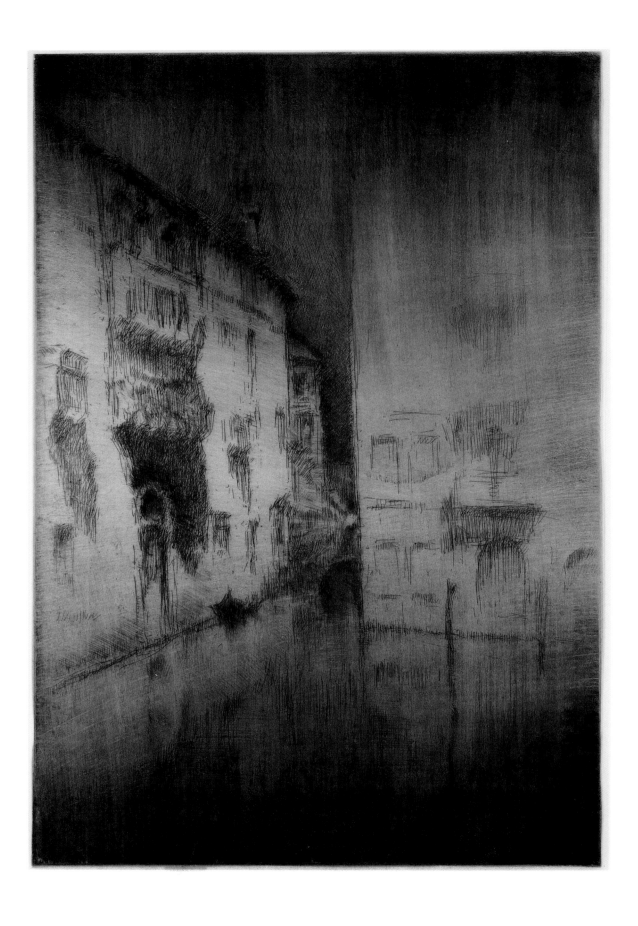

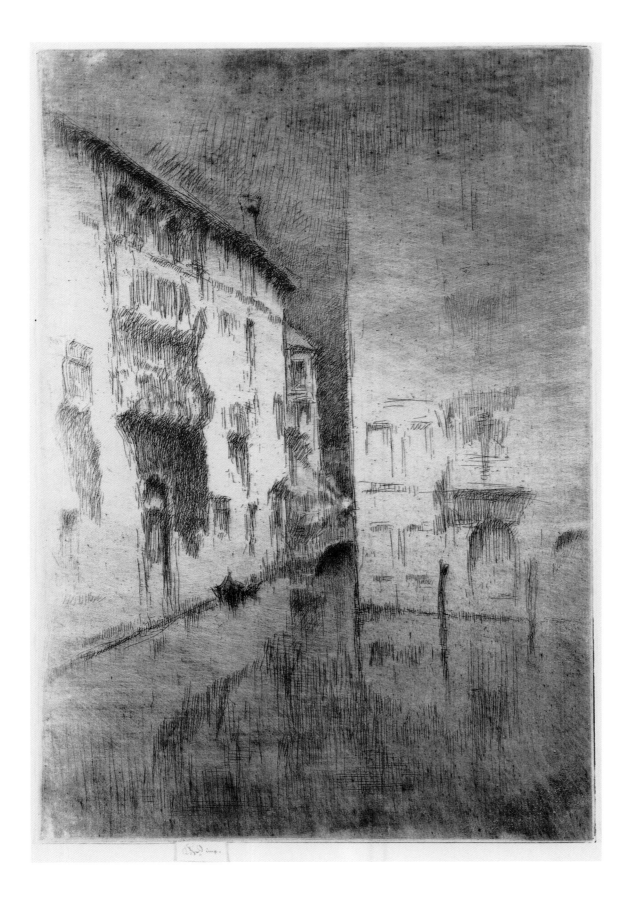

51.
James McNeill Whistler
Nocturne: Palaces, 1879–80
(K.202), etching and
drypoint, 11⅞ × 7¹⁵⁄₁₆ in.
(30.1 × 20.1 cm), The
Baltimore Museum of Art,
The George A. Lucas
Collection, BMA
NO. 1996.48.12301

52.
James McNeill Whistler
Upright Venice, 1879–80
(K.205), etching and
drypoint, 1st state,
10�5⁄16 × 8 in.
(26.2 × 20.3 cm), National
Gallery of Art, Washington,
D.C., Rosenwald Collection

53.
James McNeill Whistler
Upright Venice, 1879–80 (K.205),
etching and drypoint,
10�5⁄16 × 8 in. (26.2 × 20.3 cm),
The Baltimore Museum
of Art, The George A. Lucas
Collection, BMA
NO. 1996.48.12307

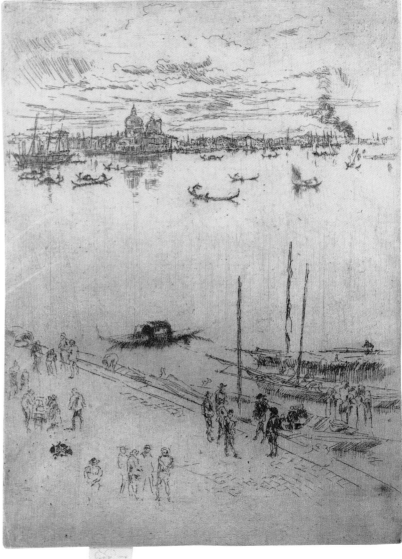

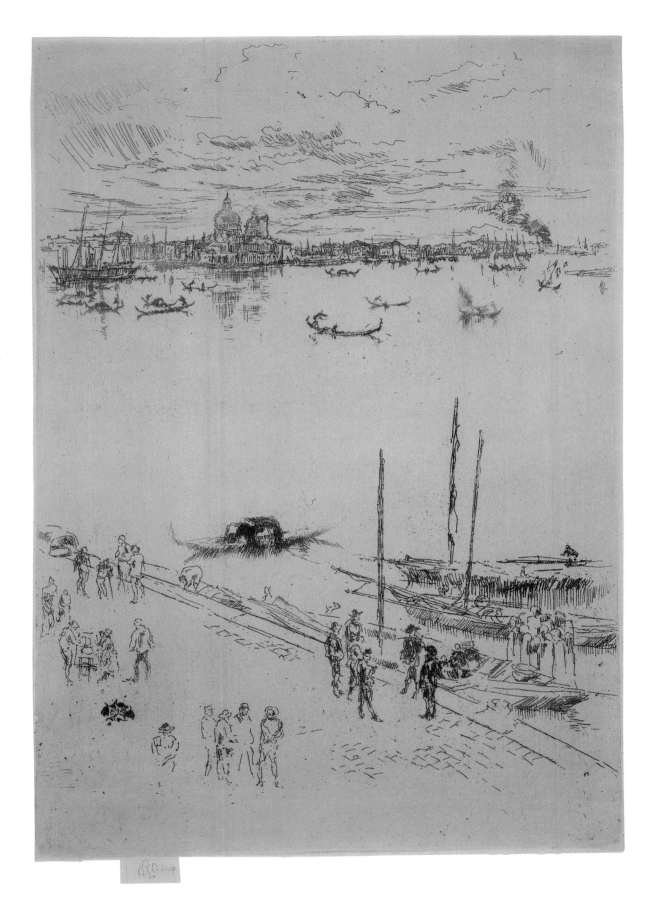

54.
James McNeill Whistler
Upright Venice, 1879–80
(K.205), etching and
drypoint, 10⁵⁄₁₆ × 8 in.
(26.2 × 20.3 cm), Library of
Congress, Washington,
D.C., LC-USZC4-10556

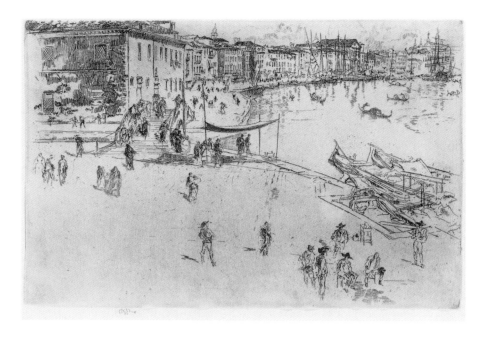

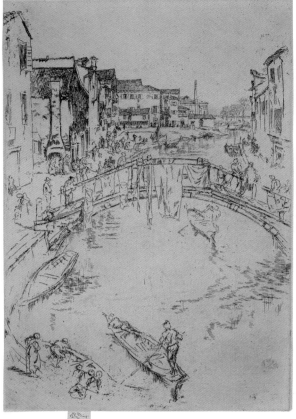

55.
James McNeill Whistler
The Riva, No. 2, 1879–80
(K.206), etching and
drypoint, 8⁷⁄₁₆ × 11⁷⁄₈ in.
(21.4 × 30.1 cm), The
Baltimore Museum of Art,
The George A. Lucas
Collection, BMA
NO. 1996.48.12313

56.
James McNeill Whistler
Venice, 1879–80 (K.231),
etching touched with gray
wash, 7¹³⁄₁₆ × 11⁵⁄₈ in.
(19.8 × 29.5 cm), The
Baltimore Museum of Art,
The George A. Lucas
Collection, BMA
NO. 1996.48.12327

57.
James McNeill Whistler
The Bridge, 1879–80 (K.204),
etching, 11 × 7⁷⁄₈ in.
(27.9 × 20 cm), Library of
Congress, Washington,
D.C., LC-USZC4-9915

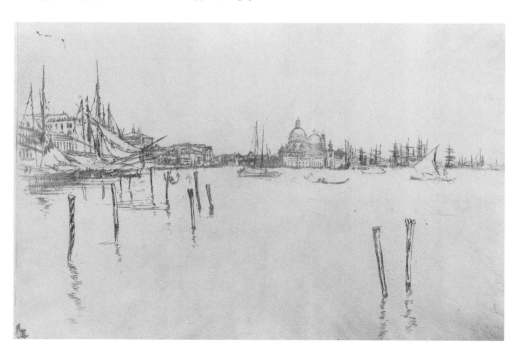

58.
James McNeill Whistler
Long Lagoon, 1879–80
(K.203), etching and
drypoint, 1st state,
6 × 8¹³⁄₁₆ in.
(15.2 × 22.4 cm), National
Gallery of Art, Washington,
D.C., Rosenwald Collection

59.
James McNeill Whistler
Long Lagoon, 1879–80
(K.203), etching and
drypoint, 6 × 8¹³⁄₁₆ in.
(15.2 × 22.4 cm), The
Baltimore Museum of Art,
The George A. Lucas
Collection, BMA
NO. 1996.48.12301

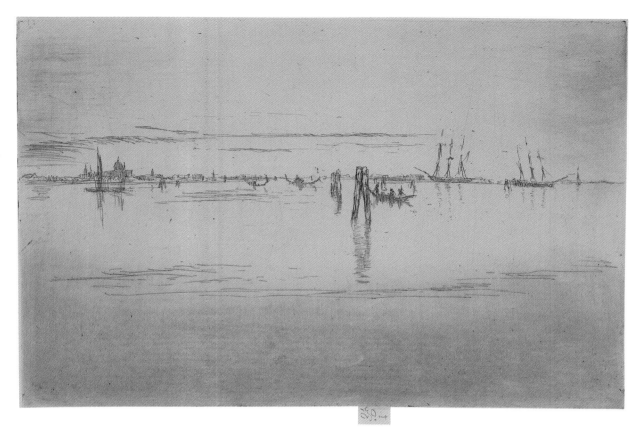

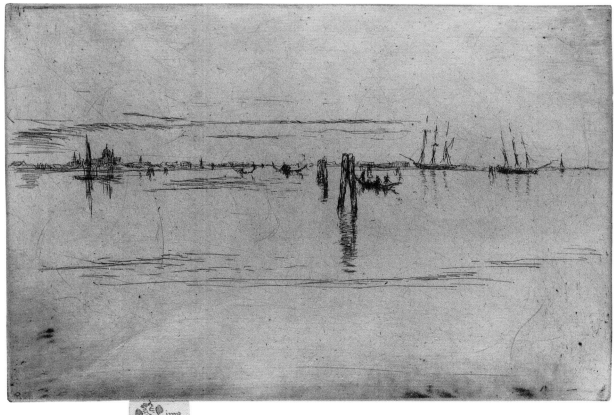

60.
James McNeill Whistler
The Balcony, 1879–80
(K.207), etching,
11¹¹⁄₁₆ × 7¹⁵⁄₁₆ in.
(29.7 × 20.1 cm),
National Gallery of Art,
Washington, D.C.,
Rosenwald Collection

61.
James McNeill Whistler
The Balcony, 1879–80
(K.207), etching, 5th state,
11¹¹⁄₁₆ × 7¹⁵⁄₁₆ in.
(29.7 × 20.1 cm), Library of
Congress, Washington, D.C.,
LC-USZC4-10557

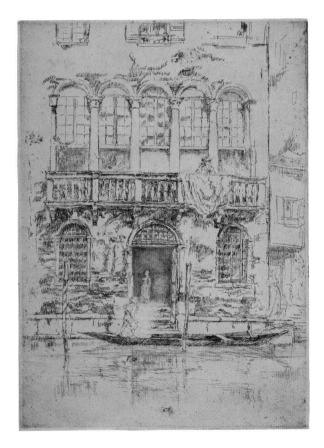

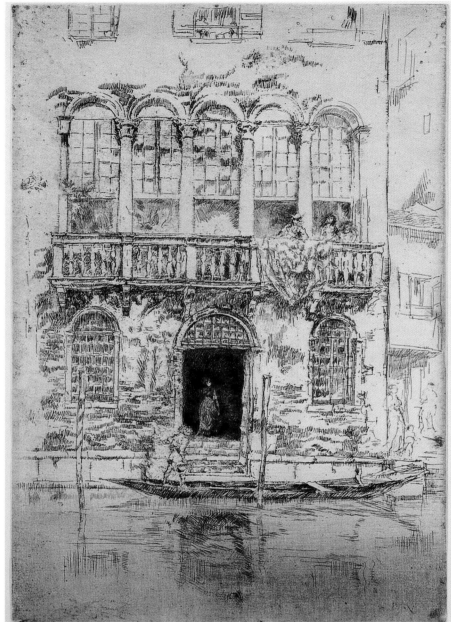

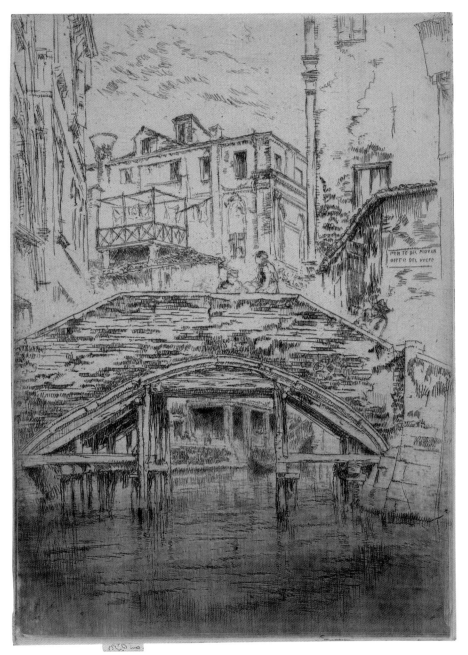

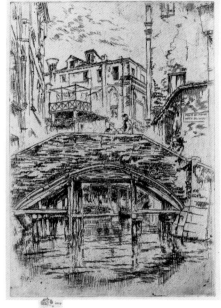

62.
James McNeill Whistler
Ponte del Piovan, 1879–80
(K.209), etching and
drypoint, 8¹⁵⁄₁₆ × 6 in.
(22.7 × 15.2 cm), Library of
Congress, Washington,
D.C., LC-USZC4-10558

63.
James McNeill Whistler
Ponte del Piovan, 1879–80
(K.209), etching and
drypoint, 8¹⁵⁄₁₆ × 6 in.
(22.7 × 15.2 cm), The Baltimore
Museum of Art, The George
A. Lucas Collection, BMA
NO. 1996.48.12317

64.
James McNeill Whistler
Ponte del Piovan, 1879–80
(K.209), etching and
drypoint, 8¹⁵⁄₁₆ × 6 in.
(22.7 × 15.2 cm), The
Corcoran Gallery of Art,
Washington, D.C., bequest
of Julius Garfinckel

103

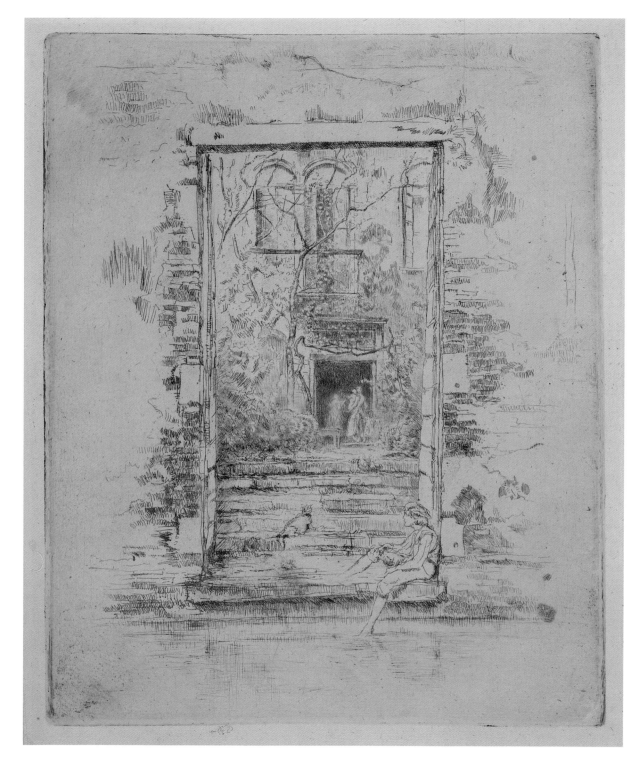

65.
James McNeill Whistler
Garden, 1879–80 (K.210),
etching and drypoint,
6th state, 11⅞ × 9⁵⁄₁₆ in.
(30.1 × 23.6 cm), Library
of Congress, Washington,
D.C., LC-USZC4-10559

66.
James McNeill Whistler
The Rialto, 1879–80 (K.211),
etching and drypoint,
11⁷⁄₁₆ × 7⅞ in. (29 × 20 cm),
National Gallery of Art,
Washington, D.C.,
Rosenwald Collection

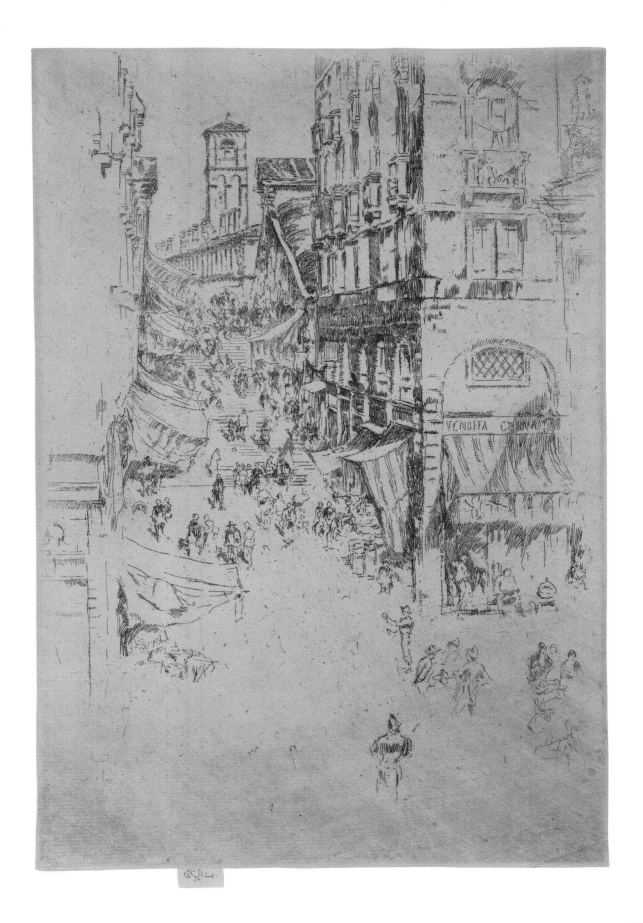

67.
James McNeill Whistler
Long Venice, 1879–80
(K.212), etching,
5 × 12⁵⁄₁₆ in.
(12.7 × 31.2 cm), Library
of Congress, Washington,
D.C., LC-USZC4-10560

68.
James McNeill Whistler
Nocturne: Furnace, 1879–80
(K.213), etching and
drypoint, 6⁷⁄₁₆ × 8¹⁵⁄₁₆ in.
(16.3 × 22.7 cm), Library of
Congress, Washington, D.C.,
LC-USZC4-10561

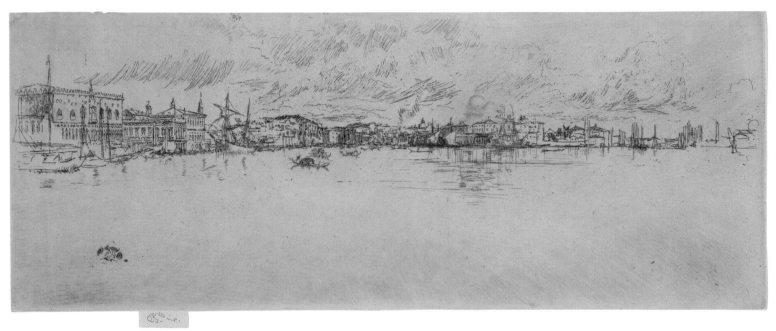

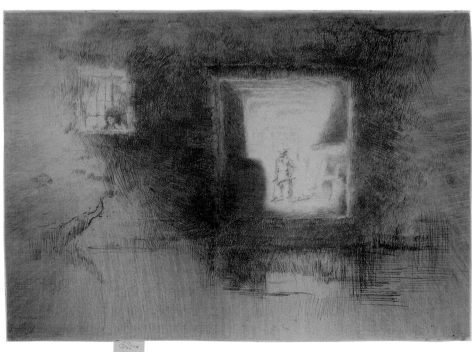

69.
James McNeill Whistler
Quiet Canal, 1879–80
(κ.214), etching and
drypoint, 8¹⁵⁄₁₆ × 5¹⁵⁄₁₆ in.
(22.7 × 15.1 cm), Library of
Congress, Washington,
D.C., LC-USZC4-9916

70.
James McNeill Whistler
La Salute: Dawn, 1879–80
(κ.215), etching, 5 × 8 in.
(12.7 × 20.3 cm), Library
of Congress, Washington,
D.C., LC-USZC4-10562

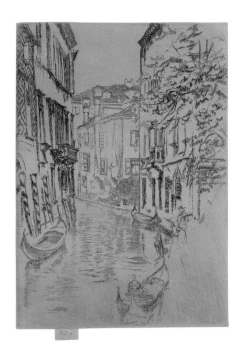

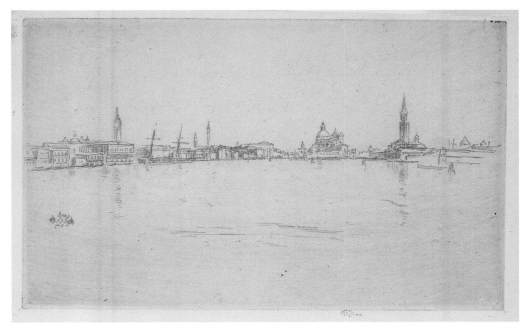

71.
James McNeill Whistler
Lagoon: Noon, 1879–80
(κ.216), etching, 2nd
state, 5 × 7¹⁵⁄₁₆ in.
(12.7 × 20.1 cm), Library
of Congress, Washington,
D.C., LC-USZC4-10563

72.
James McNeill Whistler
Glass-Furnace, Murano,
1879–80 (K.217), etching,
1st state, 6¼ × 9⅛ in.
(15.8 × 23.1 cm), Library of
Congress, Washington, D.C.,
LC-USZC4-10564

73.
James McNeill Whistler
Fish-Shop, Venice, 1879–80
(K.218), etching, 5th state,
5¹⁄₁₆ × 8¾ in.
(12.8 × 22.2 cm), Library of
Congress, Washington, D.C.,
LC-USZC4-10565

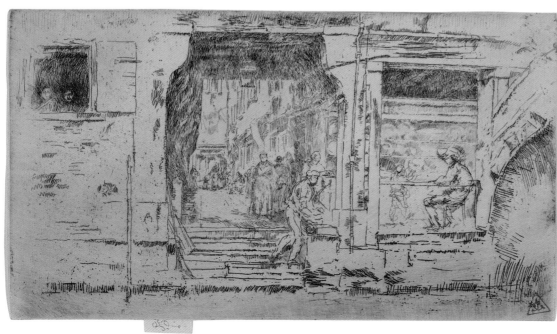

74.
James McNeill Whistler
The Dyer, 1879–80 (K.219),
etching, 3rd state,
12 × 9⁷⁄₁₆ in.
(30.5 × 23.9 cm), Library of
Congress, Washington, D.C.,
LC-USZC4-10566

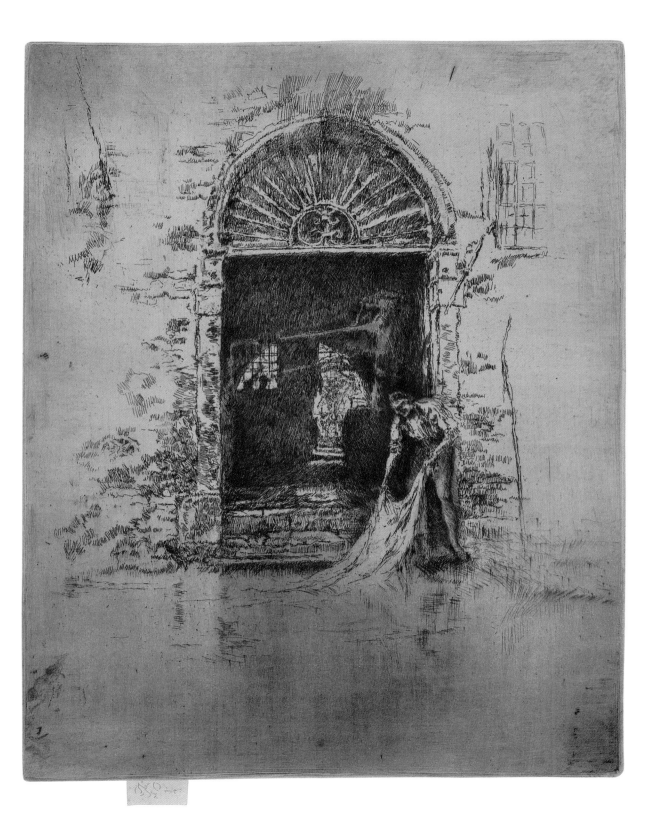

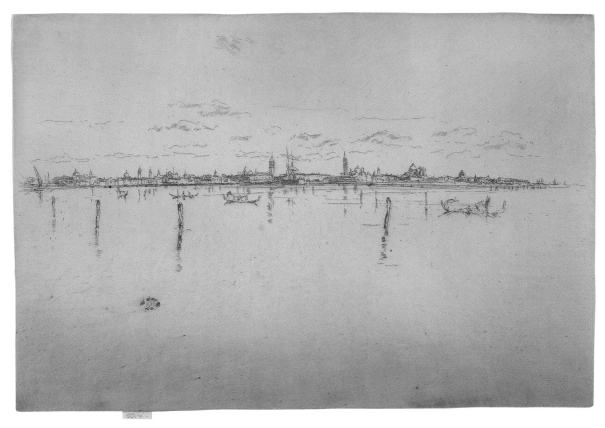

75.
James McNeill Whistler
Little Venice, 1879–80
(K.183), etching,
5³⁄₁₆ × 7¼ in.
(13.1 × 18.4 cm), National
Gallery of Art, Washington,
D.C., gift of Mr. and Mrs. J.
Watson Webb in memory of
Mr. and Mrs. H.O.
Havemeyer

76.
James McNeill Whistler
Nocturne, 1879–80 (K.184),
etching and drypoint,
8¹⁄₁₆ × 11⁹⁄₁₆ in.
(20.4 × 29.3 cm), Library
of Congress, Washington,
D.C., LC-USZC4-3884

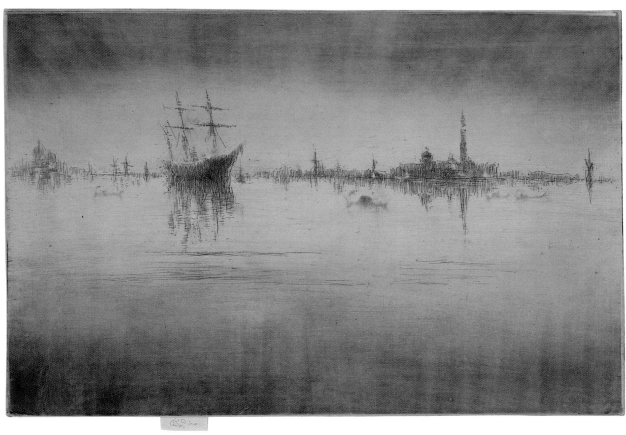

77.
James McNeill Whistler
Nocturne: Shipping, 1879–80
(K.223), etching, 4th state,
6⅛ × 8⅝ in.
(15.5 × 21.9 cm), Library of
Congress, Washington, D.C.,
LC-USZC4-10567

78.
James McNeill Whistler
Nocturne: Salute, 1879–80
(K.226), etching, 5⅞ × 9 in.
(14.9 × 22.8 cm), Library of
Congress, Washington, D.C.,
LC-USZC4-10568

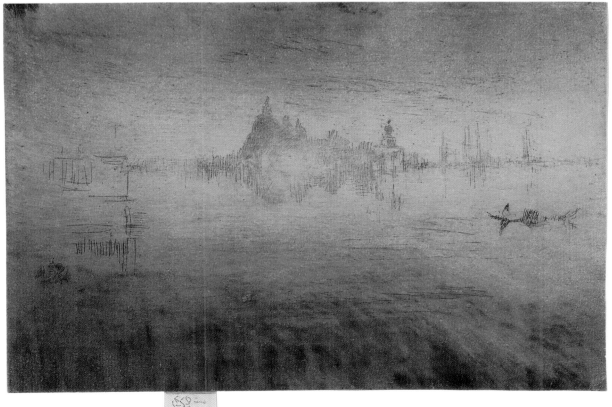

WHISTLER'S CIRCLE
IN VENICE

79.
Antonio Canale, called
Canaletto (1697–1768)
The Library of San Marco,
Venice, 1744, etching,
5⅝ × 8¼ in.
(14.3 × 20.9 cm), Collection
of The Arthur Ross
Foundation, New York

80.
Antonio Canale, called
Canaletto
The Proclamation Stone near
the Palazzo Ducale, Venice,
1744, etching, 5⅝ × 8¼ in.
(14.3 × 20.9 cm), Collection
of The Arthur Ross
Foundation, New York

81.
Antonio Canale, called
Canaletto
*The Marketplace on the Molo,
Venice*, 1744, etching,
5⅝ × 8¼ in. (14.3 × 20.9 cm),
Collection of The Arthur
Ross Foundation, New York

82.
Antonio Canale, called
Canaletto
The Old Prisons, Venice, 1744,
etching, 5⅝ × 8¼ in.
(14.3 × 20.9 cm), Collection
of The Arthur Ross
Foundation, New York

83.
Antonio Canale, called
Canaletto
*The Procuratie Nuove and San
Geminiano, Piazza San Marco,
Venice*, 1744, etching,
5⅝ × 8¼ in. (14.3 × 20.9 cm),
Collection of The Arthur
Ross Foundation, New York

84.
Antonio Canale, called
Canaletto
*Imaginary View of the Church of
San Giacomo di Rialto, Venice*,
1744, etching, 5⅝ × 8¼ in.
(14.3 × 20.9 cm), Collection of
The Arthur Ross Foundation,
New York

86.
Thomas Moran (1837–1926)
View of Venice, 1888,
watercolor and gouache
on paper, 11¼ × 16⅜ in.
(28.5 × 41.6 cm), The
Corcoran Gallery of Art,
Washington, D.C., bequest
of James Parmelee

87.
John Singer Sargent
(1856–1925)
Street in Venice, 1882, oil on
wood, 17¾ × 21¼ in.
(45.1 × 53.9 cm), National
Gallery of Art, Washington,
D.C., gift of the Avalon
Foundation

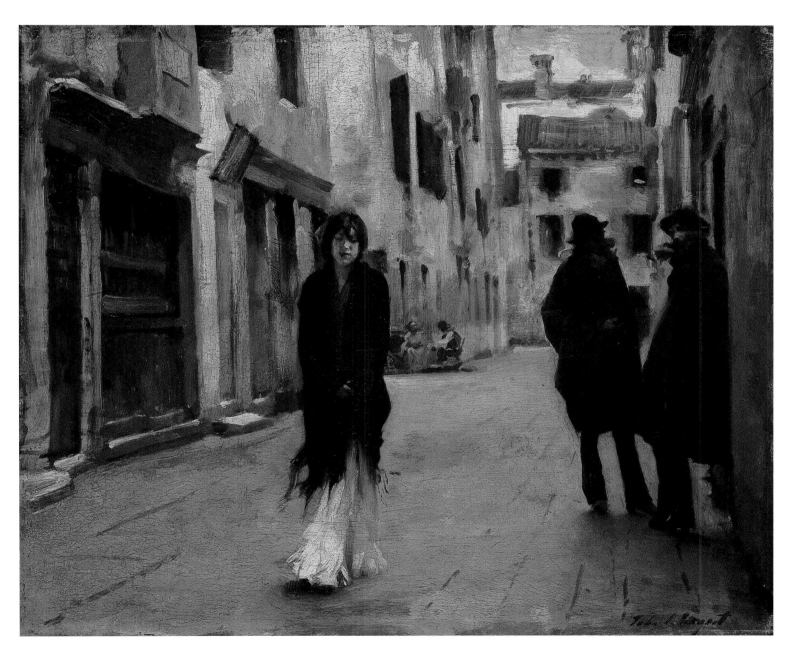

88.
John Singer Sargent
Canal Scene (Ponte Panada,
Fondamenta Nuove), Venice,
1880, watercolor on paper,
9⅞ × 14 in. (25.1 × 35.5 cm),
The Corcoran Gallery of Art,
Washington, D.C., bequest of
Mabel Stevens Smithers

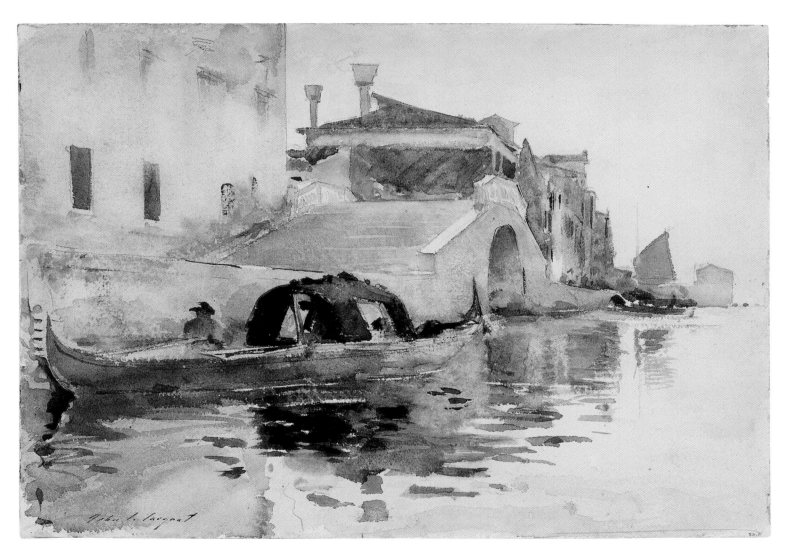

89.
John Singer Sargent
Campo dei Frari, Venice,
1880–82, watercolor with
gouache on paper,
9⅞ × 14 in. (25.1 × 35.5 cm),
The Corcoran Gallery of Art,
Washington, D.C., bequest of
Mabel Stevens Smithers

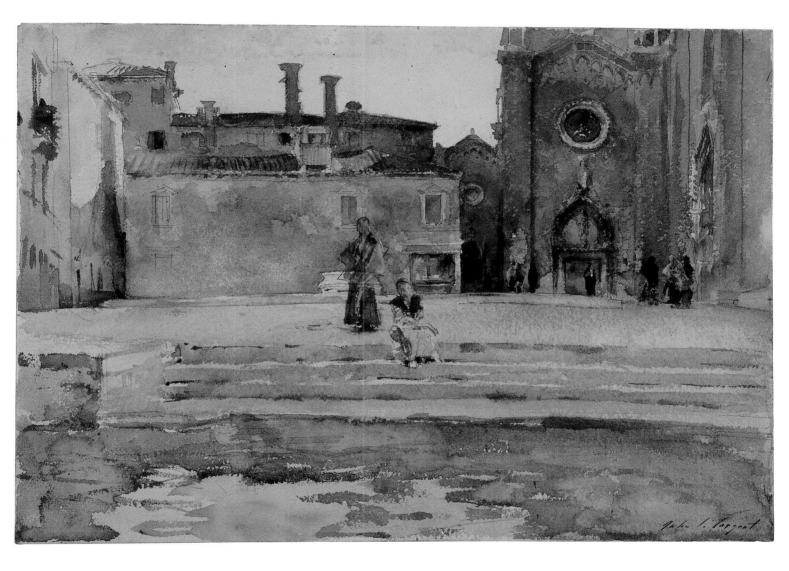

90.
Frank Duveneck
(1848–1919)
Riva Degli Schiavoni, No. 1,
1880, etching and
drypoint, 8½ × 13⅛ in.
(21.6 × 33.3 cm), The
Corcoran Gallery of Art,
Washington, D.C.

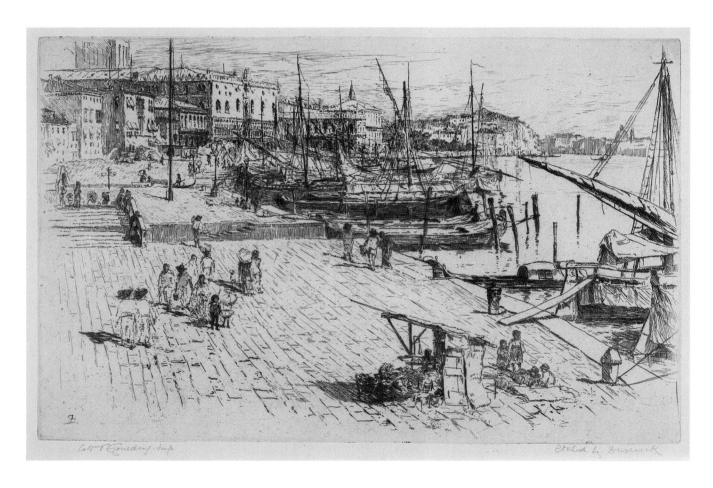

91. (RIGHT)
Frank Duveneck
Riva Degli Schiavoni, No. 2,
1880, etching and drypoint,
13⅛ × 8½ in.
(33.3 × 21.6 cm),
Cincinnati Art Museum,
bequest of Herbert Greer
French, 1943.802

92. (ABOVE)
Frank Duveneck
Narrow Street, c. 1883,
etching and drypoint,
19½ × 7¹³⁄₁₆ in.
(49.5 × 19.8 cm), Cincinnati
Art Museum, gift of the
artist, 1903.384

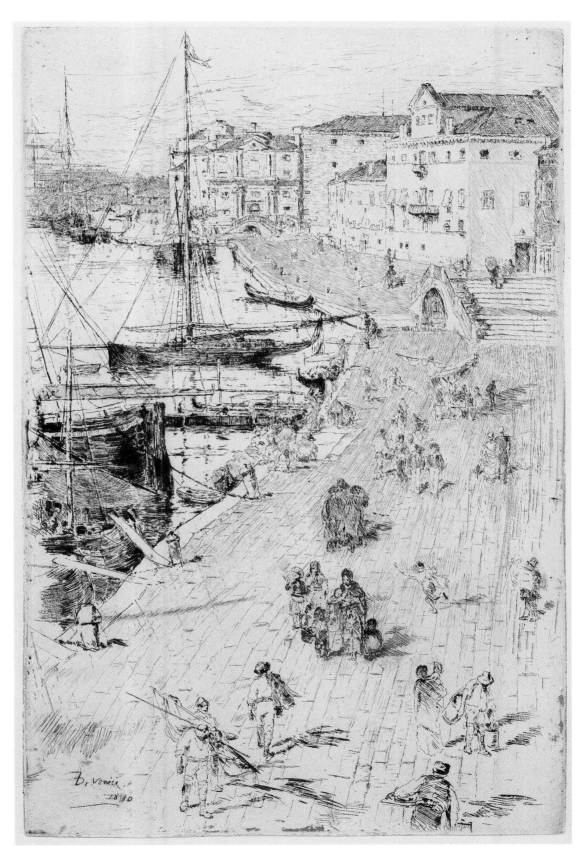

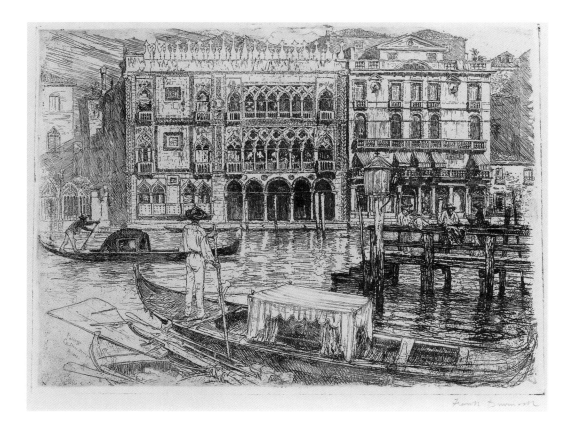

93.
Frank Duveneck
Palazzo Ca' d'Oro, 1883,
etching and drypoint,
14¹¹⁄₁₆ × 19⁷⁄₁₆ in.
(37.3 × 49.3 cm), Cincinnati
Art Museum, gift of the
artist, 1915.525

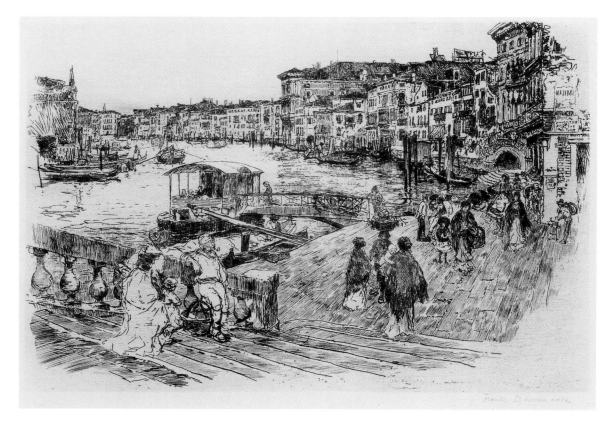

94.
Frank Duveneck
View of the Grand Canal,
1883, etching and drypoint,
10⅞ × 15¾ in.
(27.6 × 40 cm), Cincinnati
Art Museum, gift of the
artist, 1915.518

95.
Otto H. Bacher (1856–1909)
Lavanderia, c. 1880, etching,
12⅝ × 8¾ in. (32 × 22.2 cm),
Collection of Mr. and Mrs.
Stephen Bacher

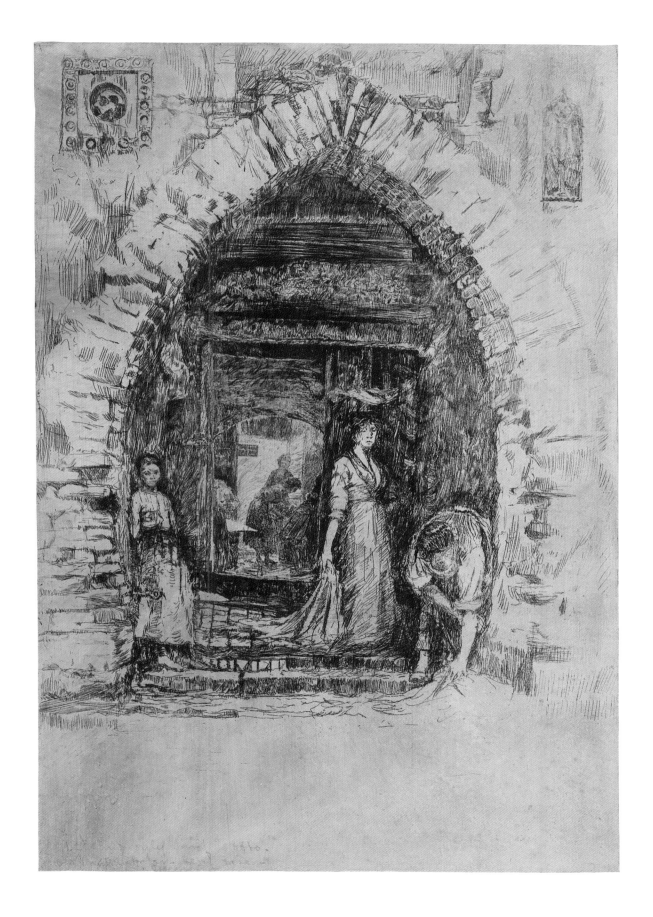

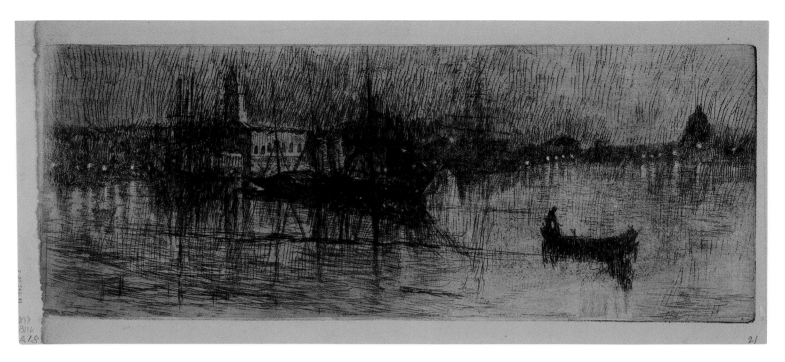

96.
Otto H. Bacher
A Rainy Night, Venice,
c. 1880, etching,
4¹⁵⁄₁₆ × 12⁷⁄₁₆ in.
(12.5 × 31.6cm), Library of
Congress, Washington, D.C.,
LC-USZC4-9919

97.
Otto H. Bacher
In Venice By Moonlight, 1882,
etching, 6⁵⁄₁₆ × 4¾ in.
(16 × 12 cm), Library of
Congress, Washington,
D.C., LC-USZC4-9917

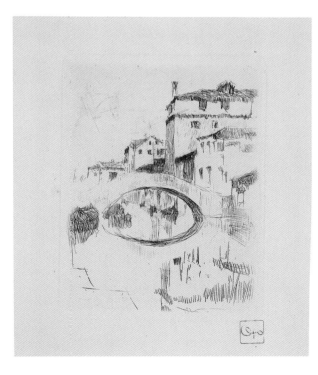

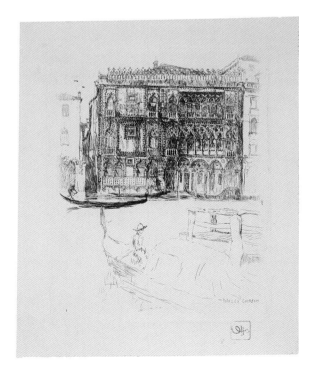

98.
Otto H. Bacher
Palazzo Casa d'Oro, *c.* 1880,
etching, 8⅛ × 6¼ in.
(20.6 × 15.8 cm), Library of
Congress, Washington,
D.C., LC-USZC4-9918

99.
Otto H. Bacher
Ponte del Pistor, c. 1880,
etching, 13 × 6 in.
(33 × 15.2 cm), Collection
of Mr. and Mrs. Stephen
Bacher

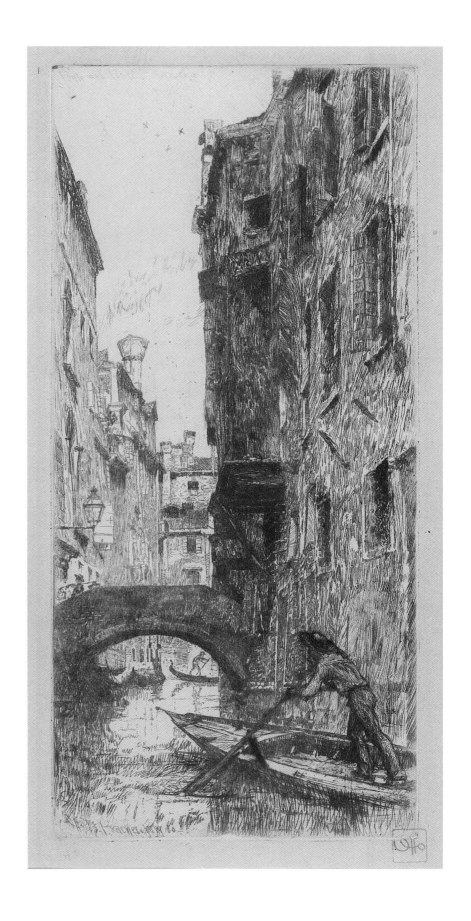

100.
Otto H. Bacher
View of the Castello Quarter,
c. 1880, etching,
8¹¹⁄₁₆ × 13⁹⁄₁₆ in.
(22 × 34.4 cm), Library of
Congress, Washington, D.C.,
LC-USZC4-9921

101.
Otto H. Bacher
The Grand Canal from the
Salute, Venice, c. 1880,
etching, 13¼ × 23¾ in.
(33.6 × 60.3 cm),
Collection of Mr. and Mrs.
Stephen Bacher

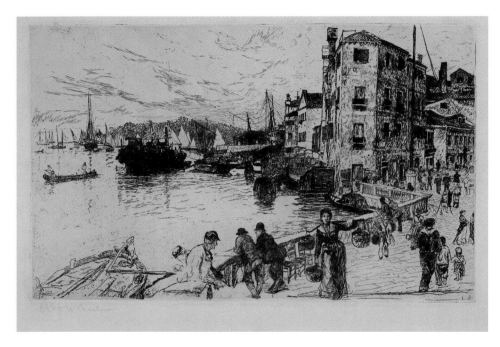

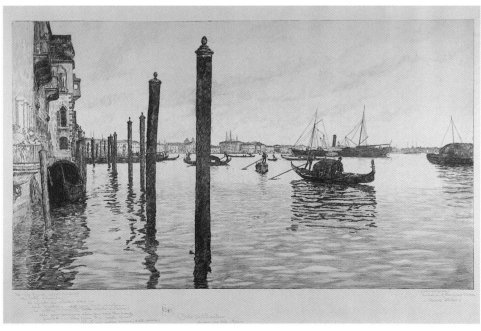

102.
Circle of James McNeill
Whistler
Two Boys on a Balustrade,
Venice, c. 1880, etching
on old Italian letter,
7¾ × 11¾ in. (19.7 × 29.8 cm),
Collection of Mr. and Mrs.
Stephen Bacher

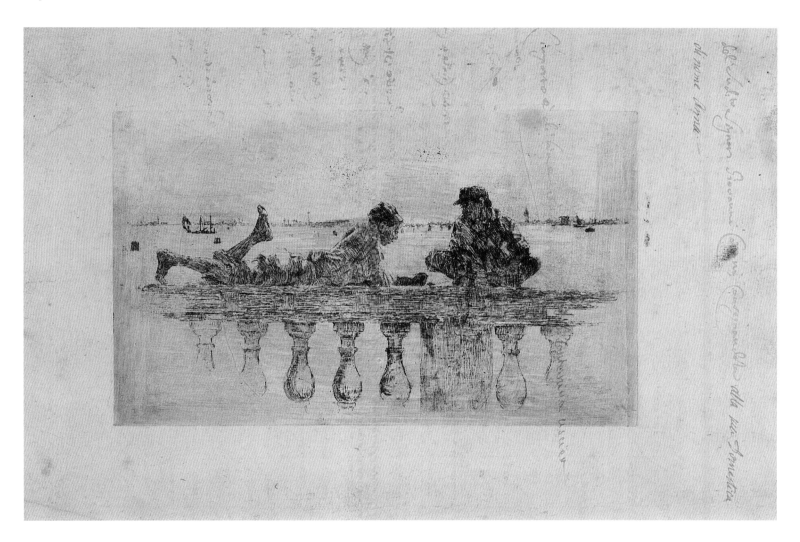

103.
Charles Abel Corwin
(1857–1938)
Scene in Venice, 1880,
etching, 8 × 5 in.
(20.3 × 12.7 cm),
private collection

104.
Charles Abel Corwin
Portrait of Whistler, 1880,
monotype, 8¹³⁄₁₆ × 6¹⁄₁₆ in.
(22.4 × 15.4 cm), The
Metropolitan Museum of Art,
New York, The Elisha Whittelsey
Collection, The Elisha Whittelsey
Fund, 1960, 60.611.123

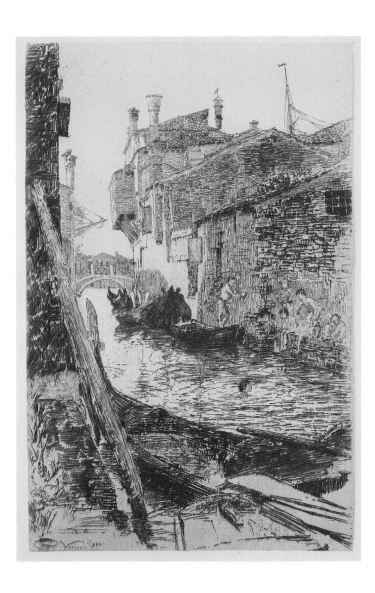

Robert Frederick Blum
(1857–1903)
*Venetian Doorway and
Gondolas, c.* 1880, etching
and drypoint, 5¼ × 7¹⁄₁₆ in.
(13.3 × 17.9 cm), Cincinnati
Art Museum, gift of
Henrietta Haller, 1905.216

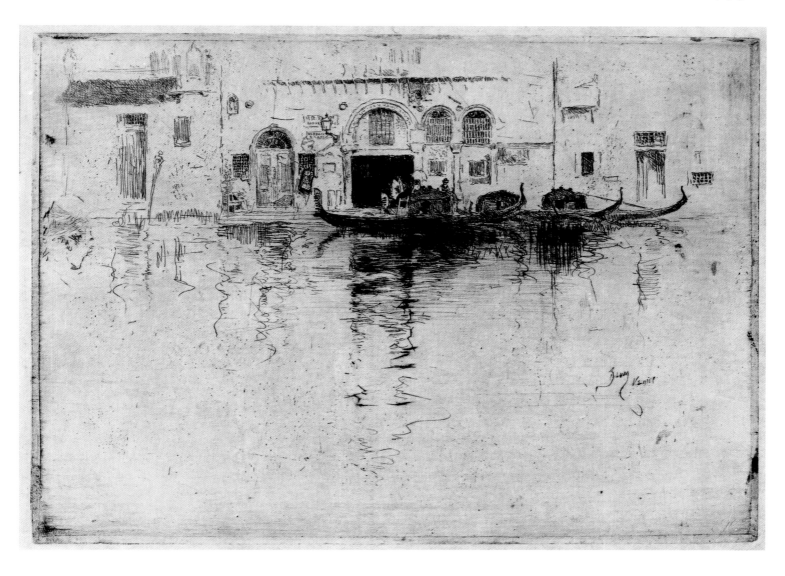

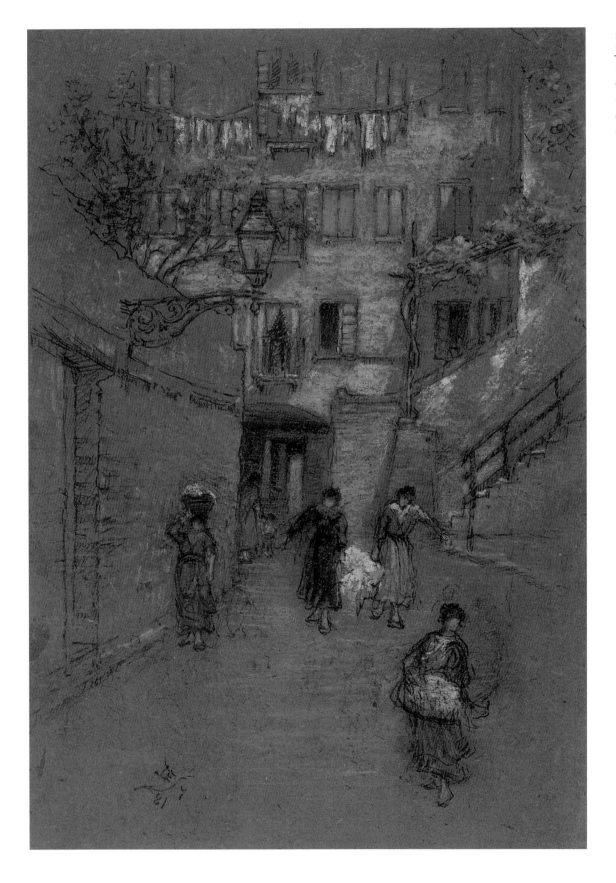

106.
Jerome Elwell (1847–1912)
Venetian Street, *c.* 1880, pastel
on paper, 10¼ × 6¹³⁄₁₆ in.
(26 × 17.3 cm), Collection
of Stephanie A. Strass and
Carleton F. Neville

107.
Mortimer Menpes
(1855–1938)
Piazza San Marco, undated,
etching and drypoint,
7⅞ × 11⅞ in. (20 × 30.1 cm),
Collection of The Arthur
Ross Foundation, New York

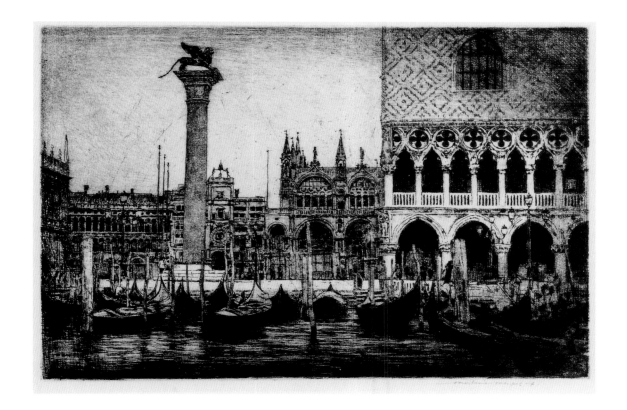

108.
Mortimer Menpes
Palazzi on a Canal, undated,
etching and drypoint,
3⅝ × 11⅞ in.
(9.2 × 30.1 cm), Collection
of The Arthur Ross
Foundation, New York

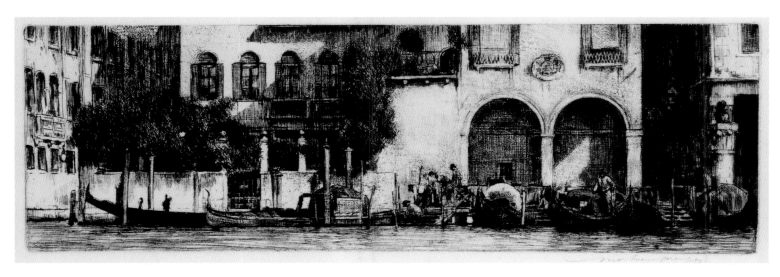

109.
Mortimer Menpes
Rio de l'Osmarin, undated,
etching and drypoint,
11¾ × 6⅞ in.
(29.8 × 17.4 cm), Collection
of The Arthur Ross
Foundation, New York

110.
Mortimer Menpes
*Bridge of Luciano, Along the
Grand Canal*, undated,
etching, 8 × 6 in.
(20.3 × 15.2 cm), Collection
of The Arthur Ross
Foundation, New York

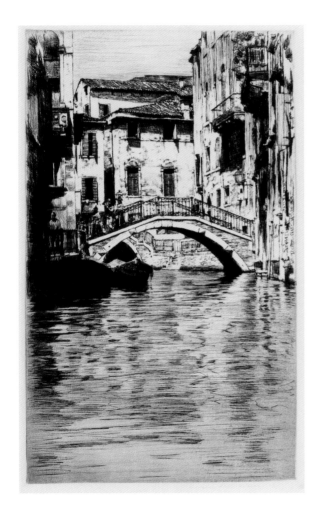

111.
Mortimer Menpes
Abbazia, undated, etching
and drypoint, 7⅞ × 11⅞ in.
(20 × 30.1 cm), Collection
of The Arthur Ross
Foundation, New York

112.
Mortimer Menpes
Back Canal, undated, etching
and drypoint, 5⅞ × 6 in.
(14.9 × 15.2 cm), Collection
of The Arthur Ross
Foundation, New York

113.
Joseph Pennell (1857–1926)
On the Riva, from Pennell's Window, 1883, etching,
8 × 10⅜ in.
(20.3 × 26.3 cm), William
Carl Fine Arts

114.
Joseph Pennell
Doorway, Venice, 1885,
etching, 9¹³⁄₁₆ × 6⅞ in.
(25 × 17.5 cm), Library of
Congress, Washington, D.C.,
LC-USZC4-10569

115.
Joseph Pennell
The Salute from the Lagoon,
1885, etching, 12⅛ × 7⅞ in.
(30.8 × 20 cm), Library of
Congress, Washington, D.C.,
LC-USZC4-10570

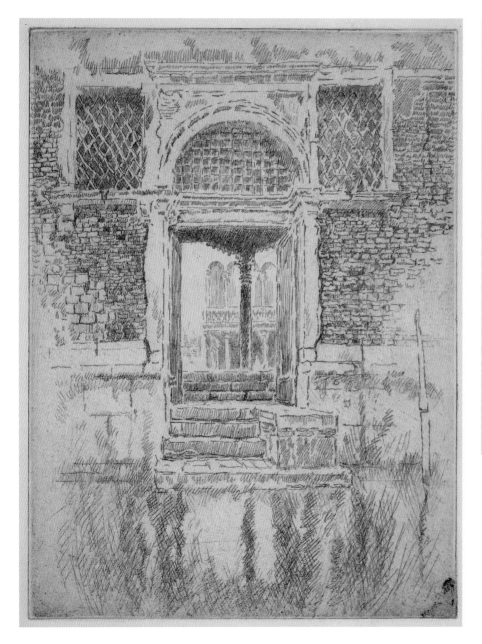

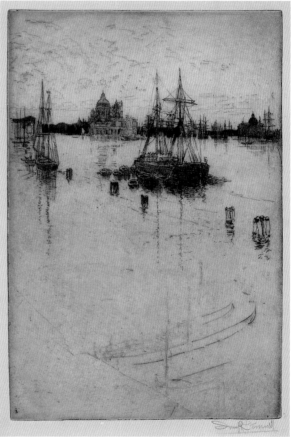

116.
Joseph Pennell
*Rebuilding the Campanile,
Venice, No. 1*, 1911, etching,
12½ × 9⅜ in. (31.7 × 23.8 cm),
National Gallery of Art,
Washington, D.C., gift of
Addie Burr Clark

117.
Joseph Pennell
*Rebuilding the Campanile,
Venice, No. 2*, 1911, etching,
9⅜ × 12½ in. (23.8 × 31.7 cm),
National Gallery of Art,
Washington, D.C., gift of
Addie Burr Clark

118.
Joseph Pennell
Venice Quadri, c. 1900, pastel
on paper, 9⅜ × 12⅝ in.
(23.8 × 32 cm), Library of
Congress, Washington,
D.C., LC-USZC4-10571

119.
Joseph Pennell
*Casa Jankowitz, Whistler's
Rooms in Venice*, c. 1901,
pastel on paper,
9⁵⁄₁₆ × 12½ in.
(23.6 × 31.7 cm), Library
of Congress, Washington,
D.C., LC-USZC4-10572

120.
Charles E. Holloway
(1838–1897)
A Street in Venice, c. 1895,
lithograph, 11 × 7⅝ in.
(27.9 × 19.3 cm),
private collection

121.
Francis Hopkinson Smith
(1838–1915)
Venetian Canal, c. 1885,
pencil, watercolor, and
gouache on paper,
23 × 13 in. (58.4 × 33 cm),
Mary Lublin Fine Arts, Inc.,
New York

122.
John Marin (1870–1953)
Ponte di Donna Onesta, Venice,
1907, etching, 7¹⁄₁₆ × 5¹⁄₁₆ in.
(17.9 × 12.8 cm), Philadelphia
Museum of Art, The J. Wolfe
Golden and Celeste Golden
Collection of Marin Etchings,
1969

123.
John Marin
Della Fava, Venice, 1907,
etching, 9⁵⁄₁₆ × 6⅞ in.
(23.6 × 17.4 cm),
Philadelphia Museum of Art,
The J. Wolfe Golden and
Celeste Golden Collection
of Marin Etchings, 1969

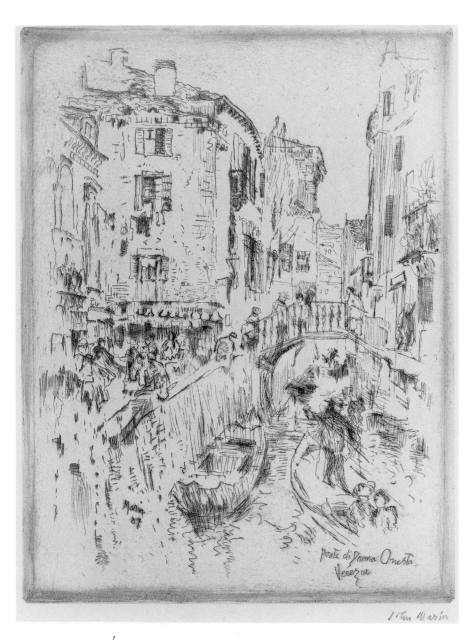

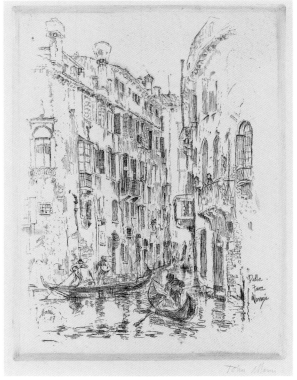

124.
John Marin
Sestiere di Dorsoduro, Venice,
1907, etching, 7¹⁄₁₆ × 5⅛ in.
(17.9 × 13 cm), Philadelphia
Museum of Art, The J.
Wolfe Golden and Celeste
Golden Collection of Marin
Etchings, 1969

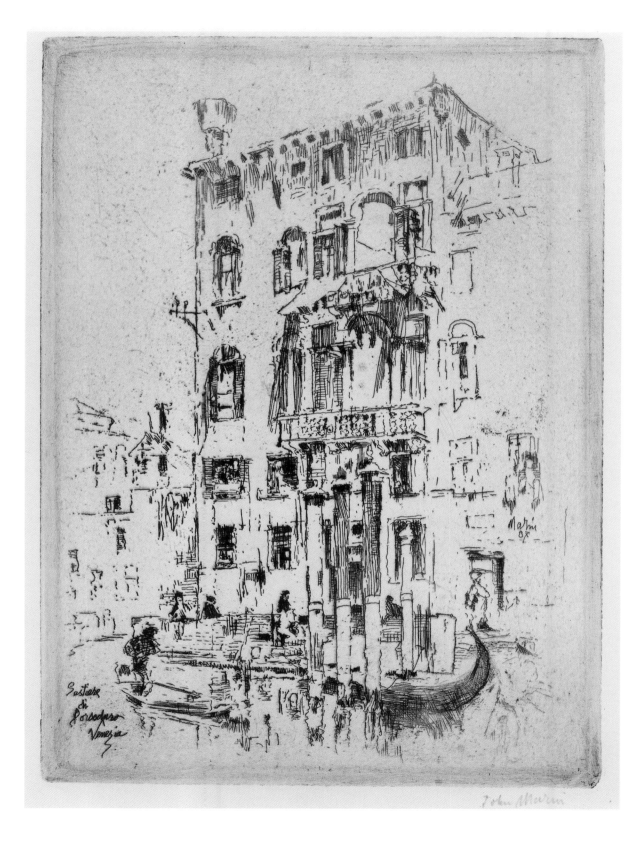

125.
John Marin
From Ponte S. Pantaleo,
Venice, 1907, etching,
7⅞ × 5½ in. (20 × 13.9 cm),
Philadelphia Museum of
Art, The Stieglitz
Collection, 1949

126.
John Marin
Window, Venice, 1907,
etching, 7¹⁄₁₆ × 5¹⁄₁₆ in.
(17.9 × 12.8 cm), Philadelphia
Museum of Art; purchased:
Lola Downin Peck Fund
from the Carl and Laura
Zigrosser Collection, 1967

127.
John Marin
Porta San Marco, Venice, 1907,
etching, 9 × 6⅝ in. (22.8 ×
16.8 cm), Philadelphia
Museum of Art; purchased:
Lola Downin Peck Fund
from the Carl and Laura
Zigrosser Collection, 1967

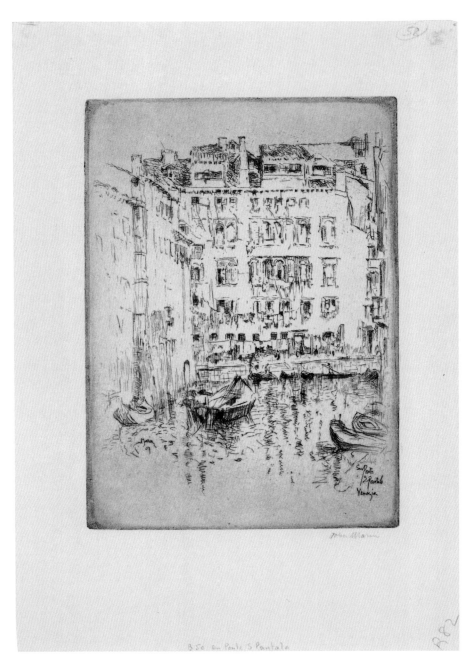

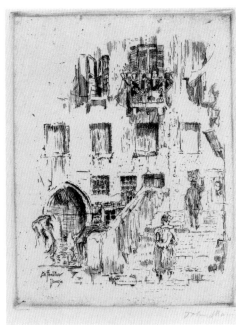

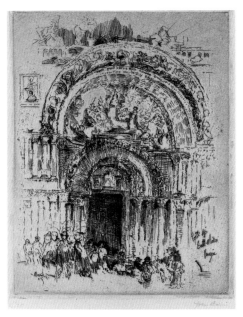

128.
John Marin
Campiello San Rocco, 1907,
etching, 6¼ × 4¹³⁄₁₆ in.
(15.8 × 12.2 cm), The
Corcoran Gallery of Art,
Washington, D.C.

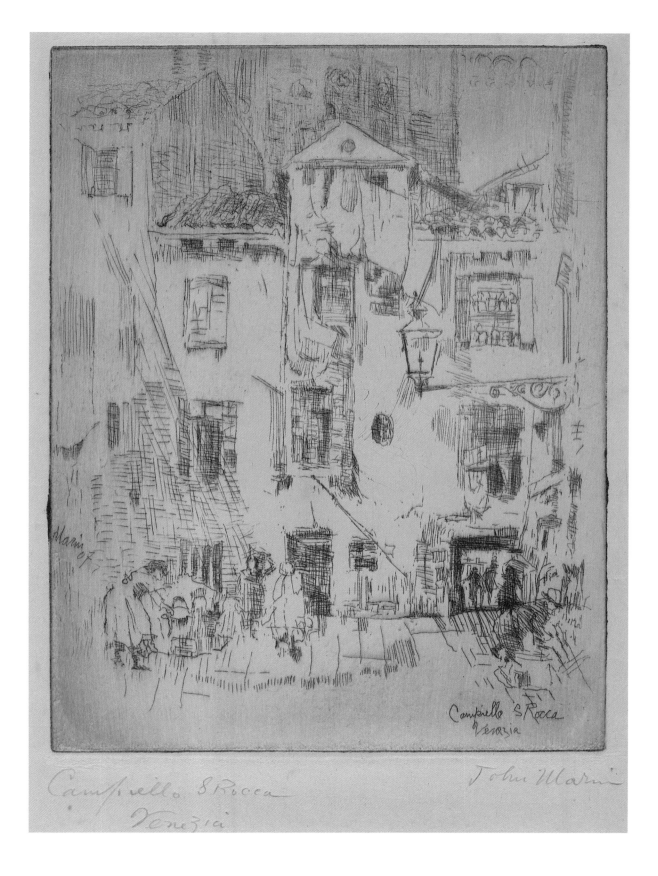

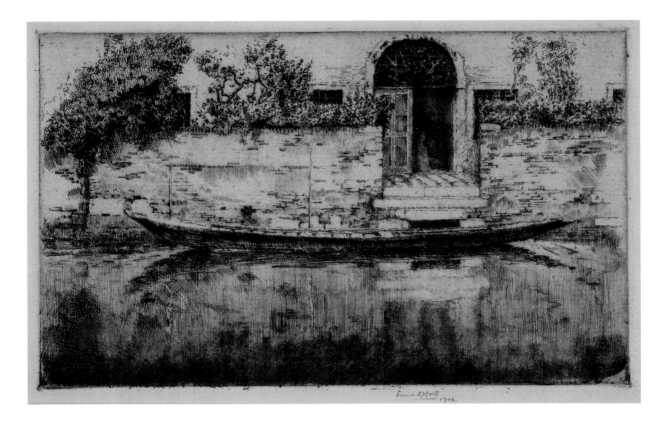

129.
Ernest David Roth
(1879–1964)
Reflections, Venice, 1906,
etching, 6 × 9½ in.
(15.2 × 24.1 cm),
private collection

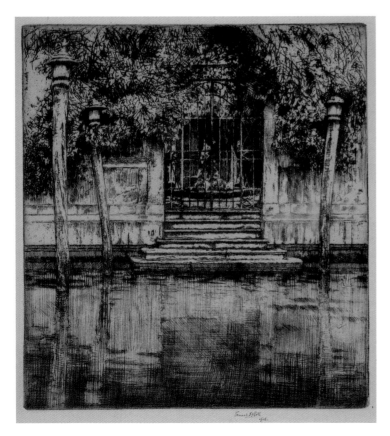

130.
Ernest David Roth
The Gate, Venice, 1906,
etching, 7½ × 6½ in.
(19 × 16.5 cm),
private collection

131.
Ernest David Roth
Campo San Boldo, 1924,
etching, 9¼ × 10⅜ in.
(23.5 × 26.3 cm),
private collection

132.
Ernest David Roth
Campo Santa Margherita,
1913, etching, 8 × 10¾ in.
(20.3 × 27.3 cm),
private collection

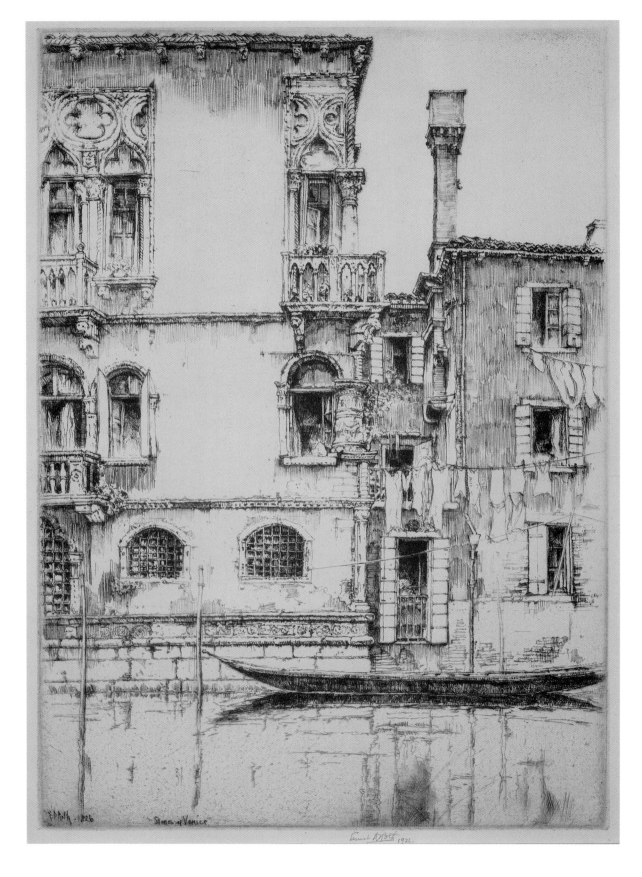

133.
Ernest David Roth
The Stones of Venice, 1926,
etching, 13½ × 9¼ in.
(34.3 × 23.5 cm),
private collection

134.
James McBey (1883–1959)
Barcarole, 1925, etching,
14⅞ × 8⅜ in.
(37.8 × 21.2 cm), National
Gallery of Art, Washington,
D.C., Rosenwald Collection

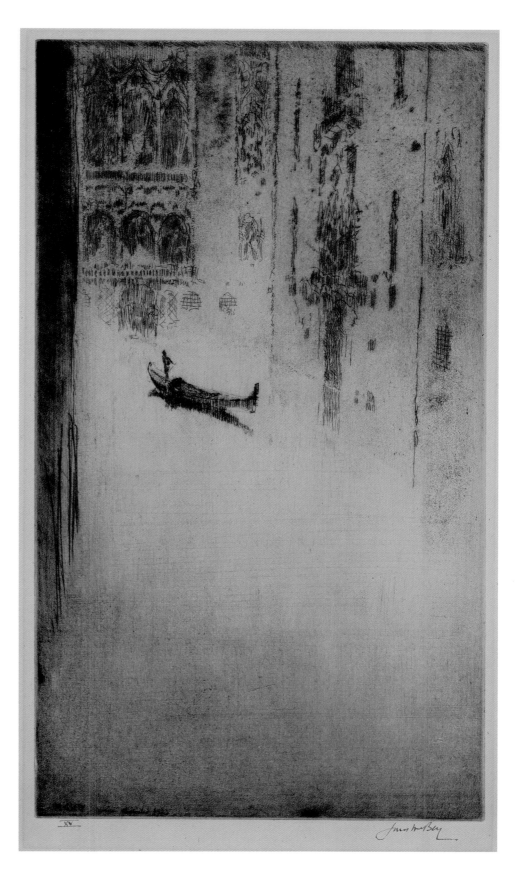

135.
James McBey
Sottoportico, 1925,
etching, 12¼ × 8½ in.
(31.1 × 21.6 cm), The
Corcoran Gallery of Art,
Washington, D.C.

136.
James McEey
The Riva at Dusk, 1925,
etching, 12¼ × 9¼ in.
(31.1 × 23.5 cm),
private collection

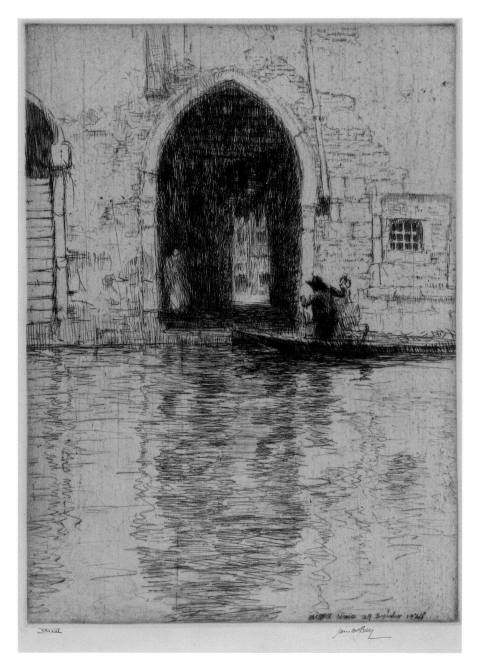

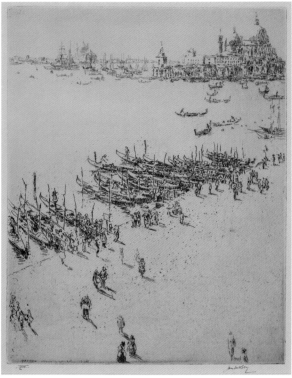

137.
James McBey
Palazzo dei Camerlenghi,
1925, etching,
12¹⁵⁄₁₆ × 8⅜ in.
(32.8 × 21.2 cm),
National Gallery of Art,
Washington, D.C.

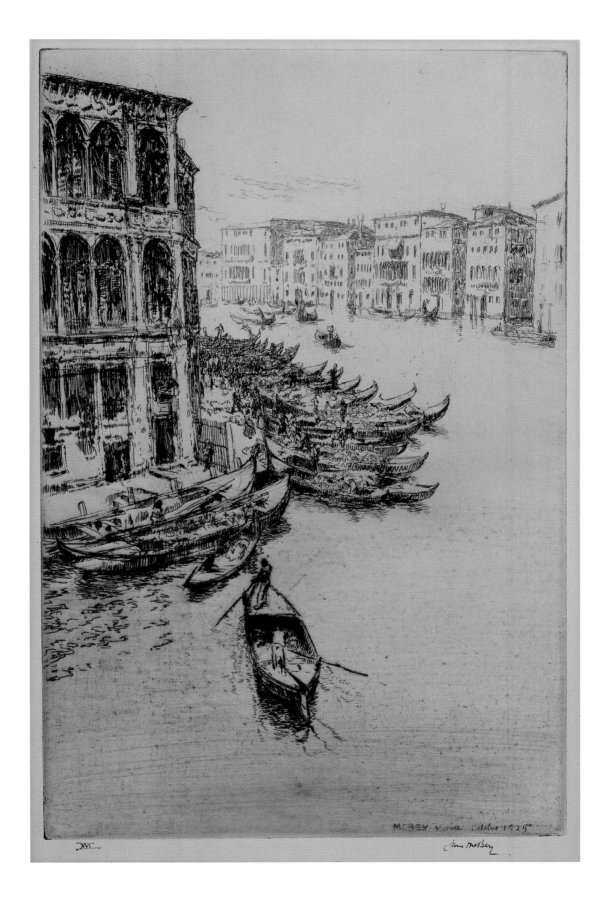

138.
Alfred Stieglitz (1864–1946)
On the Piazza, 6 a.m., 1894,
platinum print, 5½ × 7⅜ in.
(13.9 × 18.7 cm),
National Gallery of Art,
Washington, D.C., Alfred
Stieglitz Collection

139.
Alfred Stieglitz
A Venetian Well, 1894,
platinum print,
6⁵⁄₁₆ × 8⅛ in.
(16 × 20.6 cm),
National Gallery of Art,
Washington, D.C., Alfred
Stieglitz Collection

140.
Alfred Stieglitz
A Venetian Doorway,
1894, platinum print,
8⅞ × 6⅝ in.
(22.5 × 16.8 cm),
National Gallery of Art,
Washington, D.C., Alfred
Stieglitz Collection

141.
Alfred Stieglitz
Reflections, 1894, platinum
print, 6⅛ × 8³⁄₁₆ in.
(15.5 × 20.8 cm),
National Gallery of Art,
Washington, D.C., Alfred
Stieglitz Collection

142.
Alfred Stieglitz
Venice, 1894, platinum
print, 3⁷⁄₁₆ × 4¼ in.
(8.7 × 10.8 cm), National
Gallery of Art, Washington,
D.C., Alfred Stieglitz
Collection

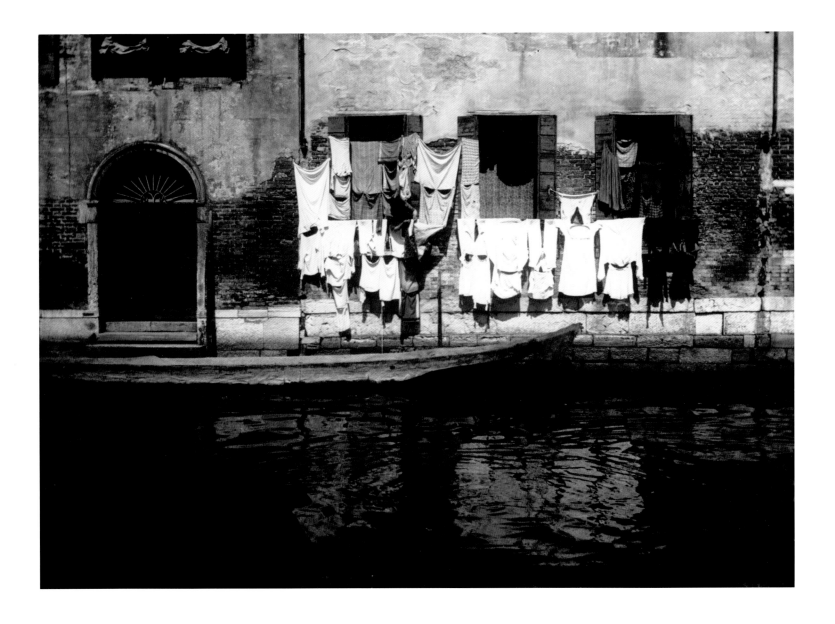

143.
Alfred Stieglitz
A Venetian Canal, 1894,
gelatin silver print mounted
on paperboard, 1924/1937,
8¹³⁄₁₆ × 6⅝ in.,
(22.4 × 16.8 cm), National
Gallery of Art, Washington,
D.C., Alfred Stieglitz
Collection

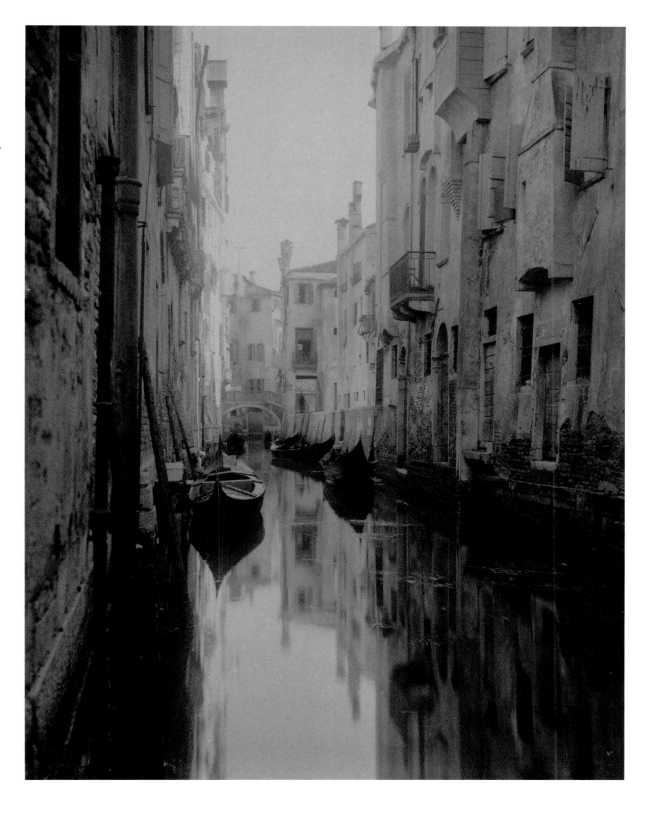

Selected Bibliography

Andrew, William W. *Otto Bacher* [1935], Madison WI (Education Industries Inc.) 1973

Bacher, Otto. *With Whistler in Venice*, New York (The Century Company) 1908

Fildes, L.V. *Luke Fildes, R.A.: A Victorian Painter*, London (Michael Joseph) 1968

Getscher, Robert H. *Whistler and Venice*, PhD diss., Cleveland, Case Western Reserve University, 1970

Grieve, Alastair. *Whistler's Venice*, New Haven CT and London (Yale University Press) 2000

Honour, Hugh, and John Fleming. *The Venetian Hours of Henry James, Whistler and Sargent*, Boston and London (Bulfinch Press) 1991

In Pursuit of the Butterfly: Portraits of James McNeill Whistler, exhib. cat. by Eric Denker, Washington, D.C., National Portrait Gallery, 1995

James, Henry. *Italian Hours*, illustrations by Joseph Pennell, Boston (Penguin) 1909

James McNeill Whistler, exhib. cat. by Richard Dorment, Margaret F. MacDonald, *et al.*, London, Tate Gallery, 1994

James McNeill Whistler at the Freer Gallery of Art, exhib. cat. by David Curry, Washington, D.C., Freer Gallery of Art, 1984

John Singer Sargent, exhib. cat. by Patricia Hills, Linda Ayers, *et al.*, New York, Whitney Museum of American Art, 1986

Lochnan, Katherine A. *The Etchings of James McNeill Whistler*, New Haven CT and London (Yale University Press) 1984

Lorenzetti, G. *Venezia e il suo estuario* [Milan and Rome 1926], trans. by J. Guthrie as *Venice and its Lagoon,* Trieste (Edizione Lint) 1975, reprinted 1990

Lovell, Margaretta M. *A Visitable Past: Views of Venice by American Artists* 1860–1915, Chicago and London (The University of Chicago Press) 1989

MacDonald, Margaret F. *James McNeill Whistler, Drawings, Pastels, and Watercolours, a Catalogue Raisonée*, New Haven CT and London (Yale University Press) 1995

MacDonald, Margaret F. *Palaces in the Night: Whistler in Venice*, Aldershot, Hampshire (Lund Humphries) 2001

Menpes, Dorothy and Mortimer. *Venice*, London (Macmillan Company) 1904

Merrill, Linda. *A Pot of Paint: Aesthetics on Trial in "Whistler v Ruskin,"* Washington, D.C. and London (Smithsonian Institution Press) 1992

Pennell, Elizabeth Robins. *Nights. Rome, Venice in the Aesthetic Eighties. London, Paris in the Fighting Nineties*, London (William Heinemann) 1916

Pennell, Elizabeth Robins and Joseph. *The Life of James McNeill Whistler*, 1st edn, 2 vols., London (William Heinemann) 1908

Pennell, Elizabeth Robins and Joseph. *The Life of James McNeill Whistler*, 5th (revised) edn, London (William Heinemann) and Philadelphia (J.B. Lippincott) 1911

Poole, Emily. "The Etchings of Frank Duveneck," *Print Collector's Quarterly*, XXV, no. 3, October 1938, pp. 312–31

____ "Catalogue of the Etchings of Frank Duveneck," *Print Collector's Quarterly*, XXV, no. 4, December 1938, pp. 446–63

Smith, Francis Hopkinson. *Gondola Days*, with illustrations by the author, Boston and New York (Charles Scribner's Sons) 1898

The Stamp of Whistler, exhib. cat. by Robert H. Getscher, Oberlin OH, Allen Memorial Art Museum, 1977

Two Views of Venice: Canaletto and Menpes, Etchings from the Collection of the Arthur Ross Foundation, exhib. cat. by Dilys Pegler Winegrad, New York, The Arthur Ross Foundation, 2000

Venice: The American View 1860–1920, exhib. cat. by Margaretta M. Lovell, The Fine Arts Museums of San Francisco, 1994–95

Way, Thomas Robert, and G.R. Dennis. *The Art of J.M. Whistler: An Appreciation*, London (John Lane) 1903

Way, Thomas Robert. *Memories of James McNeill Whistler, the Artist*, New York and London (John Lane) 1912

Weber, Bruce. *Robert Frederick Blum (1857–1903) and his Milieu*, PhD diss., 2 vols., New York, City University of New York, 1985

Whistler, James McNeill. *The Gentle Art of Making Enemies*, London (William Heinemann) 1890

Young, Andrew McLaren, Margaret F. MacDonald, Robin Spencer, and Hamish Miles. *The Paintings of James McNeill Whistler*, 2 vols., New Haven CT and London (Yale University Press) 1980

Acknowledgments

I would like to express my sincere appreciation to those private owners and museums that have generously lent their works to The Corcoran Gallery of Art, and allowed them to be reproduced in the catalogue. I would also like to thank the sponsors of the exhibition for their generous financial support of the catalogue and the show, in particular Mr. and Mrs. George T. Johnson, Martha Ann Healy, The Gladys Krieble Delmas Foundation, and The Arthur Ross Foundation. My gratitude goes also to the Italian Government Tourist Board, to Alitalia, to the Region of the Veneto, and to the Hotel Danieli, Venice. I would also like to thank His Excellency Ferdinando Salleo, The Ambassador of Italy, and the Embassy's cultural ministers, Luigi Macotta and Pasquale Ferrara, for their support and encouragement.

At The Corcoran Gallery of Art I would like to express my gratitude to David C. Levy, President and Director, Michael Roark, Chief Financial and Administrative Officer, Kathryn M. Keane, Deputy to the Director, Jan Rothschild, Chief Communications Officer, Susan Kenney, Public Affairs and Marketing Manager, Robert Villaflor and Daniel Klein in the Graphics Department, Katy Ahmed, Director of Corporate Relations, Kate Gibney, Director of Foundation Relations and Deborah Mueller, Development Associate, Joyce Fleming in the Accounting Department, Steve Brown, Director of Operations, Joanne Leach and Toni Leach, Ellen Tozer, Director of Retail Operations, Stacey Schmidt, Associate Curator of Contemporary Art, Dorothy Moss, Assistant Curator of American Art, Elizabeth Parr, Exhibitions Director, Dare Hartwell, Conservator, Emile K. Johnson, and Laura Pasquini in the Education Department, Kimberly Davis and Rebekah Sobel, Registrars, Kelly O' Neil, Rights and Reproductions Coordinator, Clyde Paton, Registrar's Office, Ken Ashton, Chief Preparator, Chris Brooks, Museum Technician, and Rachel Leverenz and Lindsay Whittle, Curatorial Interns. The task of coordinating the rights and reproductions fell to my invaluable assistant, Herbert Cooper, without whom the catalogue would not have come to fruition. I reserve a special note of thanks for Jacquelyn Serwer, Chief Curator and to Susan Badder, Senior Curator of Education for all of their support and encouragement, as well as their editorial expertise.

For their gracious assistance with the catalogue I would like to extend my thanks to my museum colleagues including Julie Dunn at the Addison Gallery of American Art, Phillips Academy; Jay Fisher, Susan Dackerman, and Beth Ryan at The Baltimore Museum of Art; Lizabeth Dion at the Boston Museum of Fine Arts; Heather Domencic at the Carnegie Museum of Art; Lynn Marsden-Atlass, Sara B. Walsh, and Linda Cagney at the Chrysler Museum of Art; Kristin Spangenberg and Scott Hisey at the Cincinnati Art Museum; Sylvia Inwood at The Detroit Institute of Arts; Mary Anne Goley at the Federal Reserve Board; Katherine M. Gerlough at the Frick Collection; Christina Brody at the Isabella Stewart Gardner Museum; Sarah Meschutt and Steve Dykstra, Glen Burnie Historic House and Museum and Julian Wood Glass, Jr. Collections; Miriam Stewart and David Carpenter at the Harvard University Art Museums; Amy Densford at the Hirshhorn Museum and Sculpture Garden, Smithsonian Institution; Jennifer Saville and Pauline Sugino at the Honolulu Academy of Arts; Katherine L. Blood and Margaret Brown at the Library of Congress; Karen Cardinal at the Mead Art Museum, Amherst College; George R. Goldner and Deanna Cross at The Metropolitan Museum of Art; Ms. Mel Ellis at the New Britain Museum of American Art; Stacey Bomento at the Philadelphia Museum of Art; Angela Dugan at the Saint Louis Art Museum, Lindsay Garratt, Kris Walton, and Monique LeBlanc at the Sterling and Francine Clark Art Institute, Williamstown; Douglas Evans at the Westmoreland Museum of American Art, Greensburg, Pennsylvania; Selina Bartlett at the Worcester Art Museum; Suzanne Warner at the Yale University Art Gallery, New Haven; Lynda Clark at the Hunterian Art Gallery, University of Glasgow. In addition I would like to express my appreciation to Barbara Bernard, Sarah Greenough, Carlotta Owens, Charles Ritchie, Andrew Robison, Alicia Thomas, and Julia Thompson at the National Gallery of Art, and to add a special note of thanks to photographers Lorene R. Emerson and David Applegate. At the Freer Gallery of Art I wish to acknowledge the generous assistance of Kenneth John Myers, as well as Neil Greentree, Tim Kirk, Susan Kitsoulis, Christina Popperfus, Josephine Rodgers, Lynne Shaner, and John Tsantes. I am also grateful to Margaret F. MacDonald for her gracious assistance with the catalogue, as well as Richard Ormond and Norma Marin. I would like to thank Warren Adelson and Elizabeth Oustinoff at the Adelson Galleries, New York; Scott A. Campbell at Frederick Baker, Inc.; William Carl of William Carl Fine Arts, Northampton; Courtney McGowan and Kyran Wilson at Childs Gallery, Boston; Mary Lublin at Mary Lublin Fine Arts, Inc.; Richard T. York and Meredith E. Ward of the Richard York Gallery, New York; and Claudia Ponton and Kristin Murray at Art Resource, New York. I would also like to thank Julian Honer, Matt Hervey, and Anthea Snow at Merrell Publishers, who have been exemplary collaborators on the catalogue. My deep appreciation to Amy Pastan who successfully guided us through the narrow shoals of editing and publishing and deserves much of the credit for the successful completion of the catalogue.

Picture Credits

All images are copyright © 2002

Addison Gallery of American Art, Phillips Academy, Andover MA, pl. 23
Adelson Galleries, Inc., New York, figs. 7, 9
The Arthur Ross Foundation, New York, photographs by Jim Strong, pls. 79–84, 107–112
Mr. and Mrs. Stephen Bacher, pls. 95, 99, 101, 102
The Baltimore Museum of Art, pls. 19, 37, 51, 53, 55, 56, 59, 63
Carnegie Museum of Art, Pittsburg, fig. 5
Chrysler Museum of Art, Norfolk VA, pl. 31
Cincinnati Art Museum, fig. 18, pls. 91–94, 105
The Corcoran Gallery of Art, Washington, D.C., pls. 27, 30, 36, 39, 46, 64, 85, 86, 88, 89, 90, 128, 135
Detroit Institute of Art, fig. 1
Hirshhorn Museum and Sculpture Garden, Smithsonian Institution, Washington, D.C., pls. 21, 22
Hispanic Society of America, New York, fig. 3
Fogg Art Museum, Harvard University Art Museums, Cambridge MA, fig. 13
Freer Gallery of Art, Washington, D.C., figs. 19–21, pls. 1–16
Glen Burnie Historic House and Museum and Julian Wood Glass, Jr. Collections, Winchester VA, pl. 29
Honolulu Academy of Arts, fig. 15
Dr. and Mrs. John E. Larkin, Jr., pls. 25, 26, 32
Lauren Rogers Museum of Art, Laurel MS, pl. 18
Library of Congress, Washington, D.C., pls. 47, 48, 54, 57, 61, 62, 65, 67–74, 76–78, 96–98, 100, 114, 115, 118, 119
Maier Museum of Art, Randolph-Macon Woman's College, Lynchburg VA, pl. 20
Mary Lublin Fine Arts, Inc., New York, pl. 121
Mead Art Museum, Amherst College MA, pl. 28
The Metropolitan Museum of Art, New York, figs. 10, 11, 17, pl. 104
Musee d'Orsay, Paris, fig. 16
National Gallery of Art, Washington, D.C., © 2002 Board of Trustees, fig. 2, pls. 33, 35, 38, 40–45, 49, 50, 52, 58, 60, 66, 75, 87, 116, 117, 134, 137–143
New Britain Museum of American Art CT, pl. 17
Philadelphia Museum of Art, pls. 122–127
Private collections, photography by Lorene Emerson and David Applegate, figs. 6, 14, pls. 103, 120, 129–133, 136
Sterling and Francine Clark Institute, Williamstown MA, fig. 4
Stephanie A. Strass and Carleton F. Neville, pl. 106
Westmoreland Museum of American Art, Greensburg PA, pl. 24
William Carl Fine Arts, pl. 113
Worcester Museum MA, fig. 12

Index

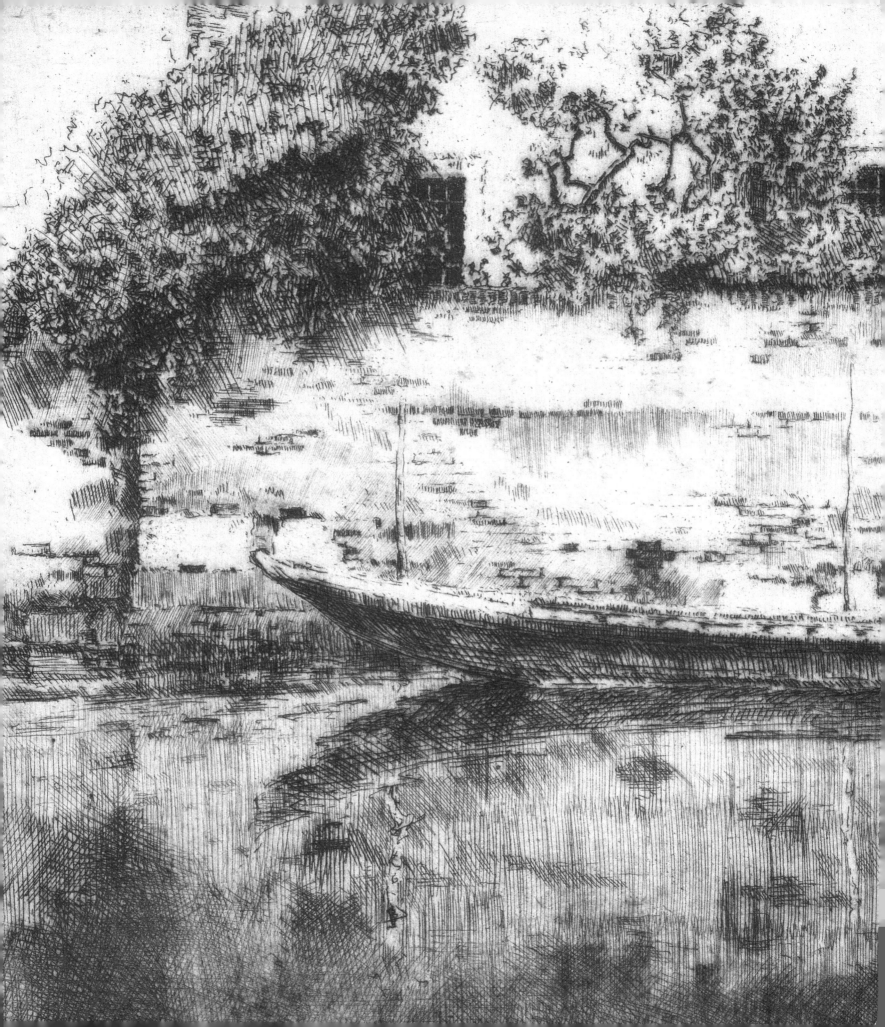